EXPRESSIVE
PHOTOGRAPHY

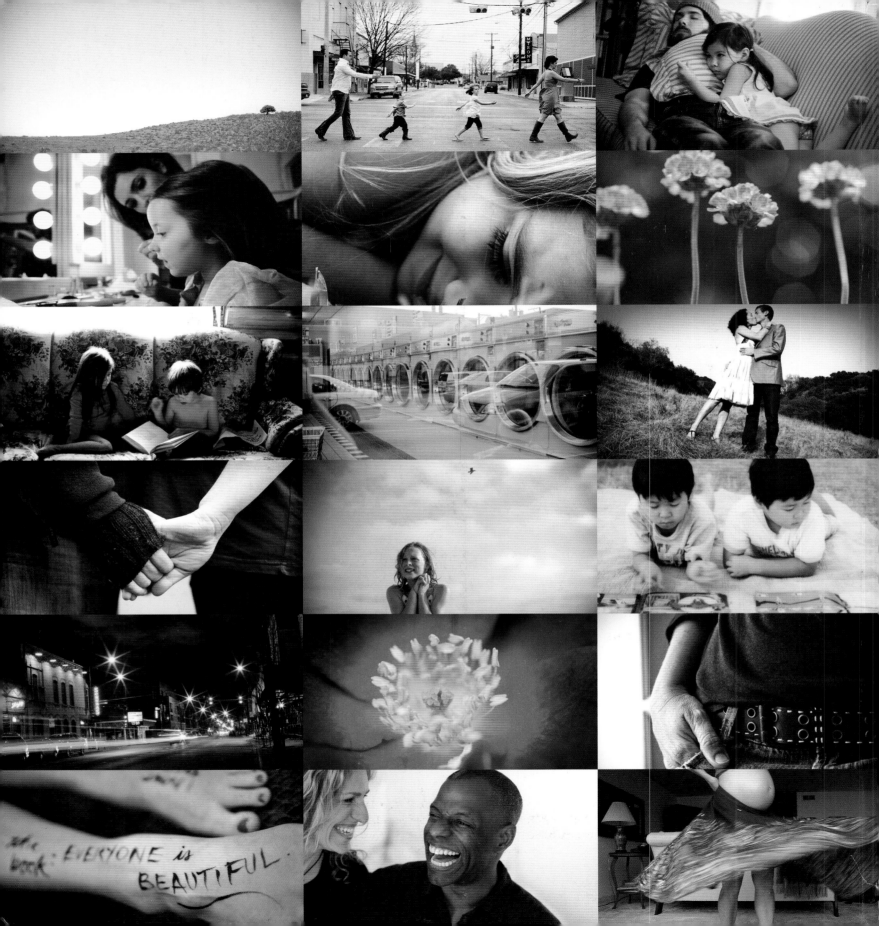

EXPRESSIVE
PHOTOGRAPHY

The Shutter Sisters' Guide to Shooting from the Heart

TRACEY CLARK

ANDREA SCHER

KATE INGLIS

SARAH-JI

MAILE WILSON

IRENE NAM

STEPHANIE C. ROBERTS

PAIGE BALCER

KAREN WALROND

JEN LEMEN

ELSEVIER

AMSTERDAM • BOSTON • HEIDELBERG • LONDON
NEW YORK • OXFORD • PARIS • SAN DIEGO
SAN FRANCISCO • SINGAPORE • SYDNEY • TOKYO

Focal Press is an imprint of Elsevier

Focal Press

CONTENTS

Focal Press is an imprint of Elsevier
30 Corporate Drive, Suite 400, Burlington, MA 01803, USA
Linacre House, Jordan Hill, Oxford OX2 8DP, UK

Library of Congress Cataloging-in-Publication Data:
A catalog record for this book is available from the
Library of Congress.

ISBN 978-0-240-81347-9

For information on all Focal Press publications visit our
website at www.focalpress.com

This book was conceived, designed, and produced by:
The Ilex Press, 210 High Street, Lewes, BN7 2NS, UK

Publisher
Alastair Campbell

Creative Director
Peter Bridgewater

Associate Publisher
Adam Juniper

Managing Editor
Natalia Price-Cabrera

Senior Designer
James Hollywell

Designer
Laura de Medeiros

Color Origination
Ivy Press Reprographics

Printed and bound in China

10 9 8 7 6 5 4 3 2 1

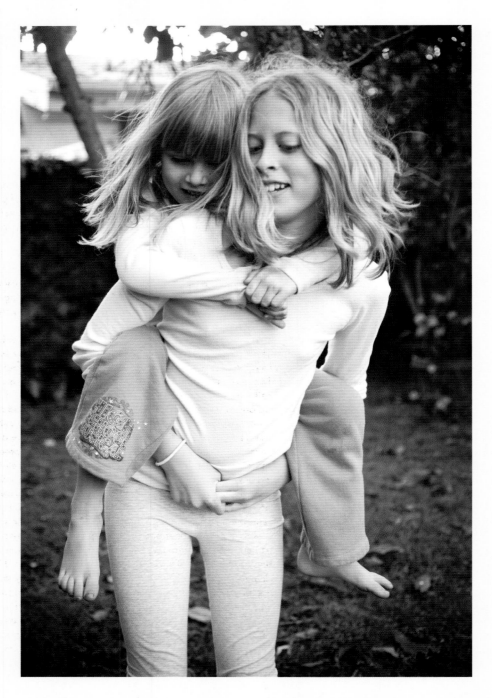

What matters most *by Tracey*
"Photography is a way of feeling, of touching, of loving. What you have caught on film is captured forever...it remembers the little things, long after you have forgotten everything." Aaron Siskind

INTRODUCTION
Tracey Clark
Founder of Shutter Sisters

FOR MANY, PHOTOGRAPHY IS CONSIDERED A SCIENCE. After all, there are precise ways of doing things. One must consider the measurement of exposure, light, ƒ-stops, and aperture. There are numbers involved and settings to understand. Learning to use a camera properly takes effort, commitment, tenacity, and trial and error. It can take time and planning to create great photographs.

Photography is also a way of documenting events, whether they are celebratory, poignant, excruciating, or exciting. As recording devices go, there is no better tool than a camera. A single click, planned or unplanned, distills a moment in history, a fragment of time memorialized forever. When using a camera in this way, the photographer relies first on intuition and second on intellectual knowledge; knowing when to snap the shutter is usually an instinct, not a reasoned decision.

Finally, photography is an art form in and of itself. Photographers use their cameras the same way painters use brushes—to create pictures rich with color, texture, and emotion. Or the way a poet uses words, narrating his or her heart and soul through the fluidity of language. In the photographer's case, this language is visual. Using a camera is an ideal means of self-expression above and beyond simple science or documentary.

I have experienced photography as all of these things—a perfect triad of intelligence, intuition, and inspiration. It's no surprise that all three were catalysts in the birth of Shutter Sisters. As a photographer and a woman, I longed for a community of other women like myself, equally passionate about the medium. Equipment and experience aside, I wanted to create a web home where women could celebrate their work by sharing it. And not just the sharing of images, but of stories, experiences, perspectives, ideas, and techniques, all based on the pure love of photography.

This book is an extension of the Shutter Sisters' blog (www.shuttersisters.com). I want it to be a warm and inviting place for you to pore over images, hear stories, and learn more about the whys and hows of shooting photography from the heart. You will be led through these chapters, each with its specific theme, by the unique voices and insights of the founding contributors of the Shutter Sisters' blog. Our goal is for you to walk away feeling inspired to not only look at things a little differently, but also to challenge yourself to approach your subjects through a more compassionate lens.

It's a powerful thing to use our viewfinders to picture the world around us. Photography provides us with the perfect way to express ourselves—as daughters, as mothers, as women, as artists. With each image, no matter the subject at hand, we illuminate what matters most to us, and that is not only inspiring, it's transformative.

Click!

THE SHUTTER SISTERS ARE . . .

TRACEY CLARK
www.traceyclark.com

Shutter Sisters' founder Tracey Clark manages to keep herself in constant creative motion. Beyond a career in photography, a personal blog at traceyclark.com, two published motherhood journals and *Shutter Sisters*, Tracey also writes for a variety of publications and websites, and shares her passion, know-how and photo-philosophies at conferences and events nationwide. Tracey and her husband raise their two beautiful and brilliant daughters together in sunny Southern California where they spend much of their spare time splashing amidst the swells and building sandcastles.

ANDREA SCHER
www.superherojournal.com

Andrea Scher is a creative entrepreneur, photographer, and life coach living in Berkeley, California. Through her award-winning blog, *Superhero Journal*, Andrea inspires other creative souls to live authentic, colorful and extraordinary lives. Her most recent adventure is as co-founder of www.mondobeyondo.org, a successful online class about dreaming big.

KATE INGLIS
www.sweetsalty.com

Kate Inglis lives on the edge of a meat-grinder sea on the far eastern coastline of Nova Scotia, Canada, where she was born. An author first and foremost, she nurtures her photographic skills by trial and error. Kate writes at sweet | salty, where she has chronicled a journey of motherhood that's been equal parts joy, blessings, and unexpected bumps. Her first novel, *The Dread Crew: Pirates of the Backwood*, was released in the fall of 2009. Kate enjoys power outages, woodsmoke, the flotsam you find on the beach after a hurricane, and the novelty of living in the saltiest place on earth.

SARAH-JI
www.sarah-ji.com

Sarah-Ji is a photographer who uses her camera to document the story of her life and those around her. The images she captures reflect her unabashed nostalgia and hunger for narrative. She lives in Chicago with her home-brewing husband, Ted, and sparkly shoes-loving daughter, Cadence. When she's not looking through a viewfinder, Sarah loves making mix CDs and daydreaming about living on a farm with her friends. She blogs at sarah-ji.com.

MAILE WILSON
www.relishportraitstudio.com

Maile Wilson has been a professional photographer for 15 years. Originally from Maui and California, she now resides in San Antonio, Texas with her husband and three children. She specializes in family portraits, has photographed celebrities such as Brooke Burke, Eva Longoria Parker, and Tony Parker, and is increasingly commissioned by clients around the world. She recently launched a new line of fashionable camera bags for women at epiphaniebags.com.

IRENE NAM

www.irenenam.com

Irene Nam is a writer and photographer whose images and words have been featured on various print and online publications including *Life Images*, *Artful Blogging* (Stampington & Company), AOL's *ParentDish*, and *Small Magazine*. She navigates a happy balance in Paris, France where she lives with her family, plays Monopoly with her two sons, carries a backpack full of Polaroid film, and collaborates on projects that help children and communities in need around the world.

STEPHANIE C. ROBERTS

www.littlepurplecowphotography.com

Stephanie C. Roberts is a documentary photographer and the creator of LittlePurpleCow Productions, a digital media production firm based in Atlanta, Georgia where she crafts multimedia stories for business and non-profit organizations. In 2009 Stephanie and Jen Lemen won the *Name Your Dream Assignment* photography competition sponsored by Microsoft and Lenovo, sending the Shutter Sisters on a journey to "Picture Hope" around the world. Stephanie lives with her family on a cattle farm where she journals in the form of iPhoneography and avoids ironing.

PAIGE BALCER

www.paigebphotography.com

Paige Balcer is a graphic designer turned professional photographer living in Omaha, Nebraska. She started Paige B. Photography in the winter of 2008 and is enjoying the adventure of being self-employed. Paige and her husband, John, enjoy frequent road trips to visit friends in Chicago, where they lived together before moving to Omaha. Paige loves dark chocolate, argyle socks, Paper Source, and any good book. She can often be found taking pictures of her cat Roxy, a common subject on her blog and at Shutter Sisters.

KAREN WALROND

www.chookooloonks.com

A former attorney, Karen Walrond is a writer, photographer, and the creative mind behind the award-winning blog *Chookooloonks*, a site that helps readers see that their ordinary lives are, in fact, extraordinary. Her fine-art images and photography projects have been included in exhibits around the country. A seasoned speaker, she has appeared on both local and national radio, and television shows, including an appearance on *The Oprah Winfrey Show*. She is the author of the book, *The Beauty of Different*, published by Bright Sky Press.

JEN LEMEN

www.jenlemen.com

Jen Lemen is a writer and photographer living outside Washington, DC. Jen is the co-founder of www.mondobeyondo.org, a successful online class about dreaming big. When Jen isn't in her studio cooking up images and short films for her new venture, *Hopeful World*, you can find her in the fields of Rwanda, taking photographs of the family and friends who gave her love when she needed it most.

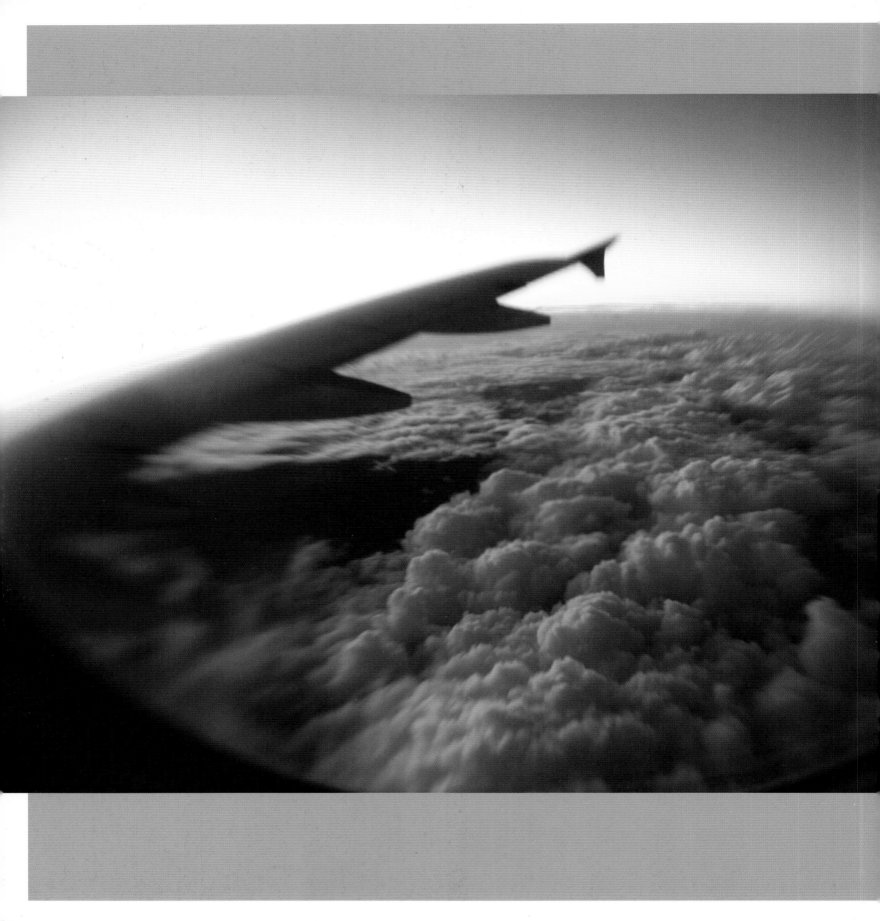

1 Horizons

Tracey Clark

"There is something bigger than fact: the underlying spirit, all it stands for, the mood, the vastness, the wildness."

EMILY CARR

I'VE ALWAYS LOVED AIRPLANE TRAVEL. THE ANTICIPATION OF being transported from one place to the next—so many miles in so little time—is electric, the energy palpable. For most of my life I have been an excited and willing traveler, flying to vacations, to work, to weddings, to friends and family, to excitement, to adventure. Although jetsetting with my family is my favorite kind of travel, there is also something uplifting about flying solo.

Having the opportunity to be whisked away, out of my normal life and into a swirl of newness, challenges, and the unknown, is exhilarating. As for the trip itself, whether I'm coming or going is of no importance. Each leg of the journey holds something unique, something to focus on or something to look forward to. And although I am usually fairly eager to reach my destination, I strive to enjoy the actual travel itself and all that soaring above the clouds has to offer.

On a recent trip from New York to Los Angeles, I found myself easing into the idea of a long, lazy flight home. I chose to stow my laptop, hold my camera in my lap (just in case), and gaze out the window, resting and reflecting. With no expectations or agenda, I watched as the world went by and I periodically snapped pictures of the mysterious and multifaceted skyscapes from my window seat.

I let the view play tricks on me as I hovered over stormy seas, looked down on a patchwork quilt of colors and textures, and sometimes felt lost in space. Hours passed and I drifted in and out of a sleepy daze. As the clouds continued to shape-shift, the sun became a subtle yet deliberate stage light, illuminating the sky as our plane floated above the last miraculous act of evening. I watched unblinking, transfixed as the last light of day sparkled and then disappeared at a final curtain call.

Entertained, enlightened, and inspired, I marveled at how grateful I felt to bear witness to this extraordinary act of mother nature. How could it be that such a wide-open sky could bring me such peace? How could the mystery of my surroundings, as I literally dangled in mid-air, leave me feeling so certain and secure?

There is an intangible quality that comes with expansive space and breathing room. A view itself is not emotional on its own—it's our mind's eye that translates a landscape into something that can stir our soul. When my heart wanders amidst an image of an impossibly endless horizon—be it of mountains, seas, or skies—I can't help but believe that anything is possible.

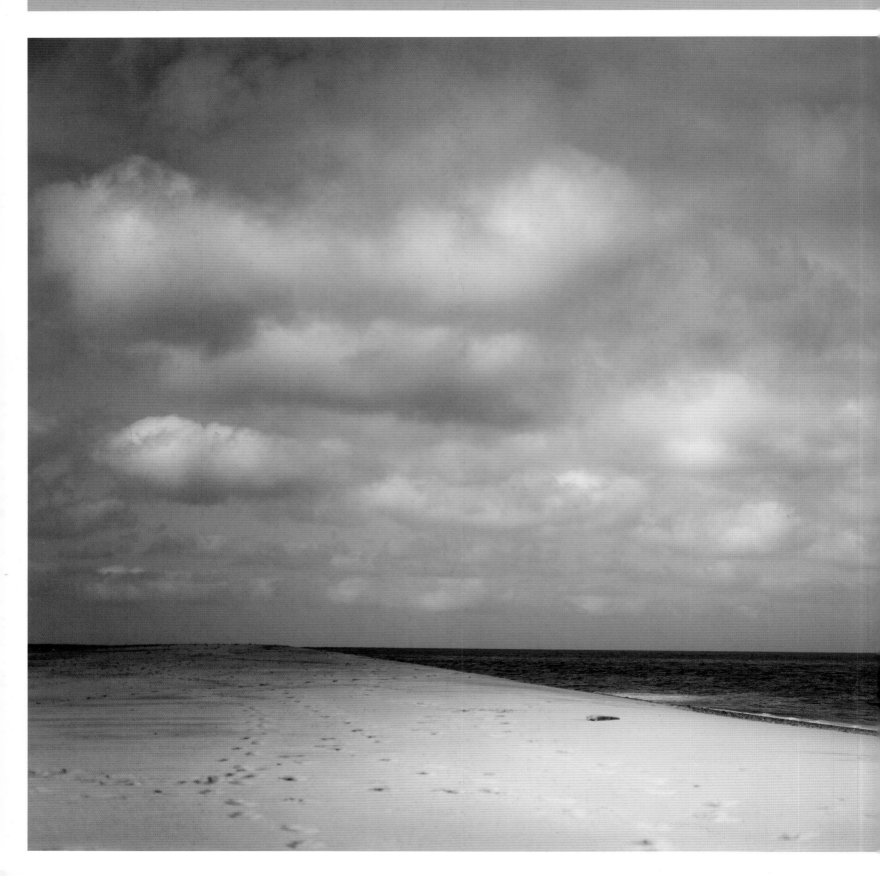

Introduction

THE DESIRE TO CAPTURE BREATHTAKING images of our horizons is universal. We take pictures of landscapes on our vacations, of famous landmarks, on outings and excursions, of our own neighborhoods and sunset after beautiful sunset. We shoot to document where we are, what we see, how it makes us feel; it's a way to recall all of these things at some later date when the scenery and our surroundings have changed. And capturing the perfect horizon can be the most inspirational of all photography—as we focus our eye on a seemingly never-ending sky or sea, we look towards the future and all that possibly awaits us there.

Even the most simple point-and-shoot cameras offer basic settings that help the photographer capture specific desired shots. But although camera modes can be useful, they are really just suggestions for improving standard shots. Without the photographer's vision to bring something extra to the image, even the most picturesque horizons can be left looking like uninspired snapshots. To avoid a flat translation of vibrant surroundings, use emotion to guide you. There's no doubt that taking in a scenic view can stir the soul—the work of Ansel Adams is proof of that. Being mindful of the vistas that inspire you and observing the details of even the most vast of views, can help you decide how to do them justice in a photograph.

◀ **Wild blue**
The elements of color, texture and light are all that are needed to tell the story of a landscape. Although some patience might be involved in waiting for the right light, unlike portraits of people, scenic shots like this can be captured with virtually no coaxing. Even still they conjure up all kinds of emotion.

Shutter Sisters' Blog
BY STEPHANIE

There are certain moments in time when you can feel the intensity of Mother Nature—the weight of her breath and the boom in her voice.

Severe storms and a string of tornadoes danced across the southeast on Mother's Day morning, 2008. And as my husband and I ventured home from a weekend trip to the coast, her devastating effects humbled us. Elderly trees had been uprooted from the earth. Pines arbitrarily snapped, their branches littering the roads and swaying from power lines. A crumpled barn. A tin roof wedged within a stately oak. As we slowed our pace through the small rural town, I quickly pulled out my camera on instinct to capture the moment.

As we continued to journey home, I realized that much of my joy in photography is capturing the beauty of Mother Nature and her precious doings (and sometimes undoings) that pave the way for new life. New blooms. Plump raindrops. Aging leaves drenched with color. Thick blades of grass. I like the way she sprinkles light like gems on water, how she breathes life into leaves as they whisper in her wind. And I love that she restores peace to the sky without fail and sets the sun to rest.

Approach

WHAT YOU BRING BOTH ARTISTICALLY AND EMOTIONALLY IN
YOUR APPROACH CAN MANIPULATE YOUR LANDSCAPE IMAGES
INTO ROUSING WORKS OF ART.

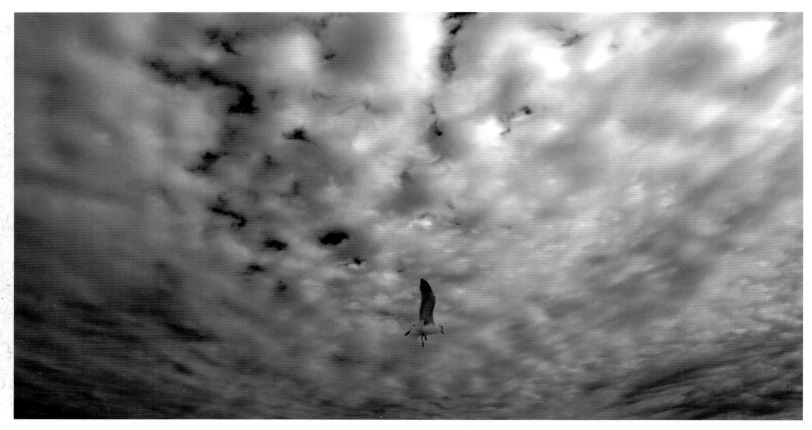

Looking at a picturesque landscape and capturing it effectively in a photograph can be a challenging proposition. Pointing and shooting will rarely get images like those found on postcards. Unless you are chasing down the sun, you will usually have time (and should take time) to contemplate the shot and plan a photographic strategy. Composition, light, color, perspective, vision, mood, and mindful reflection can all play together to bring life to your photography. Likewise, the tools of the trade you choose to use are of equal importance in translating and capturing captivating landscape shots.

Wide-angle focal lengths can distort landscape shots in such a way as to add visual interest to a scene that might otherwise translate into a rather average picture. The shorter the focal length (like 16mm, in comparison to 50mm), the wider the angle and the more potential for distortion. This is especially true as your subject gets closer and closer.

Set It!
ISO: **100**
EXPOSURE: **1/400 SEC**
APERTURE: **11.0**
FOCAL LENGTH: **18MM**

▲ **Flight of fancy** *by Andrea*
When you see an image taken with a fisheye lens, you recognize it by its impossibly wide, distorted angle. You can see a much more subtle distortion around the edges of Andrea's seagull shot. With her wide-angle lens, she shot straight up toward the bird to capture this arresting skyscape. Everything in this shot from the bird to the clouds is pleasingly in sharp focus because her aperture was set at 11.0, which allows for a deep depth of field.

▼ **Cold season** *by Kate*

Interpreting the landscape using weather to guide you is an opportunistic approach to photographic storytelling. Depending on the season, Mother Nature dictates the elements at hand (quite literally), and sets the tone—even the mood—so you can pick up the cues and use them to create expressive imagery. Kate's stark and barren winter trees offer a harsh beauty that tells the story of a long, cold winter, and how patiently we must remain, arms to the sky, waiting for the warmth of spring.

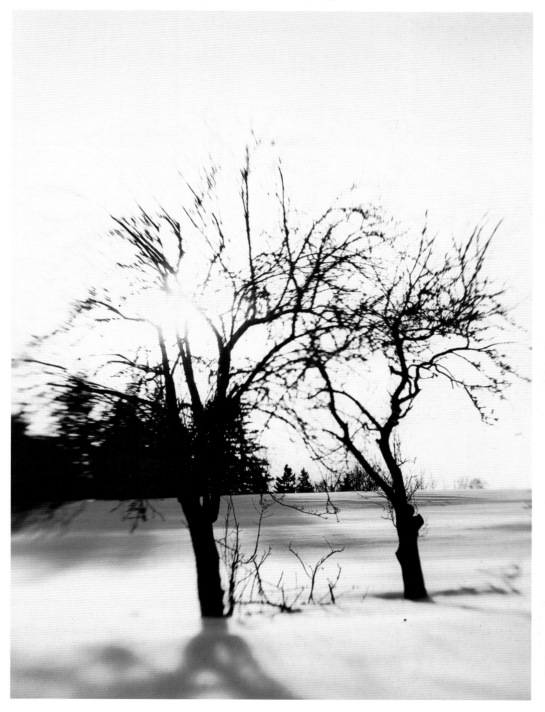

▲ **Cityscape**

The Lensbaby Super Wide Angle Conversion lens creates even more surreal images. The normally straight lines of the horizon curve and cityscapes become curiously dizzying. It's this unexpected perspective of a scenic view that helps elevate ordinary landscapes into extraordinary works of photographic art.

Shoot It!
To achieve the unique effects shown in both images here, consider a Lensbaby lens. For more details about Lensbaby and accessories visit www.lensbaby.com.

Perspective

HOW YOU VIEW A LANDSCAPE IS A MATTER OF A PERSPECTIVE
THAT IS UNIQUE TO YOU. YOUR CHALLENGE IS TO BRING THAT
VISION INTO YOUR PHOTOGRAPHS.

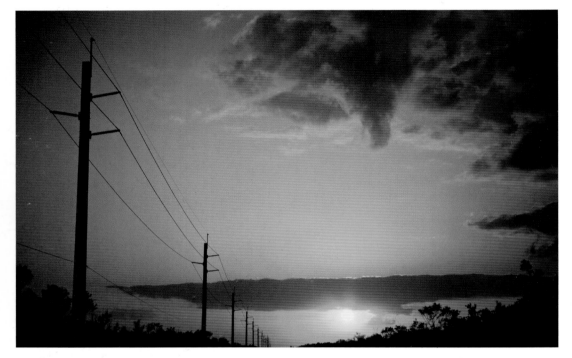

It's often said that "it's all in the way you look at it." Nothing can be more true when we're talking about good photography. Creating unique and memorable images of landscapes is a conscious choice—it's all in how you choose to frame the scene before you in your viewfinder. There is always a reason you are compelled to take a picture. If you remind yourself of what delighted you about the scene in the first place, you'll be better able to create a more compelling photograph.

◀ Roads less traveled

Road trips will inevitably offer amazing vistas and breathtaking views. Shooting through the windshield can yield surprising results. A great sunset is a perfect example. Since it only lasts a few minutes, you don't have to set up a perfect shot from an ideal location to capture it with your lens (you won't always have time!). Shooting on the fly through the windshield, you'll get a unique image that will also be part of the context and memory of the road trip itself. Jen's shot is the view of the road that stretched out before her, while my shot is a reflection of the sunset behind me.

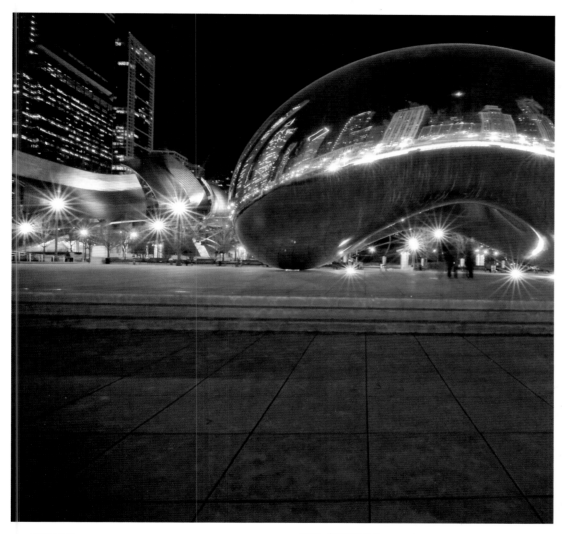

◀ **"The Bean" at night** *by Sarah*

Sometimes stumbling across an unexpected element against a familiar landscape can spark an interesting image. Case in point: Sarah's shot of the popular outdoor art installation, Anish Kapoor's Cloud Gate (affectionately called "The Bean") in Chicago. The shape and reflective surface of this huge landmark is nothing less than bewildering and yet so beautiful. Shooting at night accentuated the sparkle of the city in reflection, and Sarah's deep focal length and long shutter speed brings enough ambient light to illuminate the shot and a defined star-shaped flare from the lights in the distance. She had to set her camera on the ground to keep the dragging shutter from blurring the shot, keeping the resulting image perfectly sharp, with the inclusion of the graphic foreground. The warm black-and-white processing helps distill the wonder of the scene, with no distracting colors to take away from the majestic and otherworldly spectacle.

Set It!
ISO: **400**
EXPOSURE: **10.0 SEC**
APERTURE: **18**
FOCAL LENGTH: **11MM**
FLASH USED: **NO**

Shoot It!
Scout out a night shot you'd like to capture. Use the camera settings Sarah used. Place the camera on the ground and shoot it. Sarah often uses her self-timer for these kinds of shots to minimize any movement on the camera. Once you set the timer and focus on your scene you can quickly and carefully set the camera down on the ground before the shutter clicks. If you get too much foreground, try propping your lens up a bit with any small, stable object you can find to put under the lens.

Shoot It!
The reflective surface is creatively used to mirror back the elements of the landscape. The repetition of the tall trees creates a strong and effective composition. In addition, the curve of "The Bean" (which here almost looks like a bubble) is used to effectively break up the frame in a way that creates even more visual interest. By cropping in close and not giving the image much context, it's even more curious a scene.

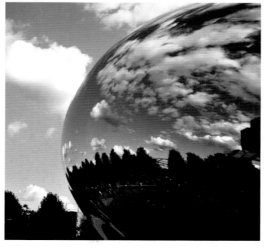

◀ **"The Bean" in the daylight** *by Karen*

This image by Karen features the same subject, but gets a completely different (although equally engaging) result. This time, the reflective surface of "The Bean" in daylight excites us, stirs our imagination, and piques our curiosity. It's the same skyline, but from a different perspective!

Composition

DISTILLING THE KEY ELEMENTS YOU'D LIKE TO FEATURE FROM YOUR LANDSCAPE AND THEN DELIBERATELY ARRANGING THEM IN THE FRAME WILL GIVE YOUR SHOT GREATER IMPACT.

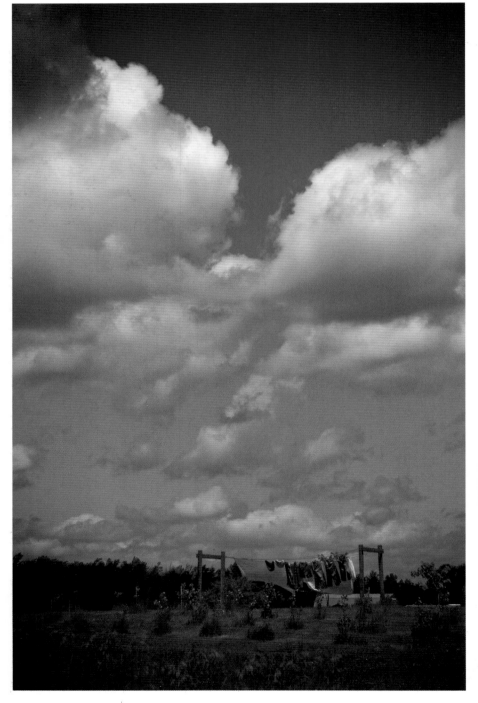

◀ **Blowing in the breeze**

A vast and expansive sky boasting billowy clouds will often beg to be captured with the sky as the focus, consuming most of the frame. In the case of this Amish countryside the clouds steal the show, but the interest of the brightly-colored laundry blowing in the breeze brings your eye back down to earth and at the same time supports the vastness of the sweeping sky. Compositionally, this keeps the eye in the frame as it wanders from sky to earth to sky again.

Shoot It!
Experiment with the placement of your horizon line. Find a landscape you can practice on and shoot it in a variety of ways—a lot of sky, a lot of earth, split in the middle, or even a tilt. See how the mood of the images changes with each approach.

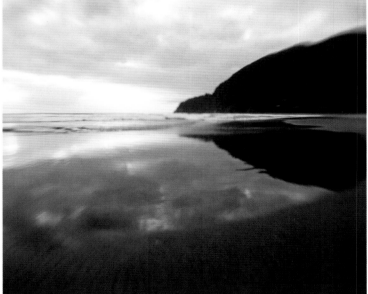

▲ **Upon reflection**

Often when you ponder a view, you'll discover something you may have otherwise missed. In this image, the combination of low tide and an overcast sky provided a reflective pool just large enough to mirror most of the distant rock, and the soft light through the clouds. The landscape went from beautiful to breathtaking with just that simple twist of fate, allowing a unique landscape shot to come together.

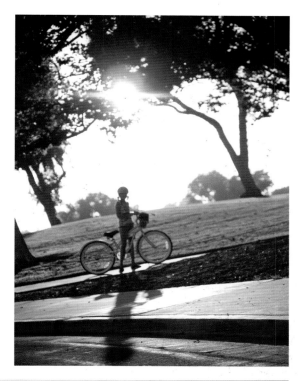

▼ Rolling hills

Scale is an important concept to consider when shooting a vast scene. Upon first glance, a landscape photograph might not deliver the impact it offers in real life. Finding something that clearly defines its scale can make all the difference and paint a picture with impact.

> **See It!**
> *While both the complementary colors and the lovely lilting curve of the horizon add interest here, it's the tiny tree that grabs our attention. Although it appears small in the frame, the viewer knows trees like this are huge and therefore gets a more accurate idea of how vast this scene really is.*

▶ Summer daze

Although it might be your first instinct, the horizon line doesn't have to be held perfectly horizontal in the frame. Lines are strong, graphic elements that can either add to a shot or distract from it. A tilt of the camera can create a diagonal that can quickly and effectively add impact to a more conventional approach. In this shot of my daughter with her bike, there are so many lines working together that they seem to almost soften one another as they slowly slope down, the street almost mimicking the path and the hill. If I'd composed the shot differently (for example, cutting the frame horizontally in half with the lines), it would have lost its creative impact and appeal.

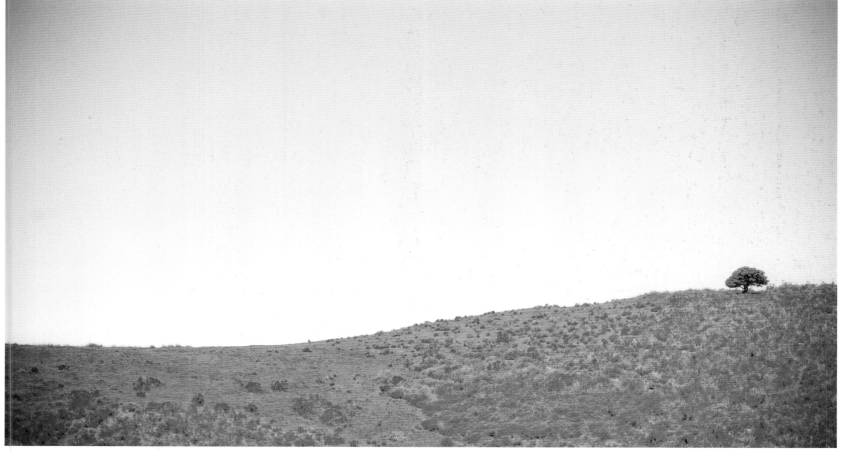

Lighting

BEYOND THE BEAUTY OF THE LANDSCAPE ALONE, THE RIGHT LIGHT
WILL ENLIGHTEN ANY VISTA. OBSERVING THE LIGHT THROUGHOUT
THE DAY WILL HELP YOU DECIDE WHEN TO SHOOT.

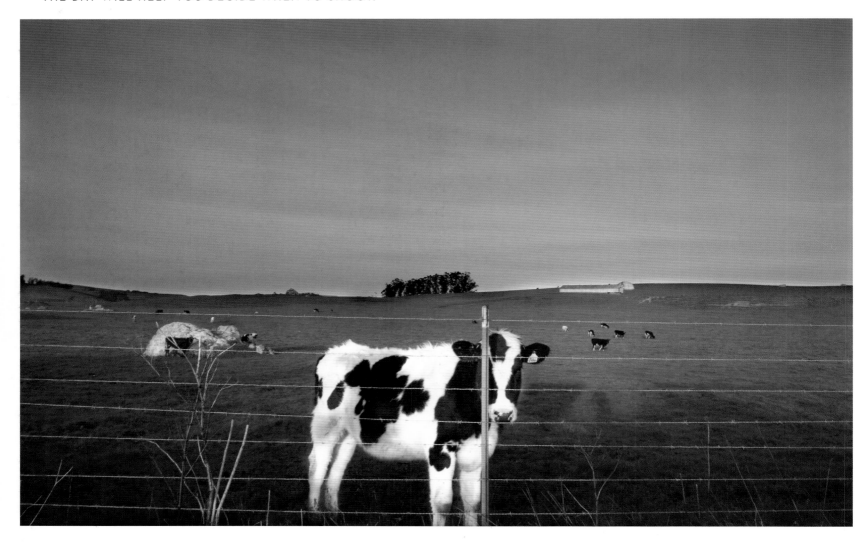

Since images of landscapes often don't include people and thus
cannot rely on facial expression for their narrative, they need other
elements to tell their stories. Beyond good compositional elements,
the light is the main tool you have for sculpting and painting the
landscapes before you. Time of day, seasons, and weather are
among the natural elements that play into how you can use light for
picture-perfect landscape photography.

▲ **Greener pastures** by Andrea
When shooting wide landscape shots, it's not always easy to expose
the entire scene properly. Depending on the scenario, what part
of the frame you are exposing for will vary. When there is a subject
within your landscape (people or otherwise), quite often your subject
and your background will be lit very differently, so you'll have to
choose what part of the image is most important to expose for.
In Andrea's shot of a friendly cow, the low light behind her shone
directly on the cow at the same strength as it did on the background,
offering a matching exposure so the entire frame is perfectly lit.

Shoot It!

Although using your flash in the sun might feel like overkill, try using it as a fill light. Find a picturesque background that's illuminated by the sun, allow your subject to remain in the light (harsh shadows and all), and shoot with your flash on. You'll probably have to override your auto settings to do it. Even small on-camera flashes can work as fill lights if you're close enough to your subject. It's a fun and easy technique that will keep your summer shots sunny.

▼ California dreaming

A bright sky can definitely throw your exposure off and when shooting a portrait against it, it can cast harsh, unwanted shadows on your subject. Using a fill flash is one way to remedy these issues. A flash will light up your subject and can help match up the exposure of your foreground to match a brightly lit background.

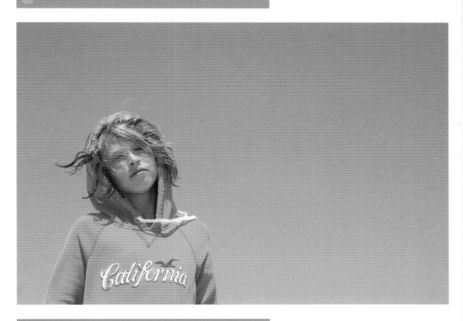

See It!

The blue cast of this shot sets the mood. The glow of the moon's ambient light created a natural vignette around it that makes it appear that the moon itself is being well cared for. A gentle tilt of the horizon line accentuates the tenderness of the shot by creating a cradle-like shape below. A mix of all of these elements combined with the foreground of subtle sand dunes, soft and out of focus, makes this shot feel otherworldly.

▶ Blue moon

Shooting at the last light of day can work surprisingly well for landscape shots. Long, timed exposures yield compelling results that are easier to achieve than in portraiture. For long exposures, a tripod works well to keep your shot blur free, but it's easy to create an instant tripod by simply setting your camera on any still surface. For this shot, I steadied my camera on a large driftwood log. The dim light offered a monochromatic palette of blues as the moon shone high above and the sun had all but gone for the night.

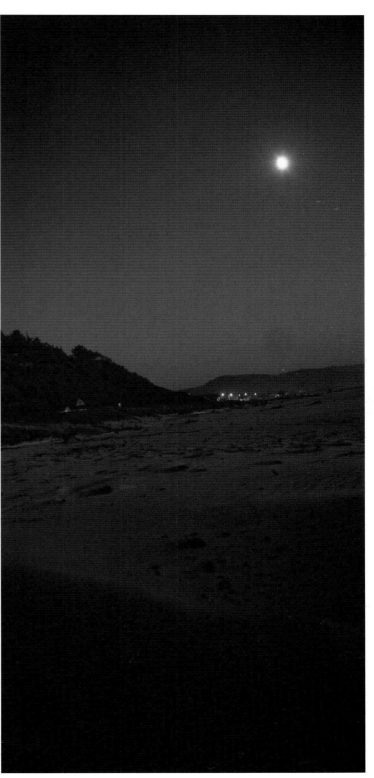

Details

PAYING ATTENTION TO SOME OF THE MORE SUBTLE DETAILS, NO
MATTER HOW VAST YOUR HORIZON, WILL HELP HONE YOUR EYE
AND ADD INTEREST AND DEPTH TO YOUR LANDSCAPE SHOTS.

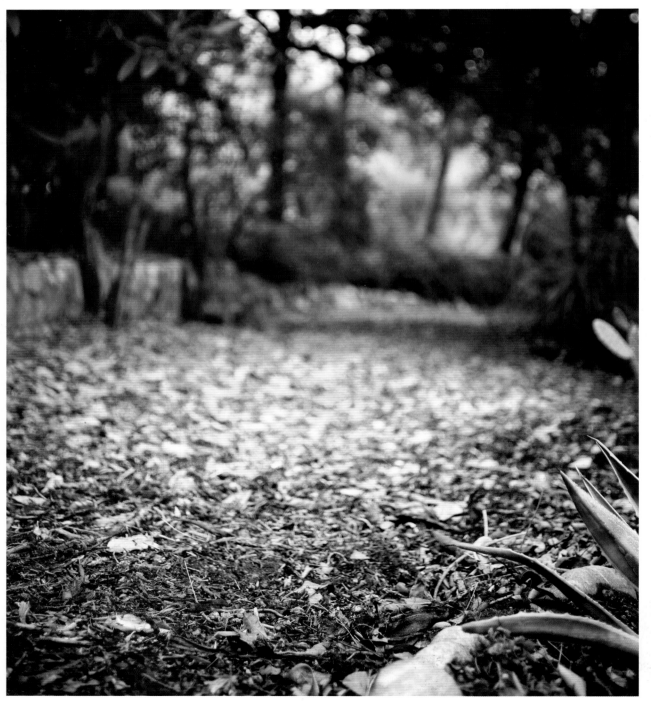

When thinking of landscape shots, large, wide-angled expanses often come to mind. A deep focal length with everything in focus is the rule of thumb, as the landscape mode of any camera will dictate. But you don't have to follow the rules (or even use the landscape mode!) when trying to create an impact with your horizon shots. In fact, taking notice of the little things and breaking the rules a bit can free you up from what you think you should be shooting—and can encourage you to dream up even more creative images. The way you see the details of your surroundings is what makes our vision unique and, quite often, your photographs memorable.

◀ **The path to enlightenment**
Using a shallow depth of field with a deliberate focal point (or sweet spot) allows a different interpretation. Whether or not you want to walk this path is more of a question. There is a mysterious feeling to this shot, accentuated by the lack of focus in the distance. There's an uncertainty about it and yet, with the light streaming in, illuminating the golden ground ahead, it still beckons.

Set It!
ISO: **400**
EXPOSURE: **1/800 SEC**
APERTURE: **2.5**
FOCAL LENGTH: **50MM**

▼ Infinity and beyond

Although a shot of soaring mountains in the distance can be breathtaking, sometimes the details of a landscape are just as compelling. Here, it's the texture of the field of flowers in the foreground that makes us swoon. Getting down on the level of your subject and shooting across the top of something like this can offer an illusion that the flowers stretch on infinitely. The focus is only on a small area, bringing out the intricacies of the wildflowers without taking away from the infinite perspective of the shot. Some of the foreground and all of the background is thrown out of focus with a shallow depth of field.

> ### *Shoot It!*
> *Get down low and shoot across your subject. If it's a gravel path or a field of flowers, your low perspective will make it interesting. Use a shallow depth of field and focus on something you find interesting or intriguing. The background will get soft, but by shooting across your image (down on its level) you can achieve the feeling that the horizon stretches on and on.*

▼ Sweater weather *by Karen*

Images of paths and walkways lure us in, and make us want to walk the road, to meander, to stroll. Karen's shot of a leaf-strewn walkway, captured with a deep depth of field, makes a fall day come alive. The textures of leaves crackle underfoot and the vibrant colors speak a story of the season. This is a road you want to travel, and in its vividness and clarity, it seems possible to step right into the scene. Don't forget a sweater.

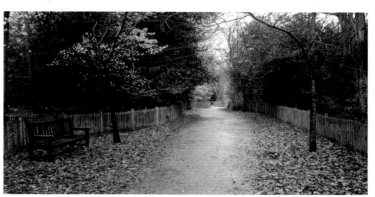

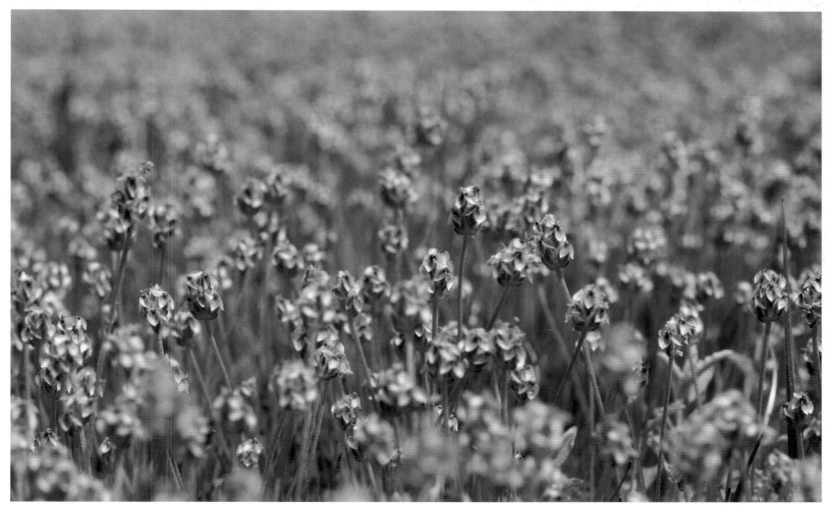

Processing

DIGITAL ENHANCEMENT CAN HELP YOU ELEVATE THE SCENERY OF YOUR SHOTS TO BETTER REPRESENT WHAT YOUR EYE SAW WHEN YOU SNAPPED THE SHUTTER.

With all the freedom of the new digital darkroom, it's hard not to get overwhelmed by the many possibilities for image transformation. The idea of manipulating images into extraordinary works of art can be seductive. With the click of a button, your basic color image can be altered to be sepia, black and white, vintage, or washed in every hue of an artist's palette. Although the possibilities are endless, you don't have to change the image substantially to make it great. In fact, sometimes the smallest changes can enhance the imagery of landscapes to their utmost potential. From sweeping transformations to small tweaks, the horizon has never looked more promising. On the other hand, drastic alterations can yield extraordinary results.

▼ **Vintage postcard**

It was a picture-perfect day in my home town. A view from the pier gave the perspective of a lifetime as our surroundings were like a dream. So much sky and so many perfectly formed clouds over the coastal town begged for a unique and eye-catching treatment. Changing the color tone of the blue sky to a retro teal turned this landscape into an instant classic. With all the definition in the clouds, this image would have been lovely in a number of treatments, but for me, the teal blue made the shot timeless and pure magic.

Manipulating the sky in your photographs can transform your shot. Whether you choose to merely enhance the blue or change the shade of the blue is up to you. And cloud definition can be difficult to capture, which makes post processing a useful tool in bolstering your horizons.

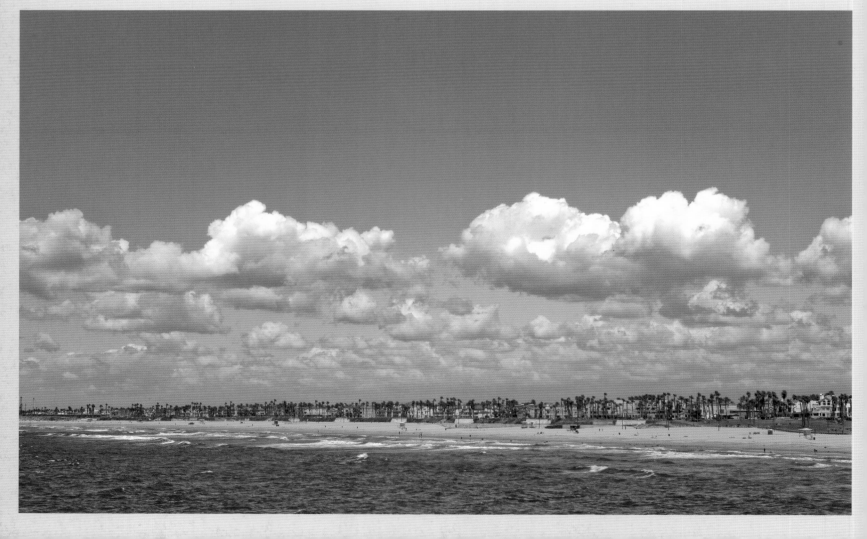

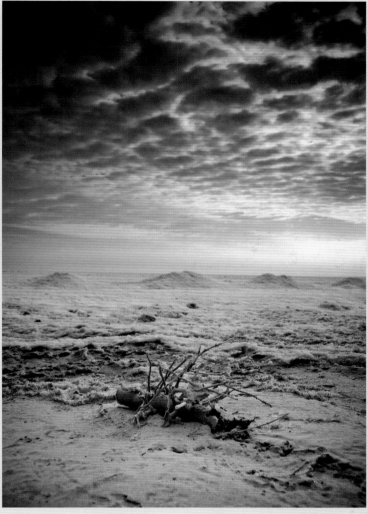

▲ Modern color

Only a few minor enhancements made this urban landscape pop. A simple ramping up of the contrast and color saturation worked wonders to bring out the beauty that my eyes saw, but my camera didn't capture quite as vividly.

▶ Surrealism *by Sarah*

Sarah's take on vintage processing transports her otherworldly shot to a totally different level. Its muted tones only enhance the impossibly surreal landscape. Sarah is a master of creating effective (and beautiful) presets in Adobe Lightroom. There are many post-processing resources and ways to acquire the Photoshop actions and presets that other photographers have developed. With the click of your mouse you can turn a traditional color image into a work of art. But even without the complicated photo-editing software, even the simplest of programs or editing services can help transform your images into something unique. The key is to experiment with your options, follow your creative bliss and have fun.

Shutter Sisters' Blog
BY JEN

"How long do you think it will take before I start to feel better?" I ask my neighbor Nick as he makes dinner. I am supposed to be helping, but all I can do is walk circles through the house, thinking of my recent trip to Rwanda and all the stories still swirling in my head.

"I think it will take a while," he says gently, not wanting to disappoint me, but wanting to tell me the truth. As my soul brother, he knows my heart is wrecked, both from the happiness of being in Rwanda and from the sorrow of having to leave to come home. I try to remember what I used to do before experiencing so much love in that tiny village, in that sweet family—the home of my dearest friend Odette. I wonder why I am here and not there. I wonder if there is any place on earth as sacred or as real. I sift through a thousand pictures, each one drawing me close into its memory, each one keeping me safe while my soul tries to make sense of this experience. Who could have guessed so much joy, so much love, lies waiting at the end of a dirt road?

2 Portraiture

Andrea Scher

"Develop an interest in life as you see it; the people, things, literature, music—the world is so rich, simply throbbing with rich treasures, beautiful souls and interesting people."

HENRY MILLER

THIS IS A REFLECTION OF ME IN THE DRESSING ROOM OF A Banana Republic in downtown San Francisco. It was June and hot, and only days before, I had miscarried during my first pregnancy. I was incredibly devastated, reeling, and trying to make myself feel better by buying a new shirt. Go get something to perk yourself up, my Mom would have said. And so, in some way trying to mother myself, there I was.

There are times when we go through the fire, when we must undergo unthinkably painful trials to grow and change, and become fully who we are. We come out on the other side new, stronger, and more beautiful for it. I think of a piece of clay being fired in a kiln and coming out even more dazzling than it was before. Colors you didn't even expect come to the surface, the whole piece stronger and more stunning.

I treasure this photograph because it is a visual record of that very difficult time. I see myself right in the fire itself, still aflame. I see it in the dark circles under my eyes, in the hardness of my gaze. I also see the tenderness, the rawness of my spirit. I see the oceans of tears behind my eyes.

This record is as important to me as a journal entry might be to another person. Without words, this picture documents one of my most sacred stories. Just like a writer might always have pen and paper tucked away in their back pocket, I always seem to have a camera nearby. I have a compulsion to capture, to hold moments in my hand for future examination, to make stories out of them. Perhaps this is what it means to be an artist—the desire to create beauty and stories out of all of the threads of our lives.

As we learn to explore portraiture as photographers, we find ways to hold—in suspended animation—a part of our subject's soul. In the case of self-portraiture, there might be a tender moment in our lives we choose to forever document; a testament of one of the many authentic experiences that make us who we are. Many people wouldn't even consider attempting a self-portrait under any circumstance, let alone during such a vulnerable moment. Yet I believe wholeheartedly that seeing ourselves as we really are, through our own lens, is a rare gift we can give ourselves. A gift of self-acknowledgement, of self-care, of truth and, ultimately, of healing.

As I gaze at this photograph, I know in hindsight what I couldn't have known that day: many more tears were still to follow. But years later, after I gave birth to my son Ben, I held him in my arms and felt how far I'd come from that self-portrait in the dressing room. With every difficult passage, we increase our capacity to be compassionate and authentic. With every loss, we have the opportunity to gather wisdom and strength. On the other side, we will know ourselves better and hopefully love ourselves more. Now, I can finally look at this image with the kindest eyes. Like that piece of clay, I see a girl who will be more dazzling for all of it.

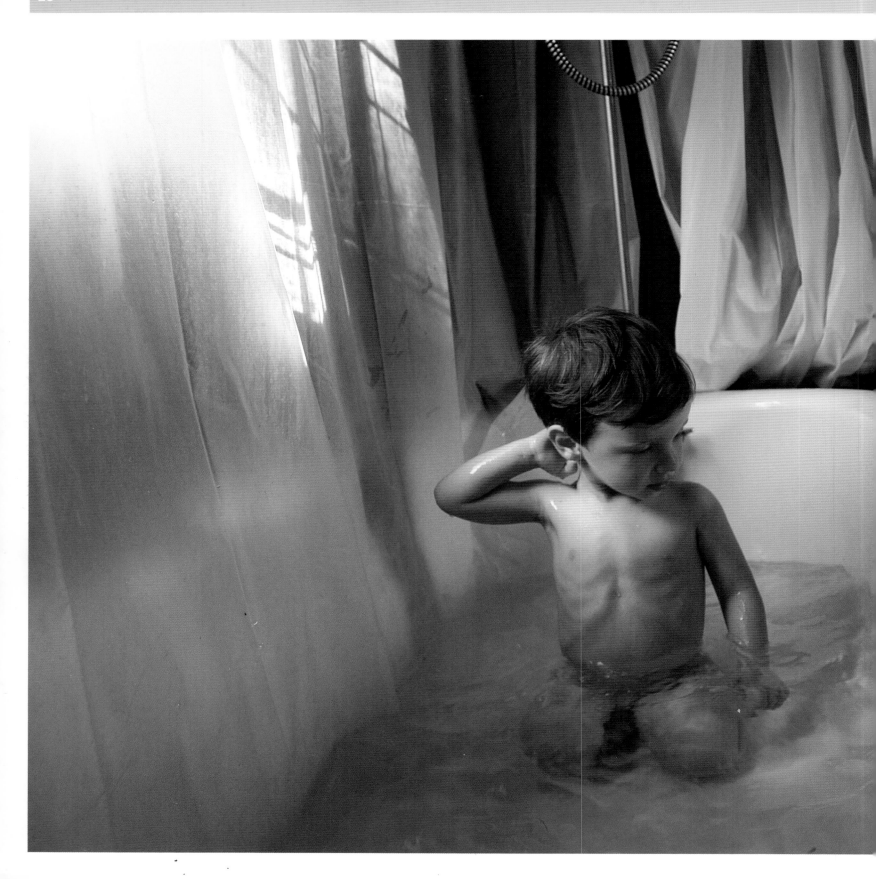

Introduction

WHAT WE ARE REALLY LOOKING FOR WHEN we take portraits is a connection. We are looking for an expression, a mood, a certain something that reveals the spirit of the person we are photographing. We are watching and waiting for something to happen. Something real. Like hunters, we are stalking beauty. We are looking for aliveness. We are waiting for that spark.

This is the nature of that elusive thing called a portrait. Our job is to notice, to see so deeply into the moment that we don't miss a thing. As we practice taking photographs, we are more and more prepared for that moment when it arrives and we get more and more skilled at drawing it out.

Seeing things in the right light is an age-old expression, but it holds true for photography, literally and figuratively. As photographers we are light seekers; we want to see something extraordinary through our lens and we usually do. In a very literal sense, we are trying to see things in the right light so that they please us, are interesting to us, and give us the pleasure of appreciating them.

◀ **Submerged in thought**
The gift that we, as photographers bring when we create portraits, is that we get to reflect the extraordinary beauty of people and their lives back to them.

Shutter Sisters' Blog
BY MAILE

Years ago, I read a book that suggested there are three things we're all looking for in life: adventure, beauty, and intimacy. This really resonated with me at the time and recently it occurred to me how much this statement also relates to photography. After all, a photo shoot is nothing if not an adventure. No matter how much you plan, there are always surprises: different light, new twists and turns, personalities. Downloading your camera to see what you caught is like dumping out a bag of shells after a day at the beach. And often what drives the adventure of photography is a quest for beauty, whether you find it in a hand, a kiss, a landscape, or a ladybug. There is something within us that is naturally drawn to the miracle of lines, shapes, and proportion. Finally, there's intimacy. To me, this is the most important piece. With portraits, it's about trust. Someone is giving us a piece of themselves, trusting that we'll be kind in our interpretations. Even if they're not using words, we have to hear what they're saying with their eyes, lips or hands. As the photographer we must be willing to be seen ourselves. If we are guarded, people will mirror us. But when we let people in we find magical moments where we realize that photography, this gift we have for interpreting others, can be just as much a tool for interpreting ourselves.

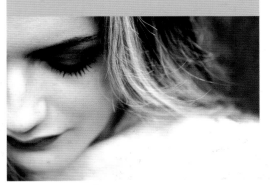

Approach

THERE'S AN ALCHEMY CREATED IN PORTRAITURE AS YOU MERGE BOTH YOUR VISION AND WHAT YOUR SUBJECT WILL REVEAL ABOUT THEMSELVES TOGETHER IN A SINGLE SHOT.

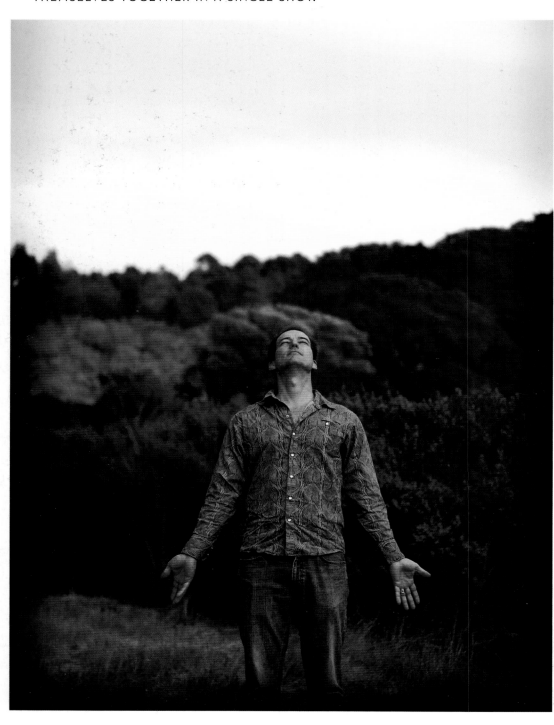

A portrait is not just an image; it's a vibrant collaboration between photographer and subject. The subject might be alone in the frame, but every successful image reflects the talent and expertise of the photographer, and their connection with the subject.

There are as many ways to create this connection as there are photographers. Sometimes the subject is your child or your partner, and there is a way that your love for that person just comes right through the lens. Other times you need to cultivate the trust and ease with your subjects.

Portraiture is sacred because it is so intimate. There is something beautifully vulnerable about being seen and witnessed. How often does someone stop and stare into our eyes? How often does someone ask us our story or simply sit and witness the beauty in us?

How do we reveal a deep truth about someone with a photograph? How do we evoke not only their beauty, but also their strength, their truth, something deeper? As photographers, we have the ability to not only witness, but also to create a moment before the lens. In fact, part of our job is to coax out something genuine from our subjects. We do this in a variety of ways: in the intimate way we connect with our subjects, in the way we choose to direct them to elicit a certain emotional response, and in our keen listening for and witnessing of who our subjects truly are.

Shoot It!

Interacting with our subjects can help draw out the image we are supposed to take of them. In this case, Andrea suggested this father-to-be stand in surrender to what was about to come: the beauty and mystery of parenthood. Prompting your subjects to express themselves as you shoot isn't cheating! It's working with what you have to create a soulful portrait.

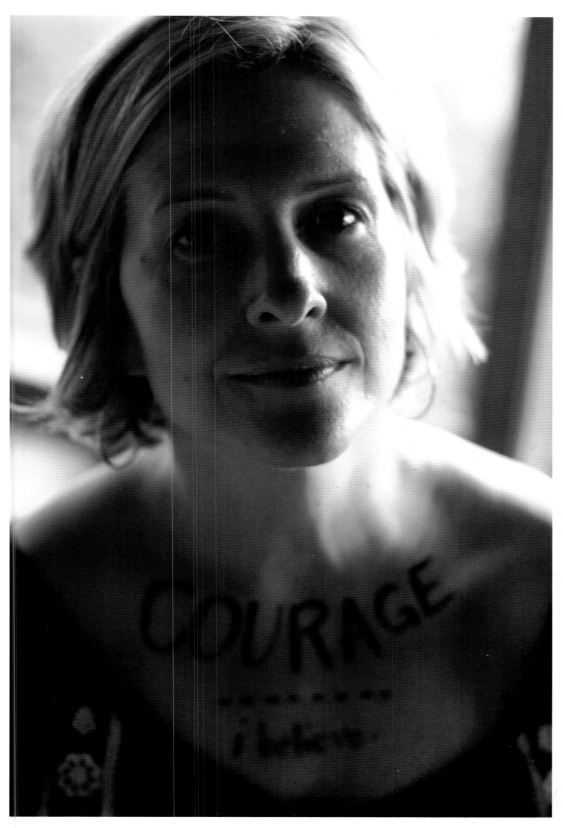

▼ **Laughter**

Expression in portraits is vital because it is the narrative. It translates the emotional tone of the moment and tells a story about the subject and their life. Capturing a natural smile is usually the goal and if I can get my subject to laugh, both the laughter and the moments of easy smiles that follow are golden.

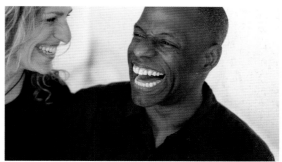

▲ **Spirit**

The aim with portraiture is to capture something authentic, something real—to reveal the spirit of your subject. This is what makes for expressive portraiture.

◀ **Courage**

Just like stopping and listening to someone share a story with you, we are listening to the stories people tell with their eyes and their hands, their gestures and their expressions, and distilling them in photographs.

Perspective

EXPRESSING YOUR POINT OF VIEW VIA YOUR OWN UNIQUE PERSPECTIVE WILL HELP NARRATE THE STORY YOU WANT TO TELL ABOUT YOUR SUBJECT.

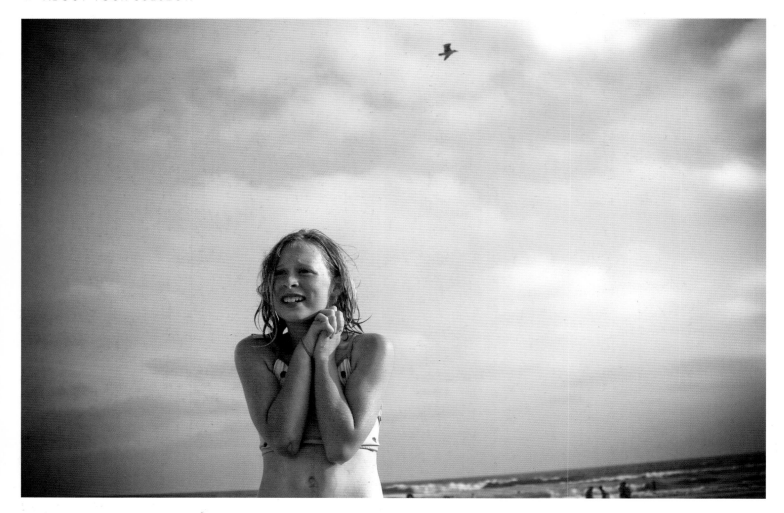

I am a life coach as well as a photographer and much of my training is about getting my clients to see their lives from different perspectives. This is how we make breakthroughs and discoveries. I pay close attention to my perspective when I am shooting portraits. Is the shot more flattering from above? What happens if I shoot my subjects from below and use the blue sky as a backdrop? What changes if we are both sitting on the ground? I tend to experiment with new perspectives as a way to shake up my creativity in the moment and to keep the subject engaged in the process as well. Each new view offers something unique.

▲ **Summer's end** by Tracey

"I can remember this moment so vividly. Although the sun was setting on the ideal late summer afternoon, the air and water were still warm. It would be our last visit to the beach before school started up again that year, which made it even harder to let it end. As my daughter stood there, urging me to let her get back into the water, the sun was soft and low, and from where I sat, the sky framed my daughter in a quintessential adolescent moment; seen from the perspective of a mother. The expansive negative space around her, with her slightly to the left of the frame, was a deliberate compositional choice and the seagull that joined her in the distance—a symbol of her fleeting childhood and summer freedom—was sweet serendipity."

▶ An exaggerated view

When shooting portraits, we can sometimes forget to go beyond the traditional headshot. There is an art to accentuating other aspects to tell a deeper story. This pregnant woman's belly is the perfect example. Without it, the entire story would not be told.

In an effort to accentuate the largeness of her belly and also include her face, I played with the perspective of lying down at her feet and shooting upwards with my wide-angle lens. This created an exaggerated view of her world, and one that offered a bit of humor and play to the image.

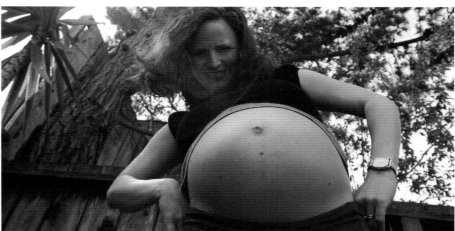

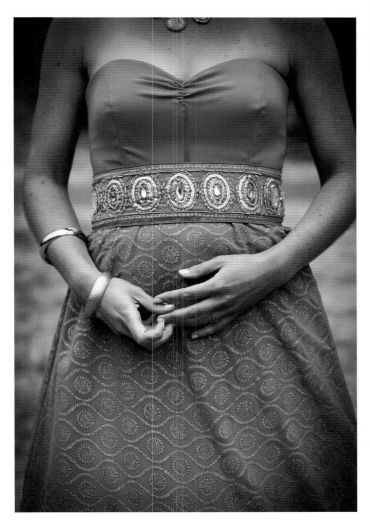

▲ Nervous hands

Beautiful and telling portraits do not have to include your subject's face; often, you can find enough of a story in gestures. In this shot, I wanted to capture the bride's nervous hands on her wedding day. I had noticed she had been trying to get a full breath all morning and was endearingly jittery for our portraits before the ceremony. This moment, when she was picking her nails, expressed her state of mind in a wonderfully poetic way.

▼ Her passion for style

Sometimes shooting portraits in the right context can tell the perfect narrative. A designer with a passion for color, pattern, texture, and fabric sits where there is intersection of color and pattern, telling a story of who she is—creative, daring, and bursting with color.

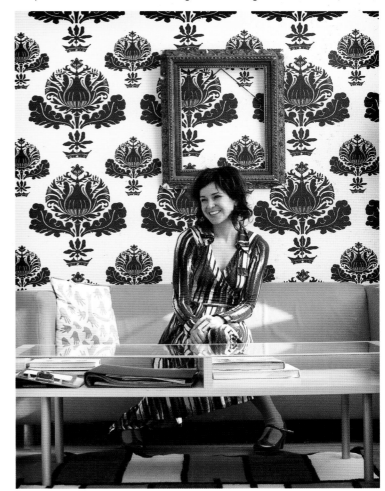

Composition

EVEN BEYOND VISUAL INTEREST, CREATIVE PLACEMENT OF YOUR SUBJECT WITHIN YOUR VIEWFINDER'S FRAME WILL ADD DEPTH AND MEANING TO YOUR PORTRAITS.

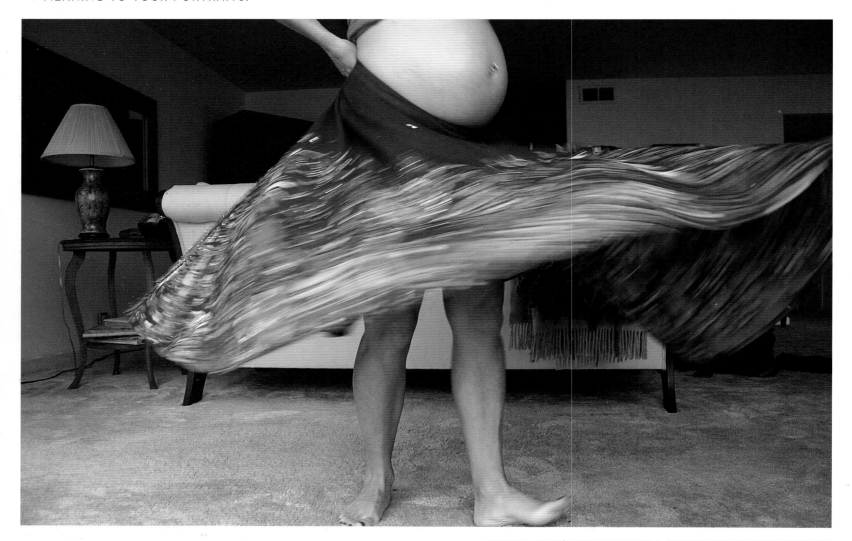

How do you make a portrait that is universal? How do you create an image of an individual that transcends the personal and expresses something even more extraordinary? Something that captures the human spirit in a universal way?

What you decide to place inside the frame—and what you choose to leave out—can result in a wide range of emotional responses. When you choose to compose your frame featuring something unique to your subject and yet universal in the human experience, your image can serve as a symbol. This woman could be your wife, or your friend, or she could be you. What the photograph communicates is something broader and bigger than the personal—the joy and beauty of pregnancy, and the promise of a new life.

Set It!
ISO: **400**
EXPOSURE: **1/40 SEC**
APERTURE: **4.0**
FOCAL LENGTH: **18MM**
FLASH USED: **NO**

See It!
Beyond interesting composition the blurred movement of the skirt adds interest. Dragging the shutter can bring just the right motion to a shot like this.

▶ Sweet spot

Composition is about creating harmony not only between the elements placed in the frame, but also between what is blurred and what is in focus. Shooting with a shallow depth of field offers a dreamy, blurry effect in the background of your shot that, when used correctly, can make almost anything look extraordinary—a garden hose, a bowl of rice, toys strewn on the kitchen floor.

The key to effective shallow depth of field is to first choose your sweet spot of focus (the part of the image that will be the focal point). I usually choose my subject's eyes or, in this case, smile, which is after all, the heart of the photograph.

Set It!
ISO: **200**
EXPOSURE: **1/250 SEC**
APERTURE: **1.4**
FOCAL LENGTH: **50MM**
FLASH USED: **NO**

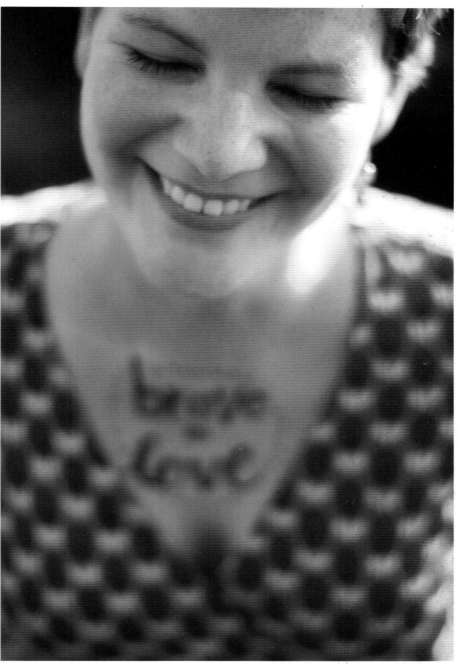

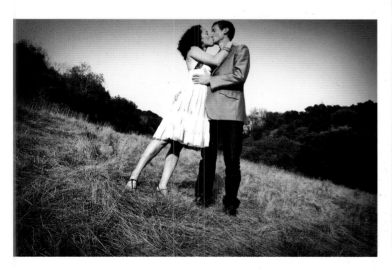

▲ Full length of love

When aiming for something romantic, the tendency is to get in close, creating the feeling of total intimacy, yet I have learned that intimacy can also be achieved by stepping away and shooting from afar. Framing this couple with the space of their surroundings using a wide-angle lens, your eye is led right to their kiss—their connection. In this case it makes their love seem larger than life.

Lighting

SEEKING AND EFFECTIVELY CAPTURING THE LIGHT AS IT ILLUMINATES YOUR SUBJECT IS THE KEY TO CREATING POIGNANT, EMOTIONAL PORTRAITS.

▼ **The magic of catchlights** *by Kate*
It's amazing that a small detail like a mere dot of light in your subject's eyes can offer a spark of life to your subject like a glint of magic. Those little lights are called catchlights (the highlight in the subject's eye from a light source) and they are an important element in portraiture. Kate's image of her son is the perfect example of how to use catchlights to create the perfect portrait.

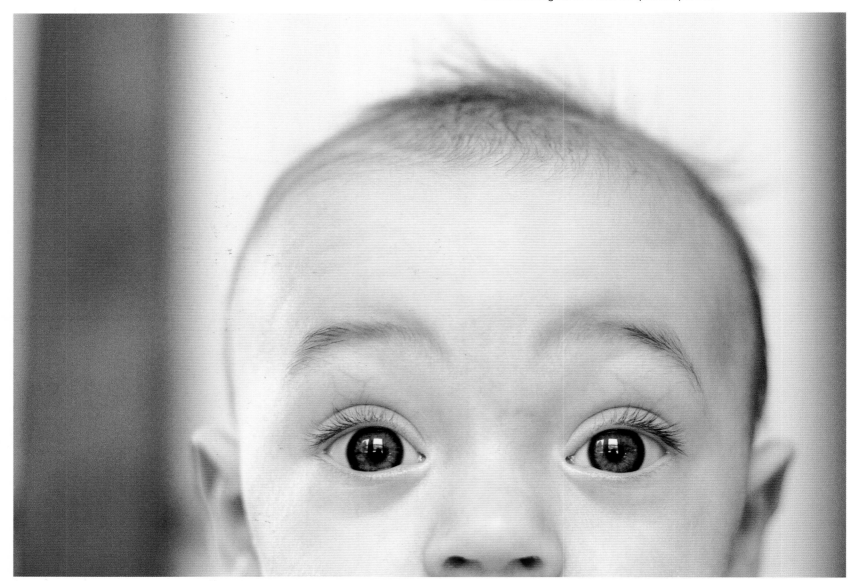

Every photographer knows that light is everything. Lighting can turn the most ordinary things into magic, elevate them to a kind of poetry. In the right light, everyone looks more beautiful, more true.

Lighting can make or break a portrait. The less harsh the lighting (the fewer the shadows), the softer the face will look and the smoother the skin will appear. Lighting can transform a simple snapshot into an artful portrait.

Shoot It!
Look for the catchlights in your subject's eyes. Find a way to accentuate expression using the eyes as a window to the soul. Creative cropping and unexpected angles can help tell the story of what lies behind the eyes.

▼ Magic hour

Although I usually stage my portrait sessions on-site, this one was different. I saw it fully formed in my mind several hours before—a vintage slip, magic hour sunshine, sexy, pretty, the golden light in curly hair, a wheaty field. I was giddy when we were able to actually realize my vision! To get the perfect glow of the sun behind her (I wanted to illuminate her curls), I metered the light for her face and then adjusted my settings for correct exposure from there. If I had simply used the auto meter, her face might have ended up in shadow, instead the light is balanced both for her face and for the glow.

▲ Shadow dancing

The magic hour is that fleeting hour at the end of the day where the sun is low, shadows are long, and the whole world softens. The light is warm and glowy, and everything from the leaves on the trees to the eyes of a friend look somehow elevated; they're soft, surreal, flawless, extraordinary. When you use the setting sun as your direct light source, and you capture the perfect expression, your portrait will be magic.

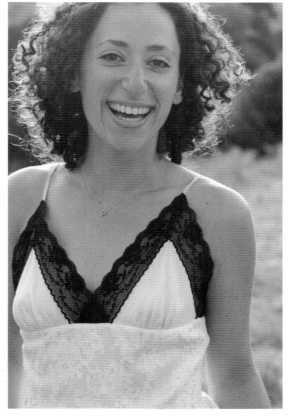

Details

ALTHOUGH OFTEN OVERLOOKED, THE SMALL GESTURES AND
SUBTLE NUANCES OF YOUR SUBJECT CAN OFTEN TELL YOU
MORE ABOUT THEM THAN ANY HEADSHOT EVER COULD.

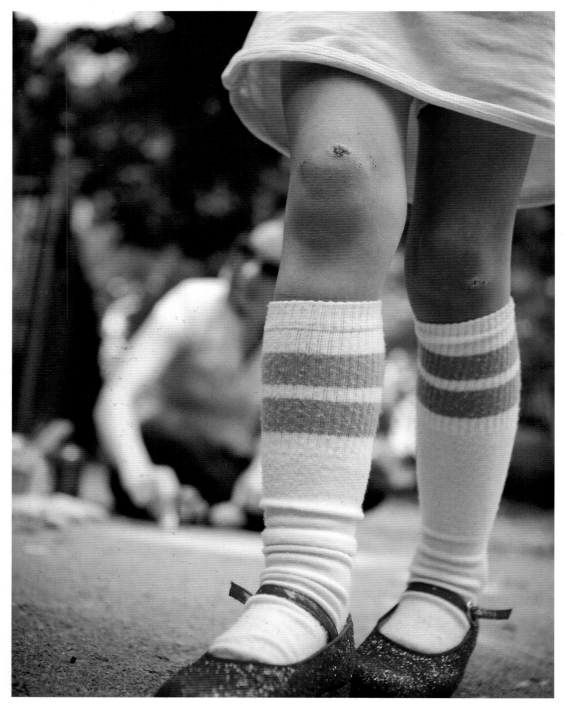

I've heard people say over and over again: God is in the details. It is as true in photography as it is in life. A subject's spirit can live in the tiniest details—in that perfect brooch, the gesture of her hands, the tiny rose peeking out of a pocket. As photographers, we get to notice it all. As seers and story-framers, we get to make these powerful choices: What story do we want to tell? Where do we want the viewer to look? What do we want them to notice?

◀ **Scraped knees and ruby slippers** *by Sarah*
Sometimes the details can give us more information, or a feeling, about who a person is and sometimes the details simply add texture and depth to a shot, or an artful flair to the story. This shot by Sarah is a perfect example. The scabs on her daughter's knees, the ruby slippers, and the tube socks with the bright blue stripes all give so much to the narrative. It is not necessary to see her facial expressions or even her surroundings; this image tells us everything we need to know.

▲ **Beautiful** *by Karen*
As photographers we get to see things that others might not and highlight them, hone in on them with our lens, and make them the focal point of a narrative.

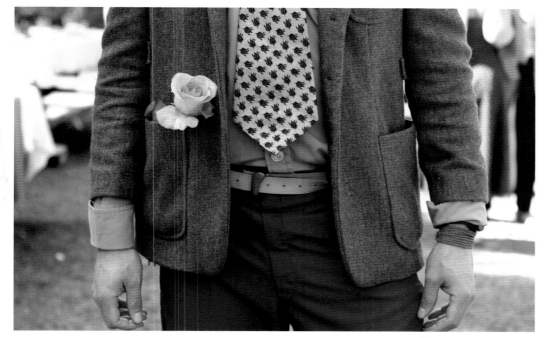

◀ A riot of color

This wedding guest caught my attention. The color and texture of his vintage brown wool coat, loud pink tie, mint green button-down, bright yellow belt and royal blue slacks was almost alarming and yet it suited him so beautifully. His outfit somehow encapsulated the spirit of the wedding day as a whole: full of color, creativity, joy, and exuberance. The detail I love most, though, is the single orange rose resting in his coat pocket. There is a softness about it that tells me a deeper story about who this man is—a romantic, an original, and a loving celebrator of his dear friends. Details like this can often tell more about a person than a traditional portrait.

> **See It!**
> This shot celebrates a clashing of vibrant colors and textures. Don't shy away from subjects that might appear too busy. All of these elements work together to celebrate a fun and festive personality.

Shutter Sisters' Blog
BY TRACEY

When I shot this self-portrait I recognized my tomboy side—comfortable in my soft cotton and denim "uniform." I saw myself in my bathroom mirror, as I do every morning, getting ready to start the daily routine. What I didn't see was my father. Until I took in the detail. And then, all at once, in one thumbnail, I saw him, undeniably. I've known I have my father's hands for years now, but it's one of those things I forget about.

I'll admit I have often complained about having masculine hands—my dad's hands—but this time when I saw a glimpse of my father in myself, it made me happy. And incredibly proud. His hands are big and can still make mine feel small. They are incredibly strong. And even amidst the cracks and calluses from years of hard work, they are soft, tender, and loving. I can only hope that having my father's hands means having all of the other wonderful things that they hold.

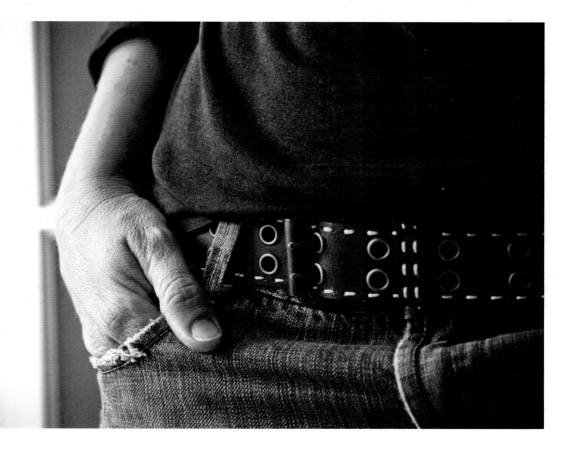

Processing

BE IT INTENSITY OR TENDERNESS, LEVITY OR MELANCHOLY, YOU
AS THE ARTIST CAN HEIGHTEN YOUR INTENTION WITH A VARIETY
OF POST-PROCESSING OPTIONS.

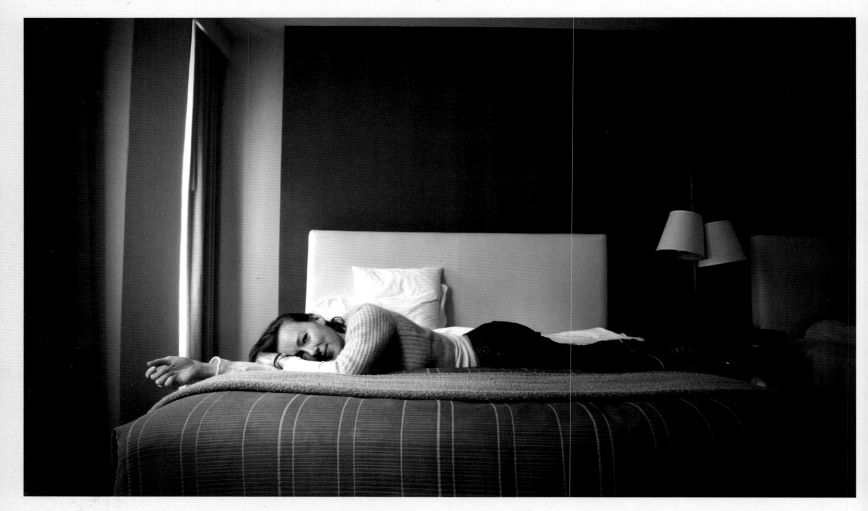

Processing portraiture is all about emotional impact, aesthetic beauty, and powerful storytelling. When we look at an image straight out of the camera, we get to decide what to do with it in our digital darkroom. How can your tools help to create a more evocative image? This could mean anything from simple color correction to adding artful textures and playful actions. You can meticulously color correct, dodge, and burn to perfection, or even add imaginative extras like vignettes and filters. In a world of so many choices, the first question I ask myself is this: What does this photograph want to be? Certain images lend themselves beautifully to black and white, while others come alive in hyper-saturated technicolor.

▲ Black and white

A great place to look when deciding if a shot should be in black and white is the simplicity of the image. Are the lines geometric? Are the forms simple? Is there good texture and contrast?

This example of a friend on a hotel room bed was the perfect occasion for black-and-white processing. The horizontal lines of the ceiling, the headboard, her body, and the blanket ground the image, while the vertical lines of the curtains and wall provide great balance. Because the shapes are geometric and either very dark or very light (lots of contrast), the image lent itself beautifully to a black-and-white treatment.

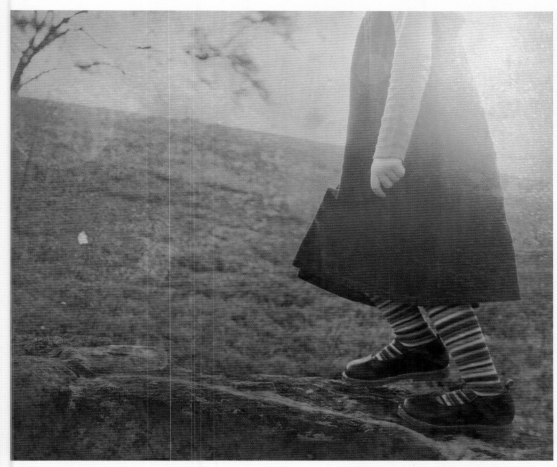

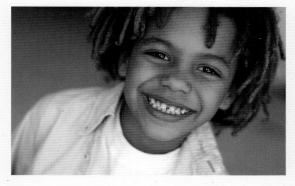

▲ Sharp eyes

My most commonly used processing tool is sharpening (I use Unsharp Mask in Photoshop). Some shots lend themselves better to a bit of blur, but most images can use some degree of sharpening for a crisp, modern look. For portraiture specifically, sharpening is all about the eyes. You can see this best with a before-and-after shot, how the eyes literally "pop" once you have sharpened the image. The effect is that the subject seems more vibrant and alive, like you could reach out and touch him.

◄ Vintage wash *by Maile*

As you experiment more and more with your processing tools, you will develop a keen sense of what's needed for each photograph and develop your own signature style of processing.

▶ Processing treatments *by Maile*

Photoshop "actions" can be addictive. With the click of one button, they set in motion a series of steps that completely transform your photographs, often in unexpected ways. They are a fantastic way to infuse some play and creativity into your process. Sometimes there's no way to tell what might enhance an image until you test and try different options. There is no real right or wrong way to process an image. You are the artist, so the final image should be to your own personal liking.

A strong portrait can often work well with a number of processing treatments, as Maile's shot (processed two totally different ways) proves beautifully.

Shoot It!

Use a beloved image to process a number of ways. See how each technique can bring a unique layer and element to changing the look and feel. Use processing to draw out more of the emotion of your picture.

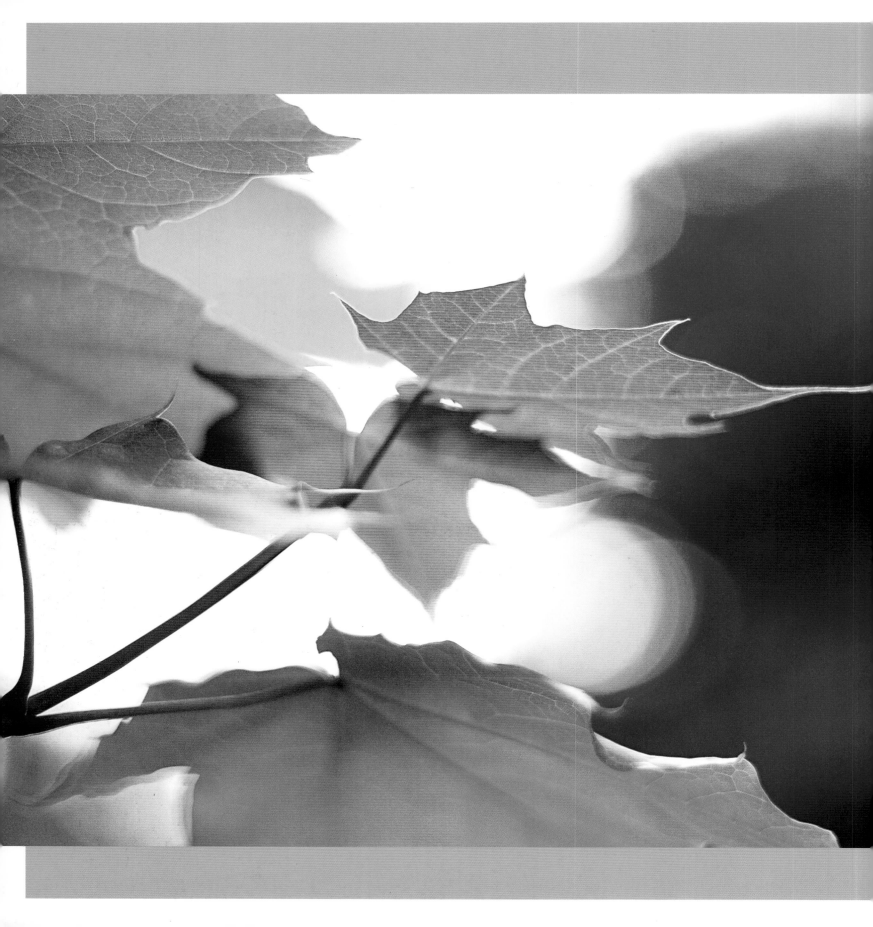

3
Nature

Kate Inglis

AT THE PEAK OF SUMMER, WE MAKE A FORAY INTO THE backyard. My son digs in dirt, grasps tree limbs, drags his hand through leaves, calling out to me every now and then to marvel at a diligent worm, the mischief of crows. With the familiar heft of my camera in hand, I open my creative eyes for what feels like meditation. We are companionable, each of us occupied in the outdoors.

There is nothing like a spontaneous nature walk—either in solitude or accompanied—to inspire wonder. Twenty minutes under the shelter of a young maple tree is an exercise in restoration. The mind slows, the heart opens. Abide with nature and nature abides with you.

There—just there, tucked in a crease of hard-worn bark. It spills over with stories, that tree. It is shared history and watchfulness no matter how many of us walk past it and think it a finite, inanimate thing.

As my son does, I find myself gazing as though seeing these marvels for the first time. I am surrounded, enveloped, in awe, and my camera translates.

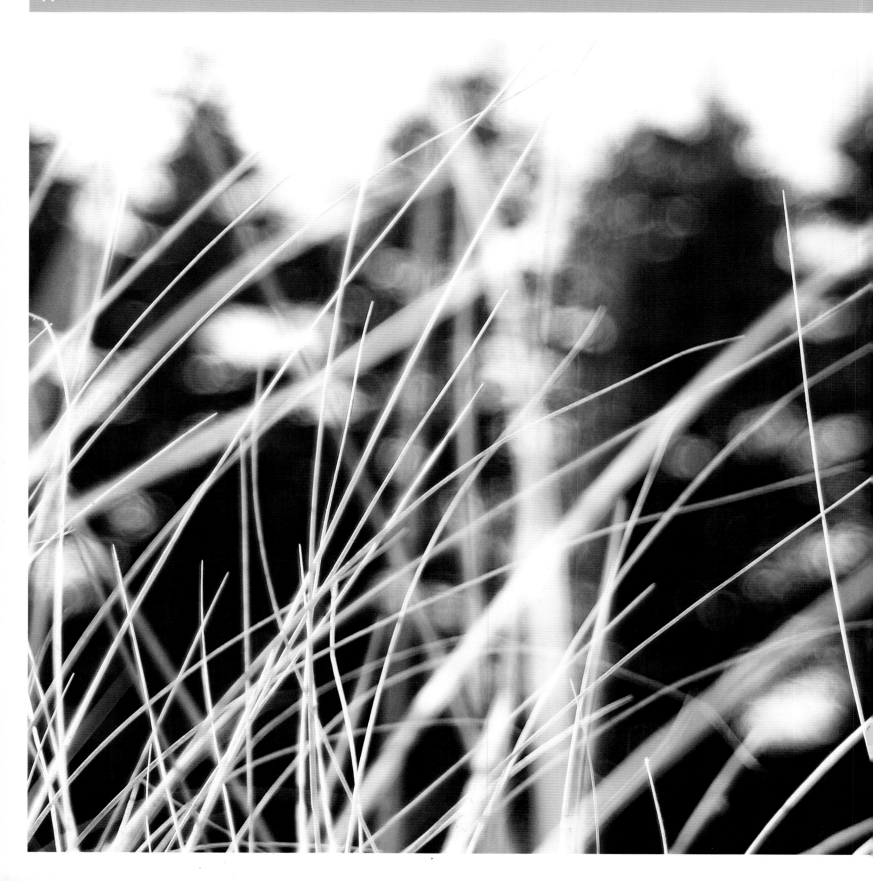

Introduction

A NATURE WALK PROMPTS A SLOWING OF breath, an attentiveness that softens sharp edges. As profound as a single drip that dangles off the lip of a thousand year-old glacier, or as everyday as one persistent dandelion—each is a story. Each is a meditation, a restoration, a prayer for believers and non-believers, and questioners and philosophers alike.

What a glorious thing, nature. You can see a piece of it right there, through that very lens. Look at how dignified it is. How proud, how free of self-pity. Birth and life, and death and yearning, all upon the lee side of a leaf.

You might have the world's most heavenly macro lens, one that obliges should that lazy butterfly turn to flirt. One that lets you capture the spine of a wing, its new, birthy wetness taking on a breeze.

But you might not. Your camera bag might be lighter than you wish it were. A kit lens, a fixed 50-millimeter that doesn't let you get closer than arm's length. A toy camera, a point-and-shoot, or a Polaroid. It doesn't matter.

On a nature walk, we give a gift to ourselves. For those two minutes or two days we nurture our sense of wonder, our humility. We are in the company of more magic, more ancient forces than we can ever truly grasp. And this—a spell of quiet reverence—might be one of the most potent gifts of all.

 Shutter Sisters' Blog
BY TRACEY

Over the weekend, during a low moment, I stepped outside for a little fresh-air therapy when, right near my front door, these tender leaves caught my eye. Tiny droplets from the previous night's rain were catching the only glimmer of light offered by the morning diffused with weather. The leaves looked so delicate and sweet. It wasn't until I pulled the images up on my monitor that I noticed a sadness, as the frail foliage seemed to be weighed down with each drop, weary with the burden. I felt through the image what I felt myself.

Does all this mean we do truly create photographs that mirror the state we're in? Do we shoot, saddled with our sorrow, or jubilant with joy, allowing our intimate vulnerabilities to be exposed through our work? Or, do we instead shoot through our exhaustion and despite our weariness in order to seek some kind of clarity powerful enough to lift us from our fog? Perhaps it's all dependent on what we need more at the moment we click—to express ourselves or to save ourselves. To realize that photography, this gift we have for interpreting others, can be just as much a tool for interpreting ourselves.

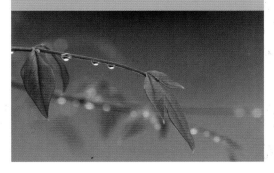

◀ **Beach grass, winter**
Capture nature's spirit. How you do it is irrelevant. Watch for light. Listen for stories. Push and blur, and get soaked with dew. Be awake and present, and then see what you see.

Approach

NATURE'S BEAUTY AND MYSTERY IS IRRESISTIBLE. BEING ATTENTIVE TO WHAT DRAWS YOU IN CAN HELP GUIDE YOUR LENS IN CAPTURING TRANSCENDENT SHOTS OF NATURE.

▼ **Inner glow** *by Karen*
Karen brings us even closer with a depth of field that reduces all but one or two of the stamens to abstract color.

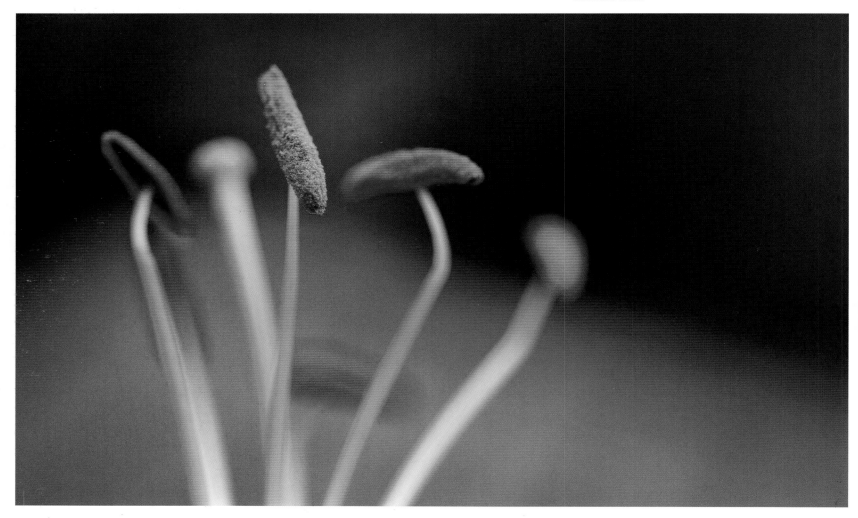

The most evocative nature photographs tend to simplify what would otherwise be riotous and wild, or a visual jumble. Instead of seeing a mass of flowers we might see one, spotlit and flanked by the distant suggestion of others. Much of this has to do with aperture, which allows the photographer to choose a shallow depth of field that can transform the incidentals of an image to pure abstract shape, rich in color, and subdue the clutter that would otherwise confuse the eye. With this artful approach, the focused subject of your shot gets the attention it deserves.

There is no intimacy quite so addictive as the intimacy afforded by a macro lens. Karen's lily is a study in textures and bounty, and a color enthusiast's joy (when in doubt, add bright orange to cobalt blue). For this capture, the glass of the lens may have been almost touching the flower—if you've had the good fortune to play with a macro lens, you know this moment. You can hardly breathe for how immersing it is to get so close, so vivid. And in doing so, you pass that good fortune onto all those who view the finished result.

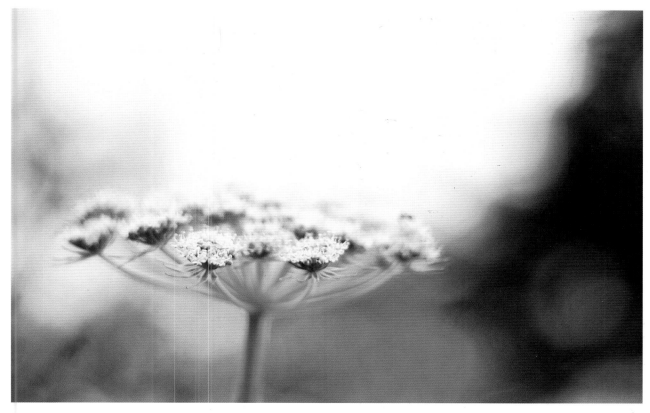

◀ Queen Anne's lace

That said, you don't need a macro lens to achieve that composition of the intimate and the ethereal that serves nature photography so well. This Queen Anne's lace shot was captured with a highly versatile fixed 50mm lens that opens up to an aperture of 1.8, an extremely shallow depth of field, for a richly blurred background and a precise point of focus. A lens like this is both affordable and indispensable, and is just as compelling for taking portraits as it is for capturing nature.

Set It!
ISO: **100**
EXPOSURE: **1/800 SEC**
APERTURE: **1.8**
FOCAL LENGTH: **50MM**
FLASH USED: **NO**

To create images that are out of the ordinary, adopt an extraordinary position. Look your subject in its metaphorical eye. Before clicking the shutter, tilt your composition in an unexpected way. Offer up a moment in time, a view, or an angle that is unique.

Rather than simply capturing beach grass, include negative space to capture the friction of how it leans into wind, determined to protect its dunes with brittle and steadfast roots. And make what would otherwise be an ordinary backyard lawn into unlikely art by playing with angle, changing the interplay of shape, light, and color.

Shoot It!

As you seek out elements of nature, try looking for the gestures that feel human. The round face of a dandelion precariously held up by a stick-like body, the dance of sea grass in the wind, a bloom unfurling, timid with newness. As you begin to recognize your universal connection with these elements you will find that they are everywhere.

Perspective

THE BEAUTY OF NATURE IS INFINITE. SO TOO ARE THE MANY
FRESH AND INSPIRING PERSPECTIVES WE CAN USE AS WE EXPLORE
NATURE THROUGH OUR VIEWFINDERS.

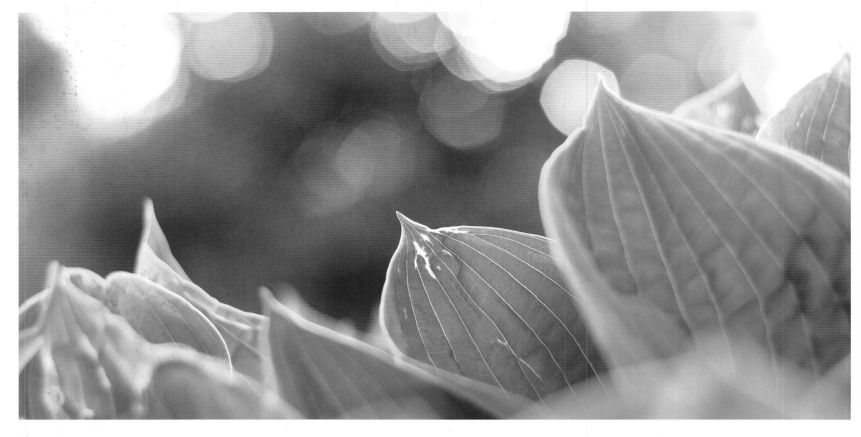

In nature photography, intimacy is the sensation of being immersed—that pulling of the viewer into some secret world, into an ancient knowing that we'd otherwise walk straight past. Achieving this immersion has much to do with perspective—the position of the camera to the subject or, better put, the photographer's unique angle. Perhaps you lay on the ground, the camera tilted so that it's lower than the tips of the grass. Or you get closer than close with a macro lens.

Featured here is a hosta in my backyard—first shot at the height of summer, and then at the onset of winter. In summer, the first frame I composed of the hosta was overwhelmingly green—habit led me to feature the cluster of leaves as the dominant subject, filling most of the frame. I recomposed slightly, on a whim, and

what would have otherwise been a snapshot transformed into a story. Now, it reaches, hungry for warmth and sunbeams, and mist. The plant asks for nourishment—and by granting the sky a more dominant role, the image suggests a relationship between nurturer and child.

With winter approaching, I walked past the same hosta, recalled the summer, and sighed. That's not beautiful. *That's not a lovely, classic nature shot. That's life all dried up.* But then I stopped, felt the call of a creative challenge. I shot it from virtually the same position, considering perspective from one season to the next, and the second study of the hosta became an abstract that I might love even more than the first. Sometimes, a twist in perspective refers to more than just the position of your camera.

▲ **Hosta in summer green**
The veins of the hosta, backlit by the sun, swept up to converge at neat points, a vision of plenty.

Shoot It!
Choose a subject that is accessible to your lens year-round. Shoot it in different stages of its life cycle, or in different seasons. As you observe the transformation of your subject, so too do you heighten your awareness and strengthen your ability to look at things in different ways.

▶ **Orchid heart** *by Karen*
A macro lens abstract has been achieved by removing context. In seeing Karen's orchid, we know we're seeing a flower—but the proximity of this shot is almost disorienting. The viewer might tilt their head a little, puzzle at the angle. That's the bewitching effect of getting really, really close—a lovely sort of wonderment that makes us all pause. It feels unconventional, alien in its beauty and shape, sensual, and otherworldly.

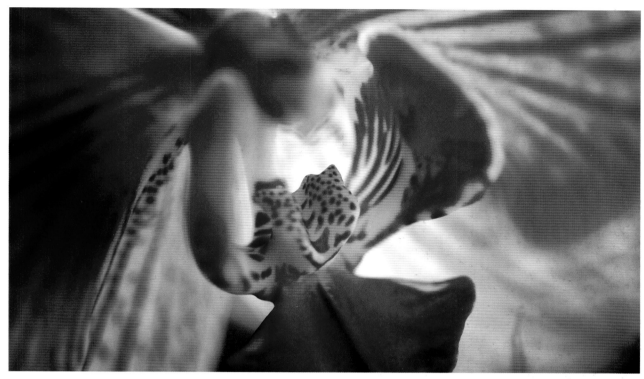

▼ **Hosta in winter hibernation**
Brittle stalks, once lush, become a study in line, sleep, and patience.

Composition

EVEN THE MOST SEEMINGLY COMMON OF NATURAL SUBJECTS CAN BE REINVENTED BY A MERE REARRANGING OF THE COMPOSITIONAL ELEMENTS IN THE FRAME.

When you're dazzled by a shot that simply works—and when you're wondering what it is that makes that image so pleasant to gaze upon—consider the presence of harmonious angles and lines. Note how your eye moves across the frame. Does it dart, spiral, swing back and forth? What shapes do you see? Watch how well they play together. When you discover harmonious form, line, and shape, and accentuate it, you create a photograph that feels more like intention than chance.

Negative space is a positive, making a spare approach to composition among the most powerful. Instead of a backdrop of branches and leaves, get low and shoot a single limb against a blank canvas of sky. Watch how a frame's harmony changes as you turn the camera by a few degrees, or tilt up just enough so that two branches echo one another instead of crossing. Craft your frame with an eye for the active role played by white space.

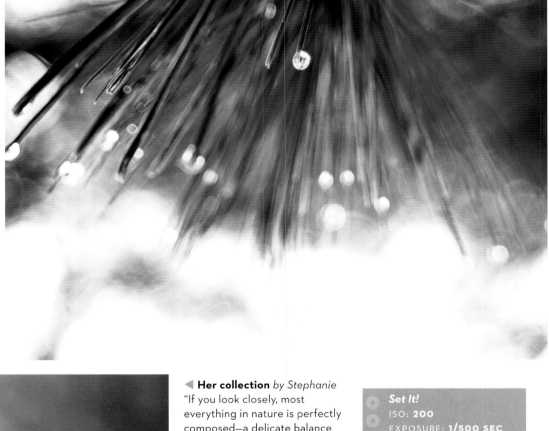

▶ **Pine tree**
Faced with a scene you're enjoying, try experimenting with a few minimalist frames—change your position to let extraneous details fall away.

◀ **Her collection** *by Stephanie*
"If you look closely, most everything in nature is perfectly composed—a delicate balance between the beauty of form and the necessity of function. While I might typically reposition myself to discover various compositions for a nature shot, I mindfully created this vignette. The arc of the leaf stem offered a soft midpoint of division between the detail and texture of the subject in the foreground and the background. More than half of the image is comprised of soft negative space to not only balance the complexity of the subject, but to frame it."

Set It!
ISO: **200**
EXPOSURE: **1/500 SEC**
APERTURE: **5.0**
FOCAL LENGTH: **125MM**
FLASH USED: **NO**

Some elements of a composition are so striking that they need to be minimized for the sake of balance. Andrea's bold and unconventional framing of a sunset boasts only the merest strip of yellow in contrast with the blues, making the golden tones more impactful and interesting—and the sky more vast—than it otherwise might have been. That choice, and Andrea's horizonless angle, ask us to consider only color, and the brush strokes behind it.

Shoot It!
Allow yourself to frame an element of nature that almost feels void of subject. With a lack of one particular "thing" to focus on, an image can become a study of color, texture or space. Taking a look at our surroundings in a big-picture kind of way can broaden our scope, and offer new ideas and ways of composing our images.

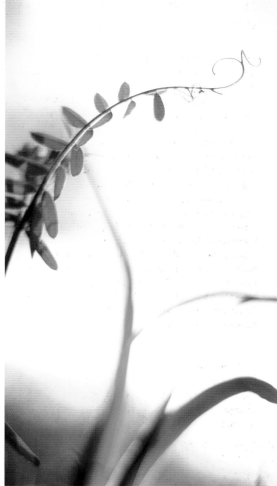

Shoot It!
When you're about to move on from a subject, pause to try the opposite of your conventional approach. I first shot the curlicue on the end of this young fern as I would habitually (left), but then turned my camera for another few clicks. The resulting photographs are strikingly different—one capture is languorous and accompanied (the horizontal), and the other is bold and unafraid (the vertical, albeit cropped here). Composition sets the tone, and twists of perspective have a way of reframing a subject as well as the story it tells.

Lighting

THE TRANSFORMATION AND EVOLUTION OF NATURE OCCURS AS
THE LIGHT AROUND IT MOVES AND SHIFTS. FOLLOW THE CUES OF
NATURE'S OWN LIGHT TO REVEAL ITS SPLENDOR.

▼ **Melancholy piece** *by Sarah*
A texture or monochrome wash
speaks volumes with wistfulness,
as seen in this leafless tree.

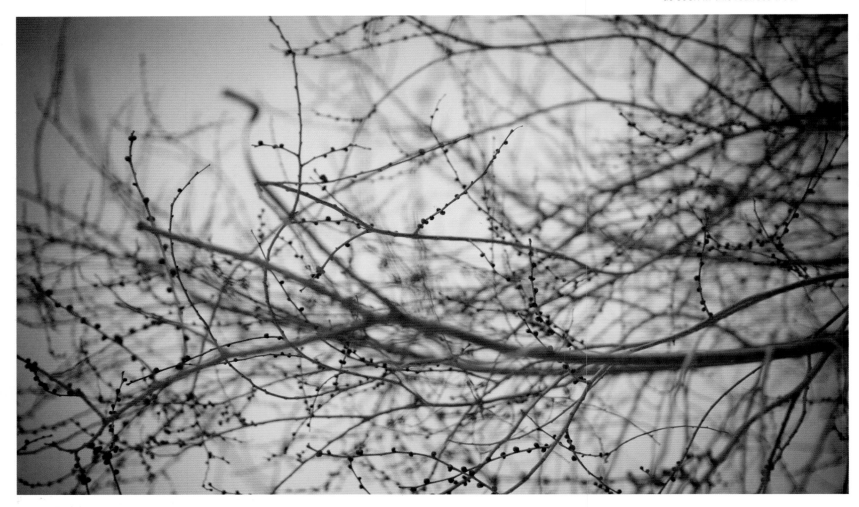

One of the most salient points of nature photography, far beyond what lenses you carry or what filters you apply in processing, is to be spontaneous when the light is good. When the light makes you stop and pause, chase it—either sunshine streaming in through a kitchen window, or the last hanging-on as the sun sinks in the sky on a winter afternoon.

The story that presents itself to you won't always be drenched in flare and glimmering sparkle. It may be a quiet, overcast sleepiness that simply needs a unique processing approach. Or it may be one of those days that seems devoid of light entirely—but look closely enough and you'll find sparkle hiding in dew drops. Mine for gems. When none are apparent, know that a story of hibernation can be just as evocative.

Too often my camera goes quiet, a victim of my seasonal prejudices. Only just this past fall did I make a conscious effort to change my own seeing—to look outside at the dwindling green, and everything going crisp and barren, and to see honor and beauty in it.

If you live anywhere outside of year-round ethereal light, remember this. There is dignity and beauty in a going-to-sleep. Accentuate all that's shriveled and passing into dust. Tell stories of farewells and persistence. Be watchful for rare light and more than ever, be ready to dash outside when you see it. Fingerless gloves help.

When your own landscape strikes you as tired or weary, push yourself to tell that story in new ways, with new tools and methods. Sometimes, all it takes is to crank up the saturation in post-processing to accentuate that last, lonely holdout of green.

▶ Jewel *by Karen*

Light can creep indoors through a door or window to tap on your shoulder. Karen's calla lily is poetically abstract and yet meticulously outlined with subtle glowing light. Any botanical subject can be stripped away until all that remains is a study in light and form—a meditation that becomes more striking as it becomes more simple.

◀ Company with bokeh *by Tracey*

"Seeking light has become my photographic calling. As my kids grow up, I find myself looking less for catchlights in their eyes, but more for light in the distance. I use these out-of-focus points of light (known as bokeh) as compositional elements of interest. They can mimic shapes or repeat patterns, complementing the subject at hand. When the light begins to interact with, play with, or echo my subject, that is when I have captured what I was hoping for."

Shoot It!

Decide on a simple subject to use as a focal point. Place the camera at least a few feet (if not more) in front of an area of dappled, spotty light. A leafy tree or bush will work. Focus on your subject and before you press the shutter, study the frame in your viewfinder. Use slow movements to recompose the shot as you watch the light in the background, literally seeing the light, which will help you decide where to best place the circles of bokeh in your image.

Set It!
ISO: **800**
EXPOSURE: **1/200 SEC**
APERTURE: **3.2**
FOCAL LENGTH: **50MM**

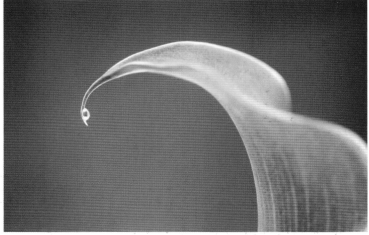

Details

ALL OF NATURE HAS ITS BEAUTY, BUT IT IS IN THE DETAILS OF THE
BIGGER PICTURE THAT WE ARE CAPTIVATED AND IN TURN, CAN
FIND THE MOST SPELLBINDING IMAGES.

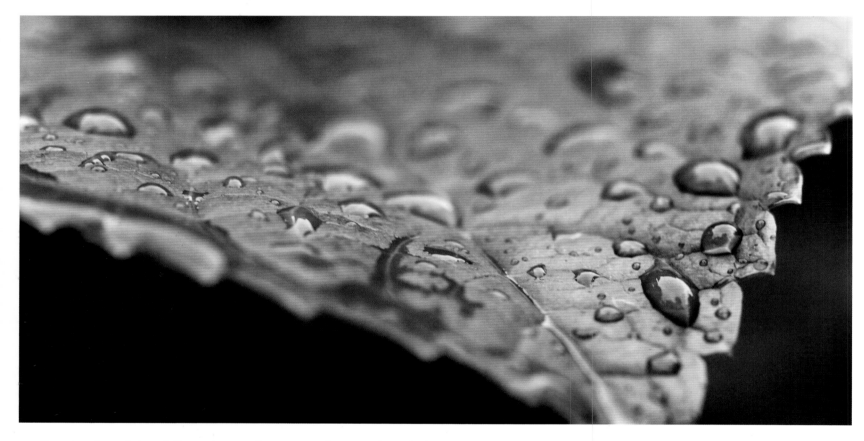

Portraits of people benefit from a bounty of expression—a face with eyes or smirks that reveal a gauntness or brightness of spirit. Nature photography asks us to pursue a different kind of bounty. Its expression requires us to translate, to reach out, and to explore the stories of inanimate or wordless or faceless things.

We find our feet as translators when we focus on details. It is the small points of interest that can take the place of all that's conveyed by a human face—and the result is just as compelling.

The capturing of moments in nature is the practice of opportunism—of being spontaneous given even just a few minutes of the right place, the right time, and the right light. In those conditions, a macro lens almost never fails to delight—both for photographer and viewer.

With a macro lens, the focusing potential is no longer which leaf, for example, but which water droplet. The moment of this choice, as Jen's image shows, is the moment the photographer becomes storyteller, guiding the viewer to appreciate exactly what she appreciated.

Details of texture, line, shape and color are of equal importance to visual storytelling. The composition of both the dried flower stalks and the fluff-topped grass accentuates near-mathematical pattern and line, but more important, the backlighting accentuates shape. Both use a shooting position and pared-down background that directs viewers to simply observe shape and movement, and to imagine feather softness or crackliness in the hand.

▲ **Emerald leaf** by Jen
Jen's leaf is lovely for its monochromatic quality, its fresh crispness, and its lines—charms of cadence that lead the eye back and forth like the arc of a playground swing.

> ### See It!
> The leaf's placement divides the frame into three asymmetrical parts or shapes with effective, albeit subtle, differentiation of monochromatic color between them. The texture on the surface of the leaf and the scalloped edges are framed and balanced by the two smaller shapes on either side. The compositional details here create a soothing, meditative study.

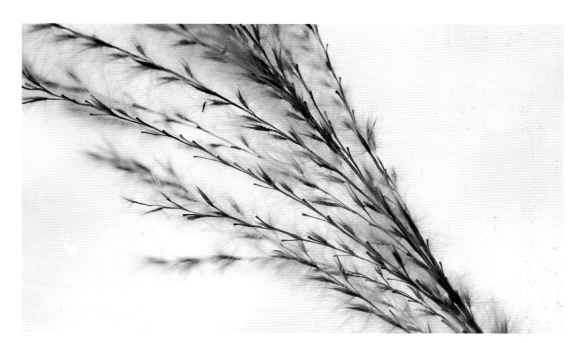

▶ Conscious exposure for texture and contrast
Watch for detail in shape and accentuate the mood in how you expose the shot. For the grass, which was in shade, I overexposed to wash the image in softness. For the stalks (below right), I underexposed for a more silhouetted effect, hoping to amplify the glow of that low winter sun.

Shutter Sisters' Blog
BY KAREN

I've never been a huge fan of roses—in my mind, there are many more beautiful, interesting blossoms. Still, when my husband, Marcus, suggested we plant a couple of rose bushes in the back of our garden a few years ago, I didn't protest: I assumed that his need for roses was somehow because he's English. Anyway, they're blossoming now. When I downloaded this shot from my camera, I was surprised at how little post-camera processing was necessary—I increased the contrast a tiny bit and added some vignetting around the sides, but otherwise, the image remains generally untouched. I'm shocked at how much more appealing roses are when you look at them up close. Like most things, I suppose.

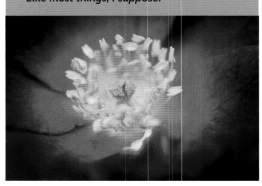

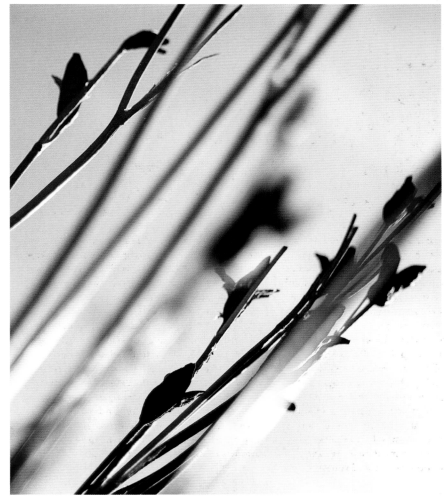

Processing

BEYOND NATURE'S OBVIOUS BEAUTY THERE'S MORE TO THE STORY.
POST PROCESSING CAN INFLUENCE NATURE'S TALE AND BRING
ADDED EMOTION TO YOUR SHOT.

▶ **Emotion in coolness and warmth**
Drama is created in the shot of the dew-soaked
grass (right) by cooling the white balance during
processing and then increasing the blacks. In
contrast, the flarey sun-drench of these brittle
flowers (far right) is a much warmer tone, another
take on the last hanging-on of the sun.

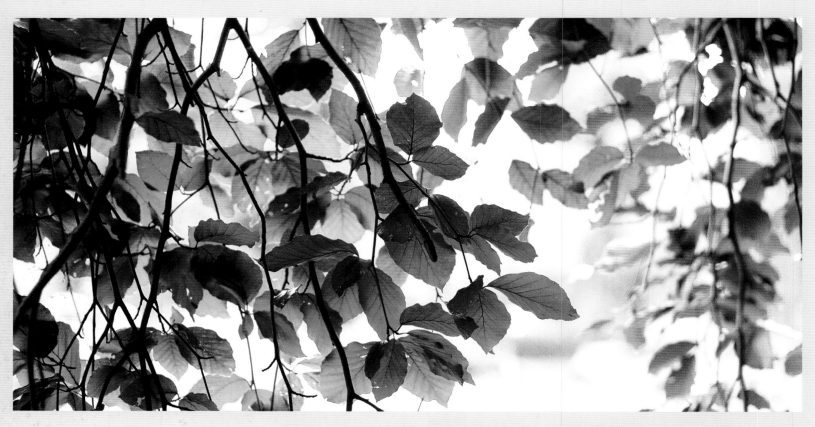

As with any photography, processing has the
potential to amplify the emotion or the vibrancy
of nature shots. Every frame of nature is filled
with commentary and so emotional vibrancy is
a given no matter what your subject. Starkness,
loneliness, struggle. Friction. Inexplicable mystery.
A texture or rounded edges, or Polaroid scratches
or a 1970s' wash can be a skin to enhance that
commentary; and the extent to which you employ
these tools is a matter of personal taste.

Slight underexposure and then brightening
or contrast work in post processing can saturate
colors more richly. A boosting of blacks in a flare-
filled shot can retain the ethereal nature of angled
sunshine, while accenting detail in the subject.

Sparing, saturated shots with a bit of a vintage
twist are my trademark—but in this late-November
shot of dried tall grass bent under the weight of

dew (facing page, top left), a simple heightening
of blacks during processing made for a dramatic,
cool backdrop that adds pop and the sensation of
frosty temperatures. You might use a mixed bag
of actions, or you might have your own handmade
routine. Regardless of your personal processing
style, nature photography adapts well to new and
unique treatments that represent a broadening of
creative boundaries.

Processing, especially in nature photography,
allows you to gently guide an image along,
manipulating it if only to replicate more accurately
what you saw with your eyes when you snapped
the shutter, as well as to translate what you felt
at the moment. By embracing processing, your
photographs better reflect both sets of eyes:
those of the vision and those of the heart.

▲ **Cave of green**
This sheltering curtain, shot from the inside of a
tent-like tree, is a refuge. Taken with the typical
settings, the camera would have balanced out the
confusing light by underexposing for the brights
of the background, turning the leaves to near-
silhouettes. I overexposed the frame by almost
two stops in order to bring the background to
a near-white glow, with two intentions: first, to
reduce the amount of visual clutter beyond the
tree's embrace and second, to allow the light to
penetrate the leaves and turn their green into a
glow. Post-download, I dialed up the black tones
(one effective method to impact contrast) to make
sure the detail—the veins of the leaves, the limbs—
would pop despite the flare of overexposure.

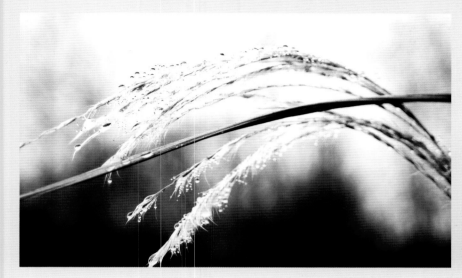

See It!

A slight vintage wash changes the tones of blue in this beach-grass shot for a base of evocative teals. Shooting into the sun is always a risk— the pursuit of flare can have unpredictable but often magical results. Experiment with your relative position to light, and in processing, adjust contrast and blacks so that detail and form are not lost in the wash of light. And remember: processing choices guide the viewer with interpretative cues. Experiment, but with a light hand. Rather than having a processing effect overwhelm an image, let the image lead.

Edit It!

1. *For a dreamy effect, increase exposure and fill light.*
2. *Increase highlights, lights and darks between 15–40%.*
3. *Desaturate all colors by 40%.*
4. *Add split tones: faded gold with slight green tendency to highlights and pale bluish purple to shadows.*

▼ **Black-and-white stem** *by Tracey*

With an absence of faces and an often abstract result, nature photography can feel like a creative gateway that lends itself well to a freer experimentation. Try new things. Play with light, tone, contrast, and texture.

Try a black-and-white treatment to strip away all other factors and turn our attention to one or two key elements, as Tracey does in this detail of a flower stem.

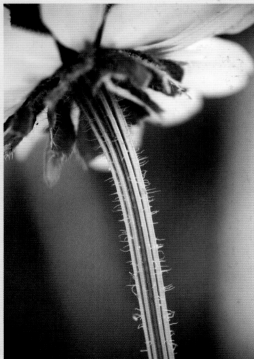

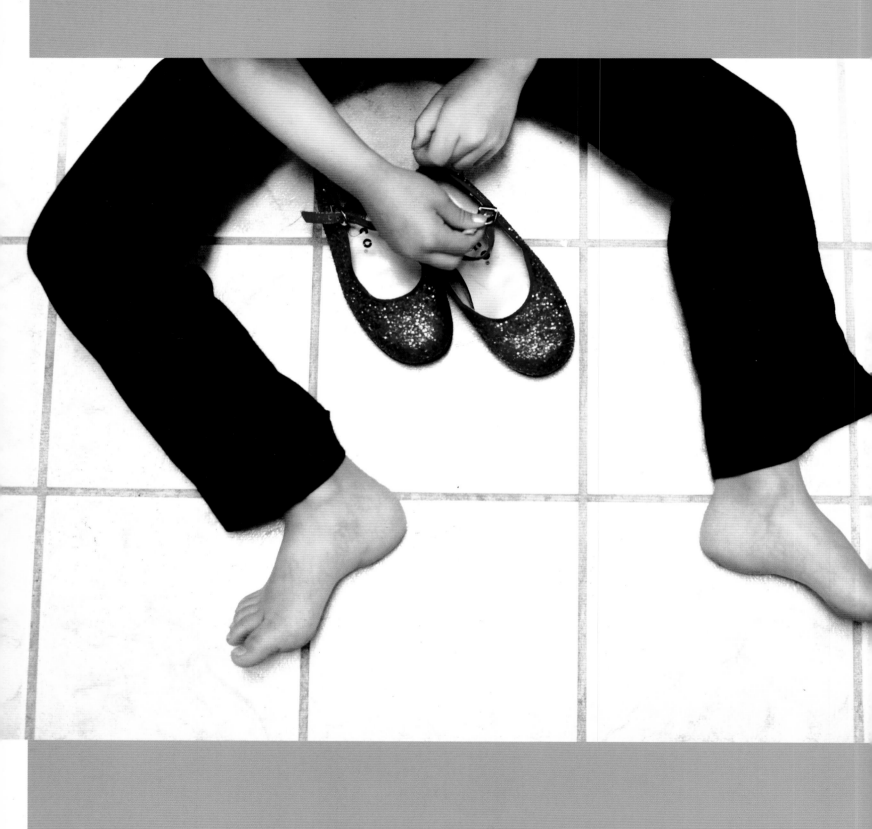

4
Spaces

Sarah-Ji

CADENCE IS SPRAWLED OUT ON THE KITCHEN FLOOR, CRYING. "They're too small!" she wails, while simultaneously trying to shove a bare foot into one of her beloved ruby slippers, to no avail. The hot summer night seems to have made her feet swell and now she looks like one of Cinderella's stepsisters, attempting to stick her feet where they apparently don't belong. These shoes have been threatening to retire for weeks now, but we've all been in denial about it.

Cadence and her red sparkly shoes (as she calls them) are legend among my circle of friends. She and Daddy found them for $5 at a thrift store in Portland, Oregon a few days before she turned four years old, and since then she has seldom been seen wearing anything else on her feet. Total strangers squeal with delight and gush over her when they see her beautiful "Dorothy" shoes. The funny thing is that Cadence has never seen *The Wizard of Oz* and she glares back at these people, wondering who in the world this Dorothy girl is.

My friend Diane once commented "Everyone's got a pair of ruby slippers that don't fit anymore." I suppose this is at least figuratively true for those of us who fall into the adult demographic. On the one hand, it's funny to imagine that we all could have a pair of red glittery pumps stashed away somewhere that our big grown-up feet can't squeeze into anymore, but that we still hold onto "just in case," like my drawer full of pre-pregnancy clothes. And on the other hand, I know it's true: I can't merely don some fancy footwear and magically transport myself back to the way things were before this tornado called life whisked me away to far-off grown-up lands.

My daughter, by the way, has not yet been initiated into the knowledge of her ruby slippers' magical powers. No one has told her about clicking her heels three times and repeating "There's no place like home..." At five years of age, she still spends much of her time at home, and if some magic spell could actually transport her anywhere, she'd probably choose the mantra "There's no place like Kiddieland..."

So here she is, sitting on the kitchen floor, crying over her thrift store shoes, and I stand over her, recognizing that my little girl is growing up faster than I'd like, and simultaneously wishing I had bought those shoes in every size when I saw them on sale at Target. I can only hope that she learns to find her own way home, wherever she may be.

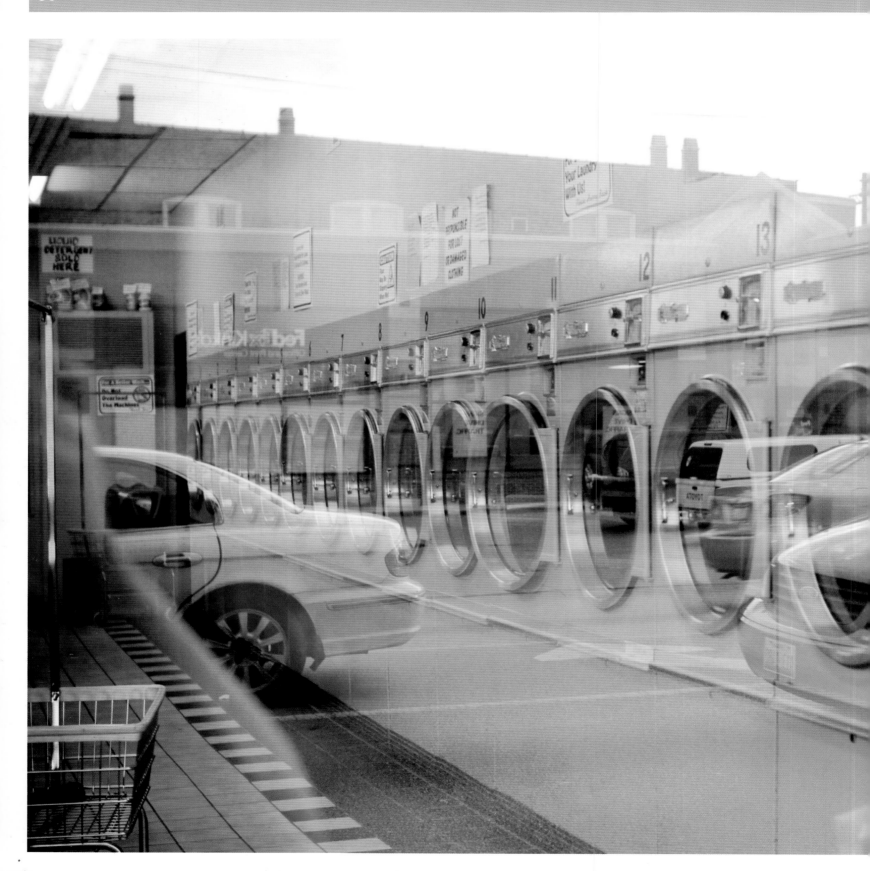

◀ The neighborhood laundromat
The ordinary places where we perform our most mundane rituals often create a sacred space for us to dream, reflect, and freely be ourselves. Capturing photographs of those places now will reap an abundant harvest of warm memories in the future. These images can be a testament to the diligent practice of creating home—a safe haven—wherever we may be.

Introduction

WE ARE ALL TRYING TO FIND OUR PLACE IN this world—our own space, if you will. Simply put, we all long for home, a place where we can leave our pretenses and defenses at the door (along with our shoes and coats). For some, home is an actual physical structure—a house, an apartment, a condo, a cabin—a space to call one's own. Others try to find home in a broader locale, a place to put down roots—a certain neighborhood, a cityscape, a coast, a country, even a continent. Still others seek home in the relationships they build, creating a safe haven of unconditional acceptance and mutual support. A friend, a neighbor, a faith community, a corner of the blogosphere: a circle of interdependence.

Regardless of how we each define home for ourselves, the spaces in which we choose to live and love are reflections of who we are. These spaces become repositories of our most poignant and unforgettable memories, and the photographs we take in and of these spaces become pieces of the storyboard that shapes the narrative of our lives. We entrust a part of ourselves to each image for safekeeping, comforted by the assurance that we can always revisit these visual cues, these myriad moments that weave the richly brocaded and colorful tapestries of our lives.

This chapter will explore the various ways we document life in the spaces where we feel the most relaxed and comfortable—whether those spaces are within our dwellings, out in the world around us, or in the most special regions of our hearts. Often, the images of ordinary aspects of our everyday lives are the ones that we end up treasuring, for these give us a glimpse into our innermost longing for a place to call home.

Approach

NO MATTER THE LOCATION, THE SPACES THAT WE ARE DRAWN TO CAPTURE MEAN SOMETHING TO US. EXPRESSIVE IMAGERY STEMS FROM THAT PERSONAL CONNECTION.

For most of us, the mere thought of a particular special place can conjure up a host of warm fuzzy feelings. Whether it's a childhood house, a backyard swing full of memories or the site of a first date, we store a treasure trove of stories and emotions—joy, acceptance, comfort, love—related to these locations. Taking photographs of them is a great way to amass physical souvenirs of the many memorable mile markers on our life journey. There are several ways to recognize and to be prepared to capture images of these special occasions, wherever and whenever they may occur.

Sometimes a moment or a setting may make your heart skip a beat or leap with joy. Or you may get a lump in your throat and feel your eyes well up with tears. Something in that scene calls out to a special place in your heart, and you know that you have to capture this image for posterity. You may not fully understand why at the moment, but you'll be thankful you listened to your intuition and clicked the shutter.

▲ **Taking a stroll through the comfort zone**
When I captured this image at a beach near my home, I was thinking of the many other nights that I had gone alone to a beach to think, and to rest in the comfort of the vast space, listening to the chorus of waves lapping against the shore, feeling the wind having her way with my long unruly hair. Many of those nights were during difficult periods in my life, and I have never forgotten how just being on that beach in the darkness, I could feel peace wash over me. Every time I look at this image now, I am reminded of that comfort.

See It!
This image is perfectly symmetrical in both the placement of the lifeguard chair and the division of the frame where the sand meets the night sky. An eerie glow illuminates the sand, and because the light is hitting the sand's bumpy surface from the right side of the frame, shadows are created, accentuating the sand's texture.

◀ Making art can be messy

If you want to capture life in the space you call home, be prepared to shoot first and tidy up later. Life unfolds whether or not your floors are mopped or your tabletops orderly, and if you're always stopping to clean up the mess before you grab your camera, chances are you'll be missing many an opportunity to capture life at home in its utmost honest beauty. The stories of our lives can't be squeaky clean all the time and neither should our photographs.

▲ Quality time on the couch

The more you shoot in the spaces that you consider to be home, the more familiar you will become with the light conditions, and how to respond with your camera. You'll know, for example, that at 10 a.m. on a sunny spring day, your living room will have enough light for you to comfortably shoot at ƒ/2.8 without cranking the ISO past 400. Or you'll know that you'll need your fastest lens to shoot inside your favorite coffee shop that has northern exposure. Making a mental note of these camera settings in relation to location and lighting conditions will help you to capture memories before they've been lost to fiddling with dials and function buttons.

Shoot It!

Get to know your own space by experimenting. Try shooting a still life in your living room (it's easier to start with a subject that won't move) with your ISO at 400 and your aperture set to the smallest number your lens will allow your camera to go. Shoot a few shots, then alter your settings and keep shooting. When shooting in the evening or by lamplight, you might need to start with an ISO closer to 1600. You can also test out different white balance settings too to help correct the color of your images if needed (especially if you are shooting at night).

Perspective

TAPPING INTO YOUR OWN PERCEPTIONS ABOUT A PLACE CAN
ASSIST YOU IN FINDING YOUR OWN UNIQUE PERSPECTIVE AND WILL
INFLUENCE HOW YOU CAPTURE IT IN A PHOTOGRAPH.

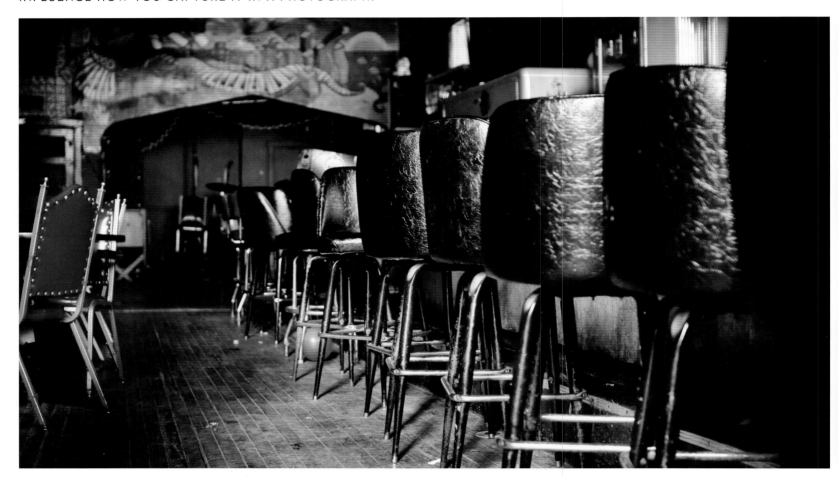

We all see the world in different ways and so it stands to reason that how we see with our eyes will influence the viewpoint through our camera lenses. The way you capture the spaces you inhabit and frequent will naturally reflect your own perceptions and convey the stories that have personal meaning to you. But, on the other hand, changing your usual perspective as you observe your surroundings can transform your experience of even the most familiar of places, and can result in a refreshingly novel point of view (both literally and figuratively!).

▲ **A daytime peek into a dive bar**
Sometimes, a new perspective may warrant seeing a space not only from a new angle but also in a whole different light. This image depicts the interior of a dive bar and music venue in Chicago that I have fond memories of—my husband and I went there when we first started dating. I happened to pass by the bar one afternoon last winter. Up until then, I had only seen the inside when it was crowded with patrons and illuminated by the dim light of a few incandescent bulbs. But this afternoon, the bar was empty and bathed in warm mid-afternoon sunlight, and I was amazed by the rich color and textures I saw. I took this

photograph with my camera resting on one of the tables, and the final image gives the perspective of someone sitting down, observing the peace, warmth, and beauty of a space that in its nocturnal state would usually be dark, dingy, and packed tight with bodies.

Set It!
ISO: **250**
EXPOSURE: **1/80 SEC**
APERTURE: **2.2**
FOCAL LENGTH: **30MM**
FLASH USED: **NO**

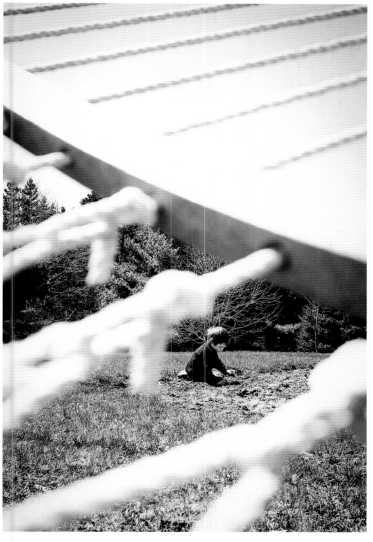

Shutter Sisters' Blog
BY KATE

At night the window is open and once all settles and the light gives up, we scooch down under the duvet with the breeze at our heads. We fall asleep to the nocturnal song of the peeper frogs in the marsh down the cove, earth from the day's weeding still tucked in the upturned hem of jeans that lie crumpled in a pile on the floor. The only thing better than a vegetable garden of blackberries, carrots, asparagus and beets is that very vegetable garden, yet to be planted. A square of earth—worms, spiders, rocks, last fall's wayward dinkies, treasures to be unearthed and tugged at. An afternoon as agreeable to the four-year-old as to his horizontal mother, who selflessly conducts scientific trials as to the healing properties of hammock plus sunshine.

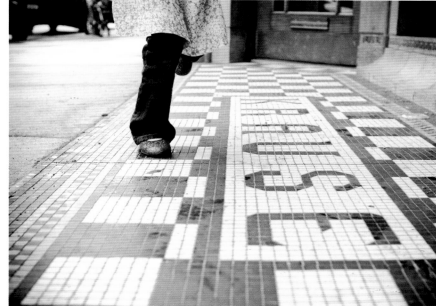

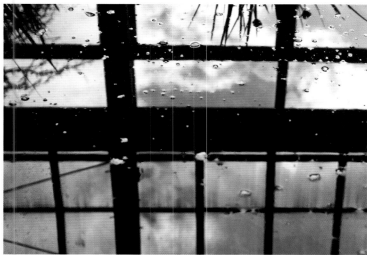

◀ **Lift your eyes up to the skies**

The perspective you choose as the photographer can signify the direction that you intend the viewer's eyes to go when looking at the image. The bright blue slice of sky reflected in this shot draws the observer's gaze upwards, where he or she can search for more of this inspirational view.

▲ **Hopscotch in the city**

Choosing a viewpoint that creates strong symmetrical lines can be effective in creating a graphically interesting composition. In this image, I held the camera at an angle so that the lines created by the tiles on the ground stretch towards the horizon, creating a vanishing-point perspective. This specific view captures my daughter in mid-hop, but only from the waist down, further emphasizing her movement, and the fact that she is hopping from one black square to the next.

Composition

IN THE SPACES WE SHOOT THERE ARE MORE DETAILS TO CONSIDER
THAN IN OTHER SCENARIOS. WITH EACH UNIQUE COMPOSITIONAL
ARRANGEMENT, THE STORY SHIFTS.

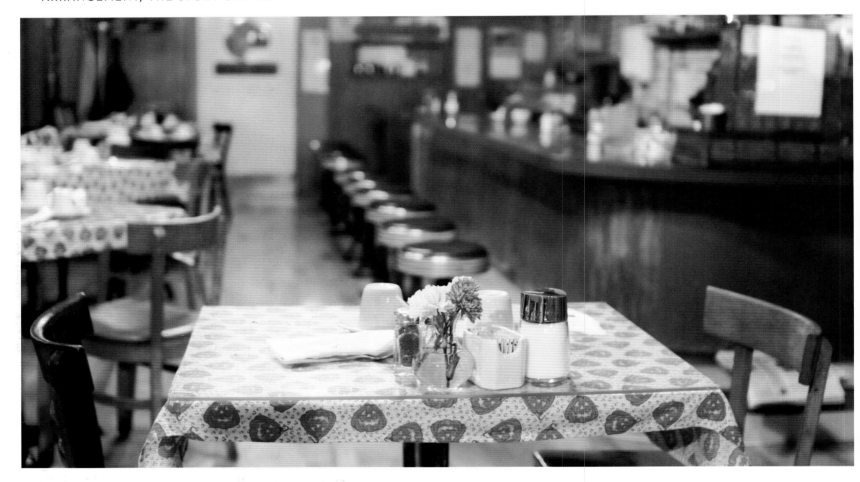

We live in a big wide world. Even when we're indoors in tiny apartments, our field of vision generally encompasses more than what fits into the minuscule rectangles and squares that make up our viewfinders. How, then, to select what elements to include in our images, and in what arrangement? The right composition can mean the difference between a forgettable shot and a compelling one.

▲ **Table for two**
Those of us whose goal it is to portray the world around us with our cameras often have only a mere moment to aim our lens and capture a story as it unfolds. Other times, however, we have the luxury of deliberation and can think through what exactly we want to include in the shot, and how we want to frame it. These opportunities may be perfect for taking a narrative approach to composition. In this image, shot through the window of a café after hours, the two chairs in the foreground seem to be on a date, enjoying some peace and quiet while sharing gossip they have overheard from patrons during the bustle of the lunch crowd.

▶ **Ready for his own adventures** *by Kate*
An effective way to convey a specific message in a photograph is through the use of juxtaposition. By composing a photograph in such a way that causes the viewer to either visually or mentally place two or more of its elements side by side in comparison or contrast, you can create interesting images that have both visual and emotional impact. In Kate's picture of a moment in her son's nursery, the juxtaposition of her son's delightful face in front of the painting of the poem by Shel Silverstein about *Alice in Wonderland* makes the viewer wonder what adventures lie ahead for her little boy.

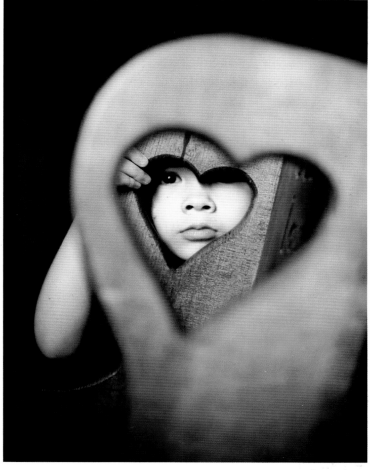

▲ Open-hearted

Whenever you find suitable structures already present in an environment—for example, windows, door frames, tunnels—it's a great opportunity to create a frame within a frame to add an interesting element to a photograph's composition, and to emphasize the focus on the main subject. In this image, the heart-shaped cutout in this wooden chair perfectly frames my daughter's face, adding a touch of whimsy to the scene.

See It!

The shallow depth of field creates a soft-focus effect in the foreground that adds to this shot's appeal. Framing your subject within a frame can be an effective way to create interesting composition, and the tack-sharp focus on Sarah's daughter's face takes our eye straight through the endearing heart-shaped frames right to her face and her perfectly wonderful expression.

Shoot It!

Try adding something new to the frame of your shot. The key is to focus on your main subject, and while holding the shutter half way down to keep the focus locked on the subject, mindfully recompose the shot. By placing your subject in different parts of the frame, you can fit in other elements within the picture. With Kate's shot, she clearly intended to include the wall hanging in the frame. With a little bit of planning, you can arrange your subject(s) accordingly before you actually shoot the picture.

Set It!
ISO: **400**
EXPOSURE: **1/100 SEC**
APERTURE: **1.8**
FOCAL LENGTH: **30MM**
FLASH USED: **NO**

Lighting

THE LIGHTING CONDITIONS IN THE CONFINES OF SPACES MIGHT
NOT BE IDEAL, BUT USING EVEN CHALLENGING LIGHT TO YOUR
ADVANTAGE CAN OFFER A COMPELLING CONTEXT.

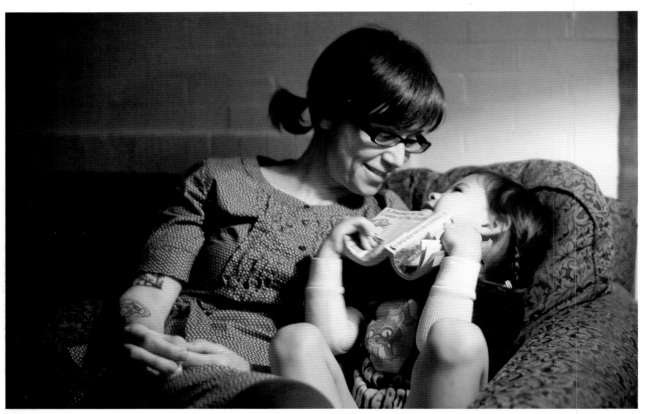

◀ **Illuminating the moment**
Although there is a time and place to use flash in the absence of adequate light, you may prefer to shoot inconspicuously so as to capture your subjects as candidly as possible—people can become annoyed or self-conscious at the constant burst of a flash. In such situations, instead of dejectedly stowing away the camera, wrangle what light is available—even the dim glow of a lamp in the corner—and continue to capture meaningful memories. I did just that in this image of my dear friend Sarah sharing a moment with my daughter.

As a photographer, pursuing light often feels like having an affair with a fickle, mercurial and inconstant lover. It's so easy during the golden softness and magic of the gloaming. Other times, however, all you get is the cold shoulder and you find yourself alone in the dark. Since life still goes on after the sun goes down and so much happens within the dim confines of our homes, it is a worthwhile and often rewarding endeavor to negotiate difficult lighting conditions.

◀ **The perfect cup of tea**
by Tracey
"Life in our sunny family room plays like a moving picture to me. Each moment is photographically worthy in its own unique yet usual way. Seeing everything in pictures is easy in nice light. And so it's not uncommon for me to bring our life to this room. We play games, read books, play with the dog, share tea and snacks, and snuggle. With optimum light in places like the home, we can focus on expression and details, bare feet on the floor, and crayons on the table."

▲ Twinkle, twinkle, city lights

For those urban dwellers who love to wander the streets at night, rejoice: this is the perfect time to capture your city painted by colorful neon signs, streetlights, and passing cars. In this image, to create maximum star-flaring of the points of light, and to turn moving vehicles into streaks of light, I set the aperture to a very narrow f/16 and used a six-second exposure. A low ISO of 100 effectively minimized potential noise from the long exposure. Don't let the lack of light prevent you from capturing the beauty of your city during the night. There are many ways to improvise a tripod and as long as you give your shutter enough time to let the light in, you don't have to crank up the ISO and sacrifice color saturation.

Set It!
ISO: **100**
EXPOSURE: **6.0 SEC**
APERTURE: **16.0**
FOCAL LENGTH: **30MM**
FLASH USED: **NO**

Details

TO ILLUSTRATE THE RELEVANCE OF A PLACE OR SPACE USE THE
DETAILS OF THE SCENE. WHAT YOU CHOOSE TO FEATURE WILL
INFLUENCE THE IMPACT OF THE SHOT.

A photographer's eye is trained to look for the
details, however small, that transform an image
from a mere snapshot into a treasured keepsake.
These seemingly tiny elements often belie the
magnitude of emotions they can evoke, or the
significance of the memories they symbolize. In
the spaces and places we call home, these little
details can be particularly potent in unlocking the
door to our most cherished memories.

◀ **Untitled, 2009, 10" x 8", crayon on plaster**
by Kate
Certain scenes call for a deeper focus or
larger depth of field to effectively convey the
photographer's intent. At first glance, the colors
are what you see in Kate's austerely composed shot
of a bright red-orange lampshade stationed next
to a perfectly complementary cool green leather
chair. A more careful examination, however, reveals
Kate's delightful discovery of a flamboyantly
scribbled crayon work from a blossoming graffiti
artist. It is that cleverly composed detail that
makes this photograph so enthralling, especially
to any grown-up that may happen to occupy an
impeccably decorated home while also raising
budding artists.

▶ **Make a note** *by Andrea*

Andrea's whimsical capture of a simple, humorous, and heart-warming message from recently-departed house guests is a perfect example of how the most mundane aspects of home life can be captured in photographs to tell a story or to recall a special moment. These narrative details are crucial in doing justice to documenting life in the most familiar and comfortable of spaces. And, most likely, it is these very ordinary details in our images that will elicit a smile, a chuckle, and a nostalgic sigh from us in the years to come.

▶ **Looking in**

The steam on this window creates an element of mystery while adding textural detail to the image. We can guess that this is a window looking into a kitchen, with pots on the windowsill and what looks like a refrigerator in the background. However, we can't be absolutely sure unless we come out from the cold and actually go inside to see what's really behind the dreamy fogged-up glass.

Shoot It!

If you have a window that is easily accessible from ground level, try peering into it from the outside. Look for interesting details that can add visual allure to the image, such as streaks of dirt, flecks of paint, drops of rain, or beads of condensation. You can use a shallow depth of field to focus on those specific details rather than what is actually on the other side of the window, or you can do the opposite and focus on the inside, letting whatever is on the surface of the outside pane fade to a creamy blur.

Processing

EVOCATIVE IMAGES EXPRESSING PLACE AND TIME CAN BE
ADDITIONALLY ENHANCED WITH THE TOOLS OF POST PROCESSING,
EACH EDIT ADDING TO THE END RESULT.

With the digital darkroom, photographers possess a powerful tool to fully realize their artistic vision in the final image they create and present to the world. Just as initial choices made in-camera—composition, exposure, depth of field—work together to convey a specific message, post-processing choices can be indispensable in highlighting the subtle nuances of the space being captured.

▲ This is what tranquility smells like

I love the aroma of a slowly burning bundle of sage. When I processed this image, I wanted to convey the sense of well-being and pleasure I experienced as I captured the shot. Since the image was somewhat monochromatic to begin with, I accentuated the warmer tones and desaturated the colors to evoke my original mood when taking the photograph. Looking at this image, I can imagine myself sitting in a room flooded by the afternoon sun, watching the graceful tendrils of smoke dance ever upwards, as the herbal aroma surrounds my senses.

> *Edit It!*
> **PROCESSING STEPS:**
> **1.** CORRECT AND ENHANCE BASIC EXPOSURE.
> **2.** DESATURATE ALL COLORS BY 35%.
> **3.** EDIT HUES TO ACCENTUATE WARM TONES.
> **4.** ADD SPLIT TONES: WARM YELLOW TO HIGHLIGHTS AND LIGHT PURPLE TO SHADOWS.
> **5.** ADD DESIRED AMOUNT OF VIGNETTE.

▼ Windows to her soul

If an image lacks color to begin with, going with black-and-white processing may create a more compelling visual impact. Oftentimes, however, the decision to process in color or black and white is more personal, and depends on the message the photographer wants to convey. In this photograph, the clutter in the background is muted by the lack of color, and the viewer's eyes are met by my daughter's magnetic gaze, just peeking above the sofa. The high-contrast black-and-white processing accentuates the forcefulness of her dark eyes, making it difficult to look away.

> *See It!*
> *The graphic elements of this shot beg for a black-and-white treatment. The lines of the upholstery carry your eyes straight to the subject's eyes, while all other components in the shot are subdued by the lack of color so that the little girl is the main focal point. Additionally, the slight diagonal line of the table's edge behind the girl runs almost parallel to the edge of the sofa, distinctly framing the main subject and her compelling eyes in between.*

◀ In the spotlight

When capturing images in close quarters, one way to make a subject stand out is to add a vignette to the edges of the photograph. This effect naturally draws the viewer's attention to the element being framed in the vignette. In this shot (taken inside a bar), the added vignette gives the illusion that the afternoon sun illuminating the drum kit is actually a spotlight shining on stage.

> ### Shoot It!
> *Try the vignette option in your photo-editing software on a still-life image you captured in a space you're familiar with. Many of even the simplest photo-editing tools offer this feature. Test it out and see how a little (or a lot) of the vignette option can change the entire feel of the image. By experimenting with this feature, you will soon be able to incorporate vignettes into your processing to enhance the impact of the overall look and feel of the final image.*

▲ Vintage fun

Most digital darkroom software gives the user the ability to save a number of processing modifications as one convenient setting that can be applied to different images with the click of a mouse. These saved settings may be called "actions" or "presets," depending on the software, and can be a powerful tool in your processing arsenal. Some images naturally lend themselves to creative processing, and presets can be an easy and fun avenue to quickly apply different moods or ambience to a photograph. The shot of an antique toy stove with an old rotary phone resting on it is perfect for trying out different vintage looks.

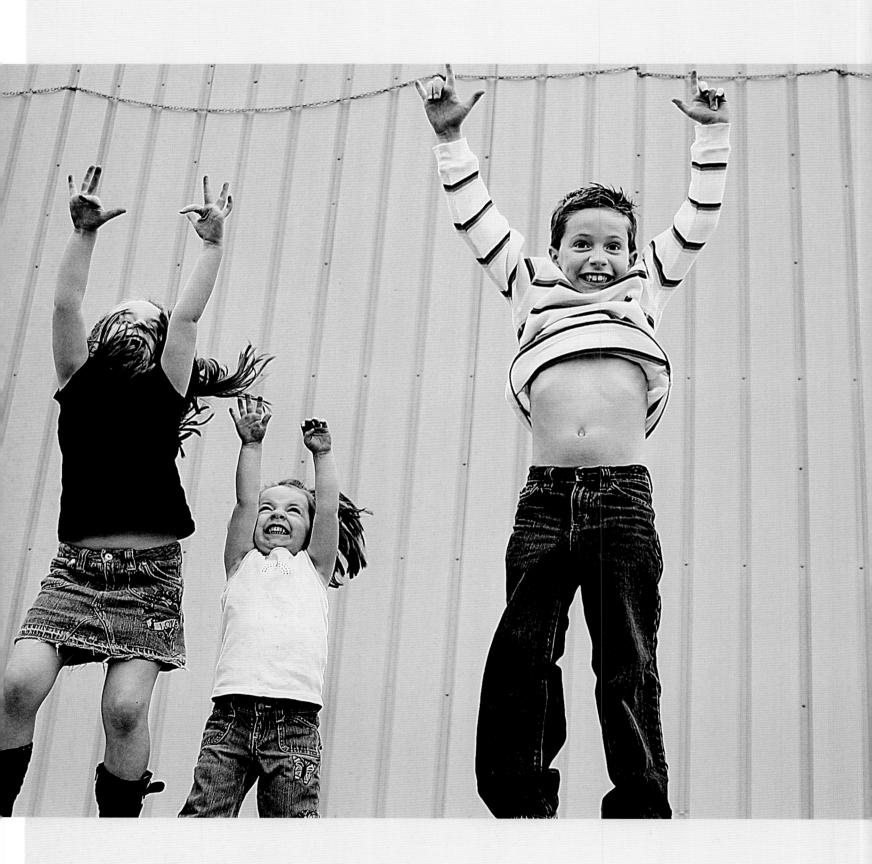

5 Childhood

Maile Wilson

> *"Childhood is measured out by sounds and smells and sight, before the dark hour of reason grows."*

JOHN BETJEMAN

DURING MY PHOTOGRAPHY CAREER, I'VE SPENT A GREAT DEAL of time taking pictures of children and their families. So when I was asked to contribute to this chapter, I thought it would be a relatively simple task. However, when I started going through my archives to compile images, I realized with a pang, how little time I'd spent photographing my own children. Initially I tried to justify it, as if it were somehow expected. After all, the cobbler's children aren't supposed to have shoes, right? But I knew there was a deeper reason as to why I hadn't been aiming the lens at my own life. Simply put, I was afraid that I wasn't enough.

It was the pile of laundry in the background, the dishes in the sink, you name it. It was ultimately my own feeling of inadequacy that made me cringe when I saw evidence of imperfection. And why would I want to document that? Even on special occasions, it was only out of obligation that I'd grab my camera. Feeling even more like everything *should* be a certain way, I was paralyzed and uninterested. We can't be creative when we're burdened with such precise expectations. So I'd put my camera down again and tell myself that *next time* I'd work harder. *Next time* it would be better. *Next time* it would be perfect. But *next time* is a slippery slope that can easily turn into never. Years pass by without permission. And one day it's possible to find that the occasions we were counting on flew away unnoticed and without being treasured.

Coincidentally, I came to this realization around the same time that one year was ending and a new year was about to begin. As was my ritual, along with all the new resolutions, dreams, and goals, came the regular purging of old images. Most of them were shots of

clients from the previous year needing to be cleaned out, and little hesitation was required before deleting. But then I came to a hidden file with the unassuming label "outtakes." Not remembering what I'd included in it, I opened it to find snapshots of my own children, taken in the first six months of the previous year. This folder was where I'd stored all the images that weren't "good enough" to blog, or print, or to keep out on display. They were out of focus and overexposed. They were pictures of my messy house, children in pajamas at three in the afternoon, with unbrushed hair. They were the not-perfect pictures of my not-perfect life. And they grabbed me in a way that none of the others ever could have. The last thing I cared about noticing was an *f*-stop. All I could see was the subtle way my son knitted his eyebrows together when he was doing his homework. Or the way my little girl's belly bounced out happily underneath her too-small T-shirt. This was my everyday life. These were the "un-retouched" moments that I wanted to remember most. I'd been living my life as if it were a photographic session in need of editing. As a result, the flawed, unedited, most real moments were being discarded. But these ordinary messes were as much a part of me as the edited versions.

This was my realization as a mother that there is simply no time for *next time*. Our children grow and change at warp speed. They move from the cradle to kindergarten in seconds. While there are birthdays, holidays, and special occasions, most of life happens messily in between the milestones. And we can't forget to celebrate it.

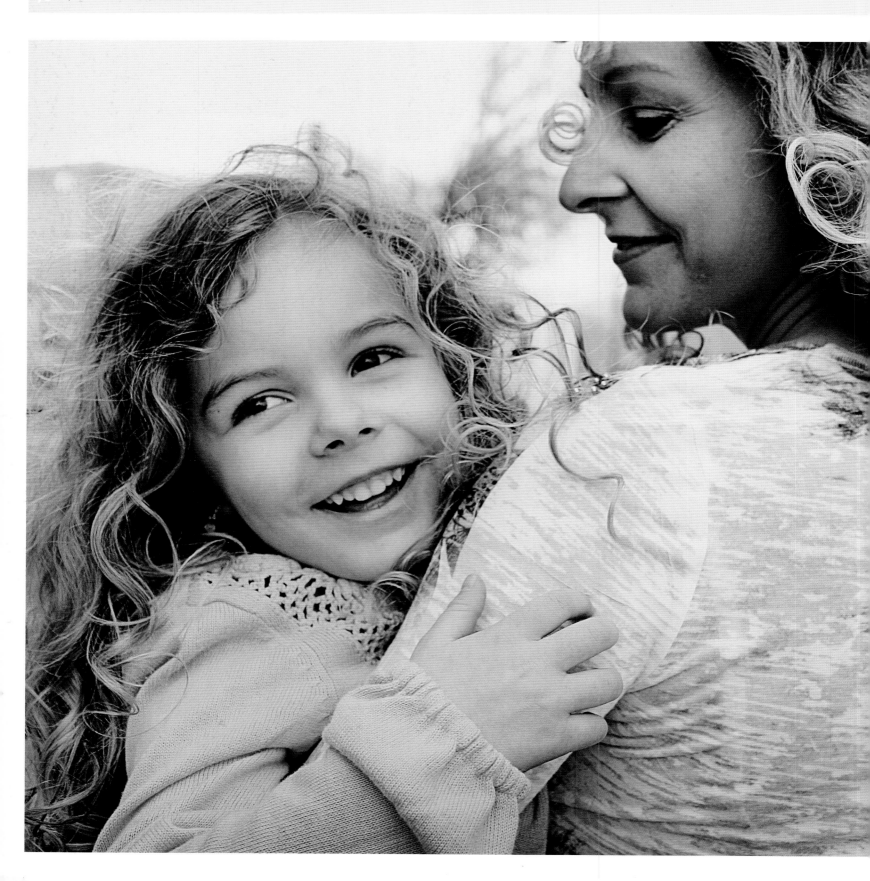

Introduction

WE ALL REMEMBER A TIME WHEN GOING TO A professional photographer meant begging children to properly fold their hands on a *faux* table that was covered in *faux* fur, in front of a *faux* paper backdrop. Maybe it was a mural of evergreens, or a field of unicorns. Regardless, the objective was to sit still and say "cheese." Thankfully, children's portraiture has greatly evolved since the *"Days of Faux."*

This is what I find thrilling. When you meet a child in his or her own world, sticks transform into rocket ships, leaves turn into sailboats, and the journey of their imagination turns into an adventure of discovery for you too.

When you capture portraits of children you have the honor and privilege to enter a whole new world: theirs. Let the children be your guide. Follow their lead. Listen, watch, explore with them. As you follow their cues, you'll be better able to capture picture after picture of not only your young subjects, but of a world full of magic and wonder, and your images will tell the story of childhood.

◀ **Natural beauty**
When a child is in a place where they feel "at home" you'll be able to capture their true personalities. There's comfort and joy found in images where a child is obviously in his or her element, totally happy and unconditionally loved.

Shutter Sisters' Blog
BY IRENE

"Shoot what you know" is what they say. And I know these two.

Yet it wasn't until recently that I realized that my sons, now almost eight, have been a constant source of inspiration whether I was holding a pen or a camera. And though I am now able to create a routine that revolves a little more around my work rather than school schedules, and I no longer feel the compulsive urge to squeeze and kiss their cheeks all the time, documenting my children's daily life is still one of my greatest joys.

It's little surprise then that some of my favorite photographers are also parents who photograph their kids. A lot. There's just something heartbreakingly beautiful and touching when we are faced with such innocence, curiosity, and unrestrained joy of life.

Approach

THERE IS NOTHING MORE IMPORTANT THAN AUTHENTICITY WHEN CAPTURING IMAGES OF CHILDREN. LET THEM REVEAL THEMSELVES TO YOU AS YOU HOLD YOUR CAMERA AT THE READY.

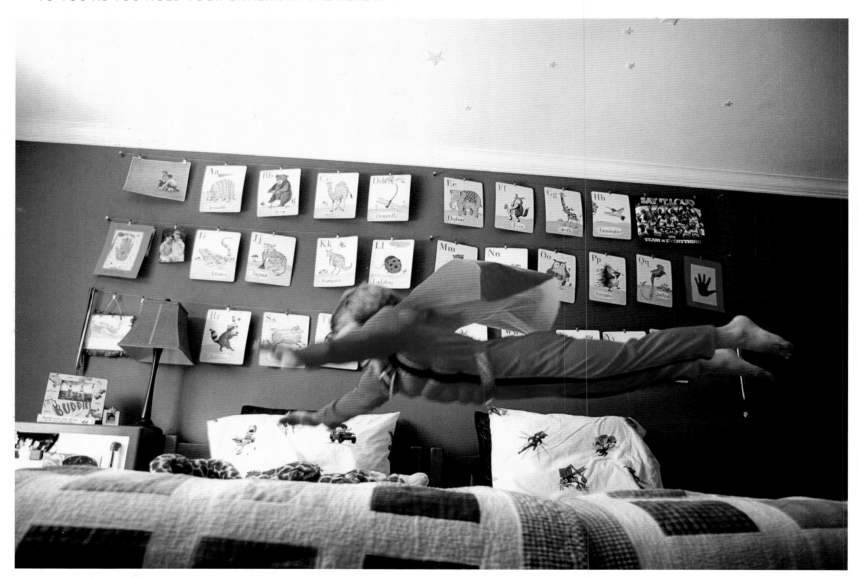

Interesting portraiture stems from connection, so it's important to consider your approach. This is especially true with children. Like adults, kids can be hesitant or shy when introduced to new people and situations. It can be even more intimidating when that new person is also aiming a large piece of metal equipment in your face. The camera can actually end up acting as a barrier. So whether I'm photographing my own children or the children of a client, I try to forget that I'm a "photographer." Instead, I'm just Mom, a friend, or a playmate.

▲ **Superhero**

Children are naturally playful, so it's easy to get a great photograph when you make it about having fun. You just have to be ready to capture the moment.

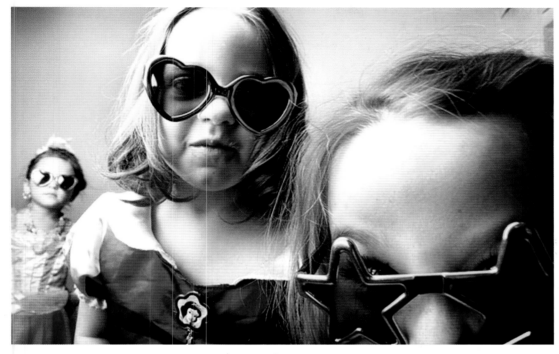

◀ Glamour girls

Did you know that dinosaurs and fairies live inside my camera lens? If you look really close and stay completely still, sometimes they'll peek out and say hello. In this image, the girls were looking for dancing princesses. For slightly older children, you can make a slightly more technical version of this "story" by saying that there's a crocodile hiding inside your lens. If they look closely they'll be able to see him "blinking" as the shutter clicks together.

Shoot It!

Tell your subjects about the magic that lives within your lens and watch them gather around, squeezing themselves into your frame. Be sure to shoot the whole process of discovery; it usually doesn't last long so shoot quickly.

▶ Aspiring photographer

When photographing newborns, it's easy to become focused on the baby. But it's nice to include older brothers or sisters—this way they feel important and included. While you're shooting the newborn, have siblings draw a picture for "their" new baby, or help to give them a bath, or play peek-a-boo. In this case, I handed the older sister my little point and shoot, and asked her if she'd like to take photographs of her baby brother too.

See It!

A picture in a picture is an intriguing concept. Maile is sure to include the small fingers of this baby's big sister on the camera to make this shot endearing to both the viewer and the mother of these children.

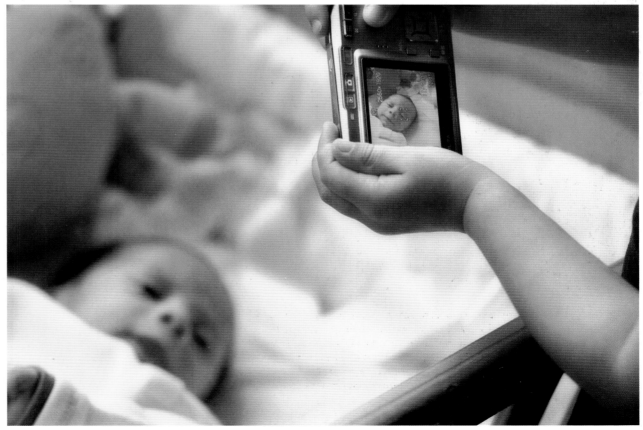

Perspective

SEEK INSPIRATION FROM THE SOURCE AND IMAGINE WHAT THE
WORLD MIGHT LOOK LIKE THROUGH THE EYES OF YOUR YOUNG
SUBJECT. YOU'RE BOUND TO DISCOVER NEW PERSPECTIVES.

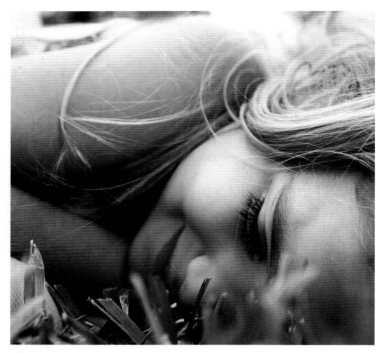

Whether it's an airplane flying overhead, or a ladybug on a window-sill, children are always paying attention, receptive to a world where ordinary moments are waiting to be filled with wonder. They notice the little things that we as adults have grown accustomed to tuning out. So spending time with them is in itself the gift of a fresh perspective.

When I'm feeling uninspired or stumped for a new idea, I find that it's often beneficial to simply move around. Sometimes a subject can become dramatically more interesting just by shifting yourself over a few feet. Allow yourself to think in three dimensions. Beyond left and right, there is also up and down.

When you ask someone if you can take their photograph, you are in essence also asking them to be vulnerable with you. Bridging this connection with children is easy because they haven't learned how to be self-conscious or guarded yet. With adults it can be more of a challenge, understandably. When someone invites you into their private spaces to record their most cherished connections, there must be a certain level of mutual trust. As the photographer, you can establish these connections by being willing to be vulnerable yourself. In this case, I was slightly uncomfortable about climbing, barefooted, onto their bed. I couldn't help but feel foolish as I wobbled above them with my camera. But it was also the only way to capture everyone from this angle; a reminder that sometimes gaining the right perspective requires taking a risk.

Shoot It!

The object in a shot like this is to really experience life like the child you are capturing in your image. Get down in the grass, or on the sand or even the living-room floor and shoot while you revel in the playfulness of a child.

▲ Little dreamer

To take this photograph, I had to lie down in the grass. By getting down as low as the little girl was, I was able to capture not just the image of her lying in the grass, but the feeling of it. She has the faintest sweet smile that I might have missed if I'd been further away or standing up.

▶ The intimacy of family

An unexpected perspective brings interest to this unique portrait. Including specific clues to the context—the family bonding with baby at home—illustrates intimacy and a tenderness that tugs on the heartstrings.

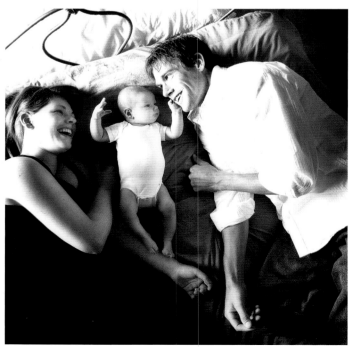

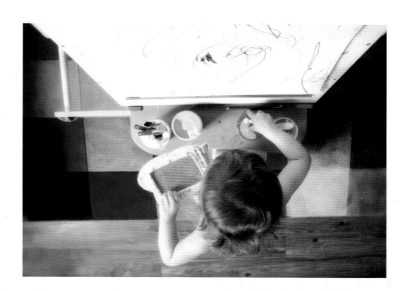

▼ **On top of the world** *by Andrea*
This image demonstrates the idea of perspective—when you place someone or something in the foreground, you create the illusion that they are larger than the background. So there is a literal "largeness" about this pregnant woman's belly that every expectant mom can relate to. But what makes this photograph even more powerful is that there is also a figurative "largeness" communicated. The fact that her belly is contrasted with the open expanse of the city creates a sense that she is "on top of the world."

▶ **Little Picasso**
I took this image by holding the camera right over my subject's head, without even looking through the viewfinder.

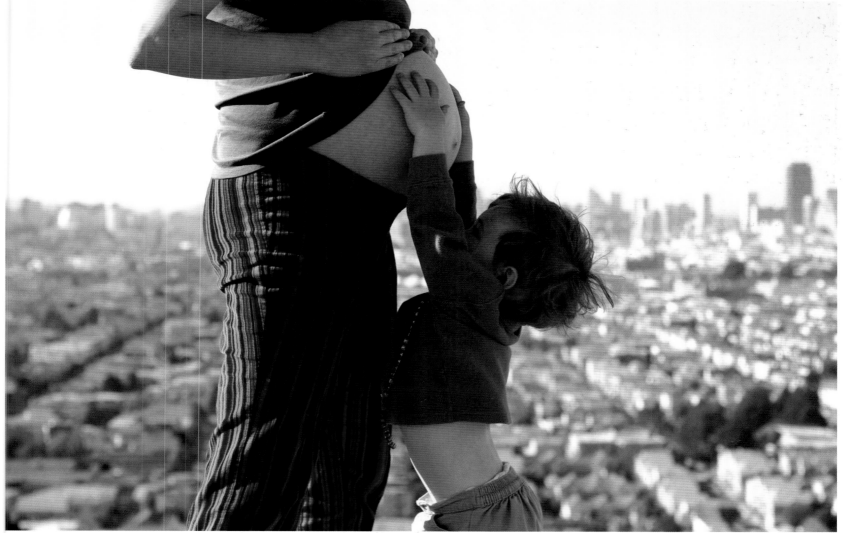

Composition

CHILDREN MIGHT NOT BE AS EASY TO PLAN AROUND AS OTHER SUBJECTS SO COMPOSITIONAL CHOICES MIGHT HAVE TO COME ON A WHIM, BUT KEEP IN MIND THAT THERE ARE INFINITE WAYS TO TELL A STORY.

Zooming in and getting down to the level of your small subjects is an effective way to get good portraits of children. But what about when you're looking to compose a shot with a little more interest? There are a number of different ways to express childhood through simple compositional techniques.

As you aim to tell the story of your young subjects, consider all the elements that can help you illustrate what you want to convey. Color, texture, location, and gesture are among those things that can be considered as you artfully arrange your images.

▲ **A little perspective**

Far from the ordinary baby portrait, this shot is a demonstration in opposites. And also of unexpected cropping: a more common way to compose this image would be to abide by the rule of thirds and position the baby in the left or right side of this image. There are many instances where off-centering a subject makes for a stronger presentation. However, this is an example of how rules can sometimes be broken to communicate a different feeling. Because the baby is almost uneasily centered, it creates a certain tension within the image that draws you in towards the baby, and makes her appear even more vulnerable and small.

◀ **Windswept** *by Tracey*
There is no such thing as an unusable background. Regardless of location, you are always under the sky. This captivating image translates this idea perfectly. The low perspective of her lens creates a lovely composition that includes trees and the sky behind the subject, her daughter. These elements, coupled with the beauty of her daughter's hair being swept up by the wind, give the viewer a sense of childlike wonder. We are drawn into a world where magic feels unquestioned and where life is a grand adventure to be explored.

▼ **Invincible** *by Irene*
Photography, just like any other art form, allows you to pick and choose the pieces you want to assemble to create something cohesive. You can do this by simply focusing on something that impresses or moves you. In this image the top half of both boys' faces has been cropped out, leaving nothing but the iconic superhero T-shirts as the main focus. Although their faces aren't shown in their entirety, the visible hand of one boy on the other's shoulder communicates a very strong bond between them. This is a perfect example of how emotion can be conveyed in other ways besides facial expression.

Lighting

SEEKING OUT A WARM GLOW VIA ANY NUMBER OF LIGHTING CONDITIONS WILL ENABLE YOU TO ILLUMINATE THE MAGIC OF CHILDHOOD FROM ANY NUMBER OF ANGLES.

In the same way that we're not always aware of our breathing patterns or our hearts beating, we're often unaware of how our photographs are utterly dependent on light. When we become conscious of light, we begin to notice the subtle ways that it shifts and moves. The harsh noonday sun can depict a field of grass as yellow, while the same field appears green on a diffused, cloudy morning. Being conscious of these changes is what allows us to learn how light works and how we in turn can work with it under any circumstance.

▼ **Wishful thinking** *by Stephanie*
In this image, the little girl is holding a handful of dandelions, which stands out brightly against the generally darker background tones. This contrast makes the dandelions the focal point. But this wouldn't have been as evident if it weren't for the way they are lit by the sun behind them. Backlighting is a very powerful way to highlight anything, especially if what you're highlighting already has a translucent quality. In this case, the illuminated dandelions feel enchanted. Not just for the way they're glowing, but for what they represent. For me, it feels like she's holding a magical handful of wishes.

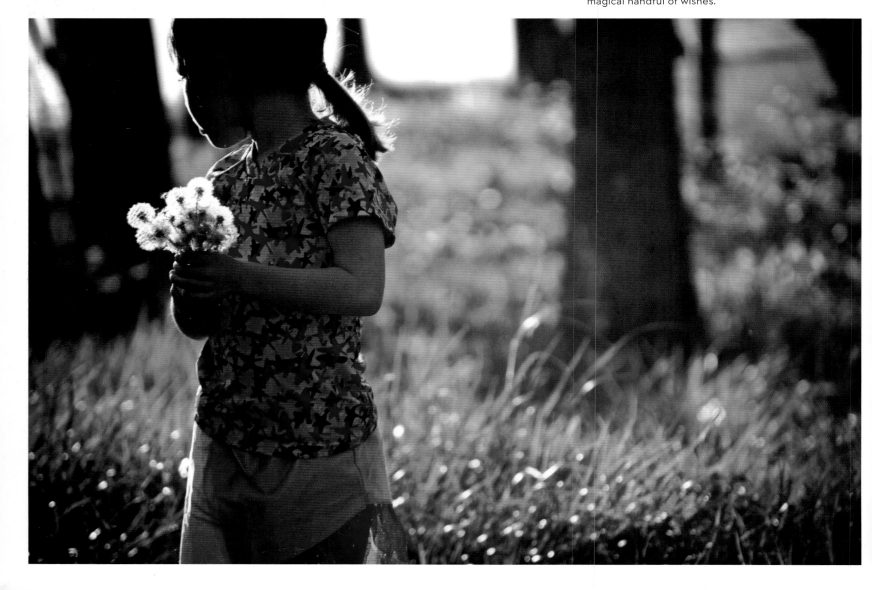

▶ Mermaid sisters

All moms know how it feels when the house gets too quiet. When the constant pitter-patter of little feet and activity turn into a silence that is often questionable. It's the silence that means forks are being jammed into light sockets or that cookies are being stolen. In this case, the house had melted into that suspicious state of calm so I was pleasantly surprised to find two mermaid sisters. They'd been lounging in the bath long enough to melt an entire bar of soap. As the muted light bounced through the window into the reflective water, it grazed across the texture of their little wrinkled toes to tell the story of their adventures.

Set It!
ISO: **400**
EXPOSURE: **1/60 SEC**
APERTURE: **2.8**
FOCAL LENGTH: **17MM**
FLASH USED: **NO**

◀ Baby love

Soft light is ideal for shooting portraits of babies. The light here is baby soft and yet strong enough to accentuate the textured lines on the chair, enhancing the graphic element that leads your eye right to the round, adorable subject.

Details

THE STORY OF CHILDHOOD IS FOUND IN THE DETAILS. WHETHER THEY ARE SPECIFIC TO THE CHILD OR UNIVERSAL SYMBOLS OF YOUTH, EVERY LITTLE THING PROVES IMPORTANT.

Often times photographing children is simply about waiting—waiting for them to laugh or jump, or tell a story about their favorite toy—waiting for magic to happen spontaneously. Other times, it's about letting the story be told by focusing simply on details. It could be tiny newborn toes or the tousled wet hair of a little girl on the beach. By zooming in on these elements, you leave space open for viewers to make their own connections about what was going on before or after the image was taken.

Over the years there have been many ways that people have defined what makes a photograph "work" or "not work." The definition is subjective based on the opinions and the aesthetic of each individual viewer. I define interesting photographs simply as those that make me stop for a second look—either because of one element that reaches out to grab my attention, or because of something more subtle in the photograph that ignites a more nebulous, but equally powerful feeling. Whatever it is, it's an element that makes you curious enough to look for something deeper in the story of that image.

◀ ▲ **Loved**
The lipstick kiss here was obviously prompted for the photograph, but it's a perfect example of how details can not only make an image more interesting they can symbolize other things and tell a sweeter story.

▲ **Cool blue** by *Tracey*
In this photograph it is the detail of the little girl's hands that draws me in. Beyond the blue drink and dirty hands, it's the remnant of her one finger nail with the chipped polish that makes the whole photograph. It goes to show that stories can be interpreted in the smallest of details.

▲ Rainbow's end *by Sarah*

We all exist in a world full of props. With kids, the options are endless. Including "props" when photographing children can instantly evoke a sense of playfulness; think an oversized lollipop, a teddy bear or a soccer ball. Here we don't see the faces of the children playing. Instead we see tube socks paired with ruby slippers, rolled-up blue jeans, and chalk-lined rainbows decorating the sidewalk. These props work collectively to give the viewer a sense of afternoon playtime among little friends, also stirring a sense of nostalgia.

See It!
Sarah's placement of the elements in this image is both deliberate and spot on. The arrangement of all the rich texture and playful color around the frame leaves enough negative space in the lower left-hand corner for our eye to rest, only to be swept back up into the action.

Shoot It!
Stand above your subjects and shoot down. You'll get a bird's-eye view of the enchantment of childhood. Don't leave out the little details that speak of childhood!

Processing

WHETHER IT'S ACCENTUATING YOUR SMALL SUBJECTS WITH A PUNCH OF COLOR, SOFT-MUTED TONES OR DISTILLING IT ALL DOWN WITH BLACK AND WHITE, PROCESSING CAN BE YOUR GREATEST TOOL.

Ten years ago it was hard to imagine a world where a photograph created with film would make a person feel nostalgic, as if it were made using some kind of relic from the past. But technology continues to become better and more affordable, making the learning curve come more easily. And because information is so readily accessible, an increasing number of people are now able to capture moments in a way that was never possible before. I don't think there's a more profound demonstration of this than the way moms have begun to document the lives of their ever-changing children. In this sense, the gift of technology has been a gift of increased memory.

◀ **Warm tones** *by Jen*
There are photographs that are obviously in color. And there are others that are clearly defined as black and white. But as another metaphor for life in photography, there is also a huge range of what lies in between the obvious. This image is one of those examples. It's not quite black and white, nor is it vibrant with color. Instead, it exists within its own spectrum of cinnamons and sepia. There is just enough color to add a sense of depth, yet it's not overwhelming enough to take away from the beautiful texture that a black-and-white image offers naturally.

Shoot It!
The next time you're desaturating a color image into black and white, see what happens when you stop somewhere in the middle.

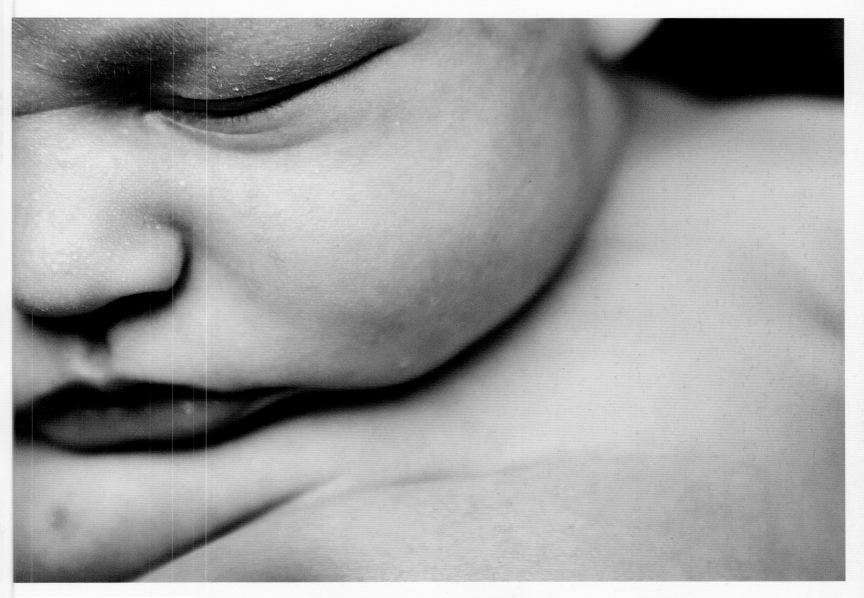

◀ **Sandy reflections** *by Irene*

When we think of processing, we naturally think of Photoshop or other photo-editing software that allows you to make changes to your image after the fact. But processing also encompasses the tools you use while creating your images. In this case, I think it's the Polaroid itself that creates the mood of the image. Polaroid pictures inherently communicate a feeling of nostalgia because of their popularity in the 1970s. The feet of this little boy could be yours or your son's, which makes it a classic representation of childhood, rather than any specific child or timeline.

▲ **Sweet dreams**

Converting a photograph from color into black and white reduces the image in the sense that it then becomes a series of just highlight and shadow. What might have been primarily seen as a tree or a door transforms in black and white into a pattern of leaves, or beautiful wood grain. In this case, I wanted the finished image to be less about a sleeping baby and more about the softness of his skin, and the folds that create soft lines that form his little features.

Shoot It!

The next time you shoot photographs of a child, deliberately shoot black-and-white images. Look for light, shape, and texture and see if this approach changes the way you look at your subjects and how it affects your images in the end.

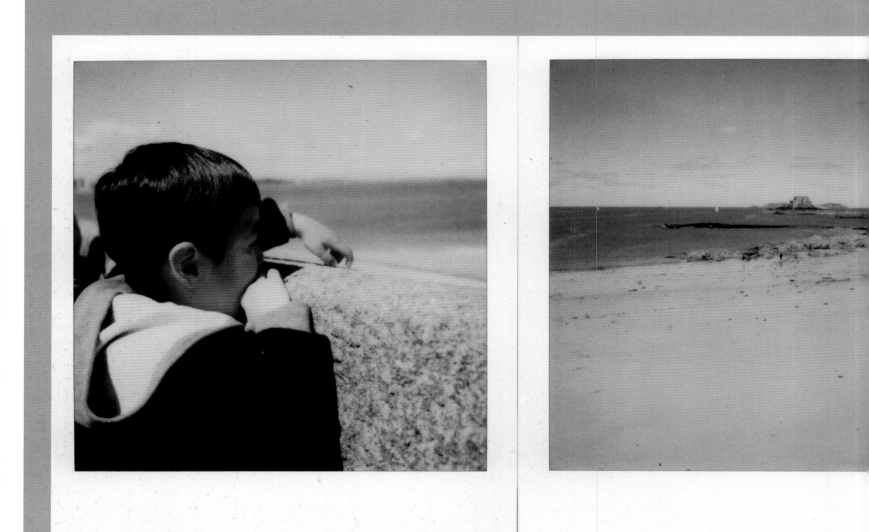

6
Stillness

Irene Nam

"Suddenly, there is inner stillness. And within that stillness there is a subtle but intense joy, there is love, there is peace."

ECKHART TOLLE

I WAIT. FIGHTING THE SCUTTLING TIDE OF BUSY PARENTS IN suits and heels, already late for work. I wait, standing on my tiptoes and straining my eyes to see my son. A little girl is playing with dolls, a little boy is clinging desperately to his mother's arm. I wait because I made a promise. I promised my son I'd be there when he finished drawing and that I'd wave at him, every morning.

A friend of mine once asked me how becoming a mother for the first time had affected my life. And I remember thinking, I should be talking frenetically, even gasping for air on occasion, about how wondrous the experience of motherhood is. My eyes should sparkle with pride as I excitedly mention fulfillment, breastfeeding, and the meaning of life, and fill up with tears as I remember the miracle of my son's birth. But what I said to her instead was "You know what? It's hard. And I don't mean sometimes. I mean it's hard most of the time."

The crowd is thinning and I can hear the distant traffic rumble down the street. I watch. Through the wide glass window, my child's head is crowned with a halo of innocence.

"I think he forgot," Louise's father says to me. Louise didn't forget and she's blowing kisses to the man whose life now revolves around her hopes and dreams. "I think you can go." Yes, I could. But I know my son. And I know that he never forgets. I wait.

Then he looks up. My beautiful boy. His face beams with contentment, his confidence restored, pouring out love and a kind of stately relief into my life. I know that I didn't fail him. And that no matter what, we will always have this.

"But there is that one moment," I told my friend, "where I am reminded of the unconditional, selfless love that I am capable of. And that moment when a wholehearted laugh, a silly joke, or the sound of little feet padding down the hall gives meaning to everything. That one moment. To know that it exists, and to live on with a better sense of gratitude and appreciation for the little things. This is how becoming a mother has affected my life."

My son waves at me. And I wave back.

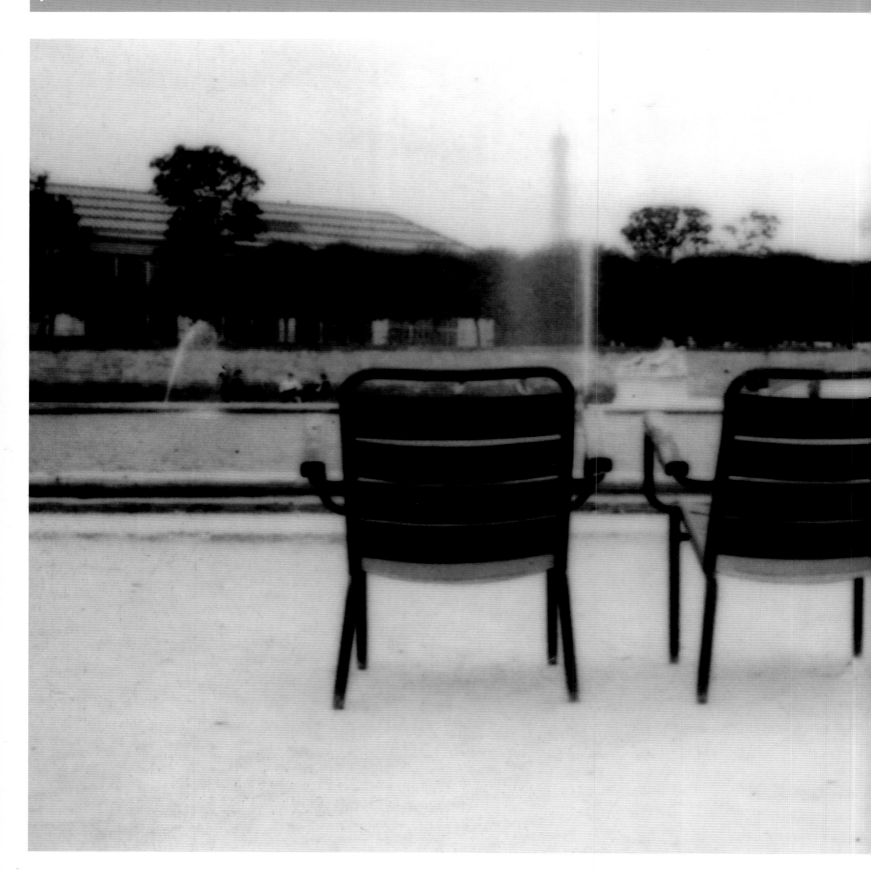

Introduction

STILLNESS IN PHOTOGRAPHY IS ABOUT THE SENSE OF PEACE AND quiet that often exudes from vignettes, subjects, and situations in our daily lives without us even noticing it. It is about finding tranquility in the way we perceive the world around us and capturing it, no matter how chaotic and unpredictable the circumstances are.

It is about that one moment when we are inspired beyond words, when clarity overflows without our questions being answered and we have certainty in the beauty of a moment and its ability to resonate far beyond the limits of time and culture—whether we're looking at a sunset over the city of Venice, laundry drying on a clothesline in the backyard, or a couple of old chairs.

Shutter Sisters' Blog
BY TRACEY

What drives me to see photographic images everywhere I look? How, when life can be messy and the world ugly, can I just put my blinders on and find beauty in even the unlikely places? Why is it impossible for me not to seek little tidbits of delight in the most mundane moments? When am I not captivated by the way light gives shape to a landscape, illuminates my children, or highlights something ordinary that sits on my coffee table?

The answers aren't clear to me and I don't really know why I'm asking. But there is something curious here. I do know I am not alone. There is a community of us for which these same questions resonate. The answers are different for everyone. For me, I believe that it is in these details of daily life that I am delivered. Where there is beauty, there is peace. If I can look around my home, jam-packed with vibrant family life (in other words, dirty dishes, toys, books, mail, shoes, a ring around the bathtub—need I go on?), and see past the chaos that often overwhelms me and discover a tiny whisper of wonder, of calm, I am transported to the place within myself where reverie lives.

◀ **In good company**
Stillness is about the joy, solace, gratitude, and sense of togetherness when a single image gifts others with the opportunity to pause, reflect, hold onto an emotion, delight in the beauty of simple things, wander freely from one memory to another, and soothe the soul.

Approach

OBSERVATION IS THE KEY TO DISCOVERING EVERYDAY VIGNETTES OF STILLNESS. AS YOU SEEK OUT THE IMAGES THAT EVOKE A QUIET, CALM FEELING, YOU'LL NOTICE THAT THEY CAN BE FOUND ALMOST ANYWHERE.

You don't need to be calm or still to find and capture stillness around you. In fact, there is often a huge gap between the dynamic of photographers' busy lives and the sense of peace that emanates from their images. Keep your attention focused on what it is that you feel—the emotions and stories that move your heart and that you want to share with others. This will center you, slow you down, and be your compass to help live in the moment.

We often take photographs that reflect where our mind is. And though our intentions are usually unspoken, they inform so much of what we unconsciously choose to do. Amidst the activity of a gathering of friends, a moment in time was perfectly distilled by the image of a boy—my son—on a swing. After spending nearly an hour playing ball, picking strawberries, and chasing the neighbors' cat, he climbed on the swing to rest a little. He was too young to motion his legs back and forth so he just sat still, totally happy. I knelt down, looked through the viewfinder for a few moments in search of the perfect angle and captured my son's feet dangling from the swing. The image that emerged after a few minutes is the memory of a simple and beautiful moment in my boy's life, and of a mother who is watching her child grow up too fast.

> **See It!**
> The subject here is an unexpected yet endearing detail of childhood at its best. Composing it slightly off-center, gives the viewer some space to breathe and room to reflect on the fleeting moments of youth.

> **Shoot It!**
> Be mindful in recognizing what is important in your life and explore the different ways to create and capture a visual symbol of it. Give your subject thought and deliberate composition to show where your heart is.

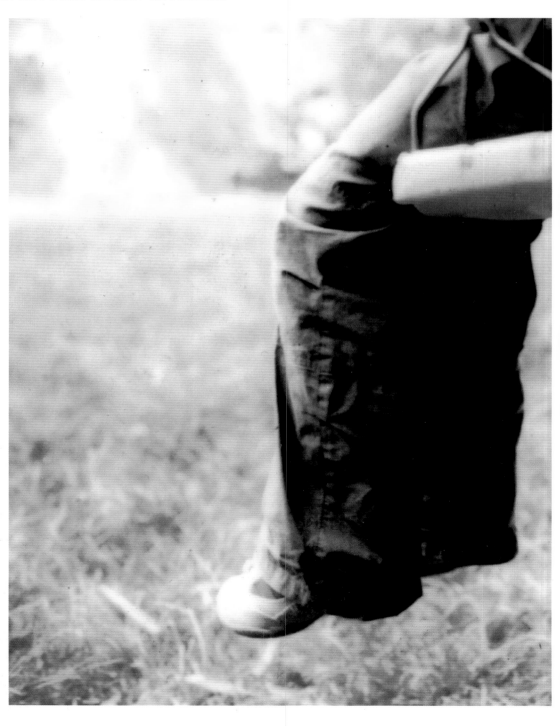

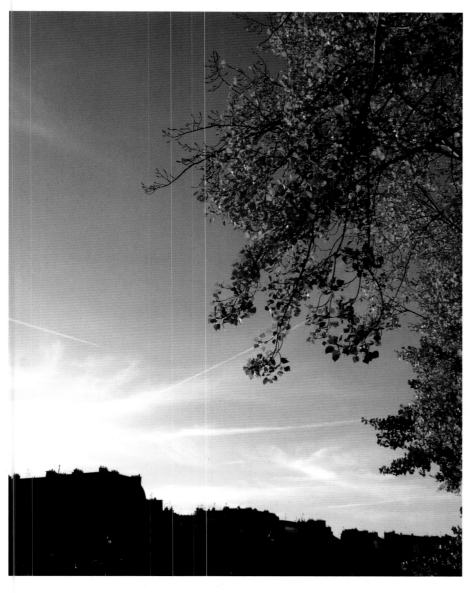

▼ Before sunset
By living in the moment, you can awaken your senses, notice the delightful and palpable energy around you and capture images of stillness.

▲ Autumn in Paris
In *Journal of Solitude*, writer and poet May Sarton wrote: "One must believe that private dilemmas are, if deeply examined, universal, and so, if expressed, have a human value beyond the private, and one must also believe in the vehicle for expressing them, in the talent." This is very true for photographers. If a moment or situation stirs an authentic emotion in you and you choose to pick up your camera to capture it, remember that your photography is not only a legitimate act of self-expression, but also an act of love that has the wonderful ability to inspire others as well.

▶ Duet
Although deliberate still-life displays often come to mind when one thinks of stillness in photographs, that's not always the case. When you keep yourself open and ready to receive and capture what signs the world has to offer, you will be surprised at what you see.

Perspective

SHARE YOUR DISTINCTIVE VISION OF STILLNESS BY CAPTURING
WHAT YOU SEE AND HOW YOU SEE IT IN YOUR IMAGES. EMOTION
WILL EMANATE FROM YOUR PERSPECTIVE.

As a Polaroid photographer I have a unique perspective on how I see the world. I think in squares, I am very aware about available light, I take my time in composing my image, and I have to really think about what kind of shot I want before pressing the shutter. At first the unpredictability that accompanies shooting with a Polaroid camera was quite overwhelming. Every time I peeled the negative off a print or waited patiently for an image to develop and appear on film, I was filled with a daunting, pervasive fear of disappointment that sometimes inhibited my desire to be more creative. Over the years, though, I've gained more confidence and a much better sense of appreciation for what this medium has taught me in terms of happy surprises, slowing down and giving myself permission to experiment and make mistakes. And it has changed my perspective.

◀ **Daisy** *by Tracey*
One of my photographer friends once introduced me to Sally Mann's work and her basic notions of photography: "Shoot what you know," and "you can find great images right in your own backyard." It's easy to forget that simple, truthful beauty emerges from ordinary things and can be found in every little corner of our homes and everyday lives. Tracey's kitchen windowsill offers views like this each morning. When we seek out the subjects that slow us down and give us perspective, what we see then becomes imbued with a sense of quality and beauty.

Set It!
ISO: **800**
EXPOSURE: **1/400 SEC**
APERTURE: **3.2**
FOCAL LENGTH: **50MM**
FLASH USED: **NO**

▶ **Solitude and togetherness**
by Andrea
Capturing images of stillness
is not so much about creating
a perfect visual as it is about
expressing the very essence
of what we are feeling and
observing at that moment. Be
aware of the space you're in. Is
it crowded, loud, empty? Take
note of all the objects you see
and how they make you feel.
The simple image of two empty
chairs can speak to us of a
universal feeling of loneliness, or
on the contrary, boast a tender
togetherness that brings an
unspoken peace and intimacy,
like in this shot of holding hands.

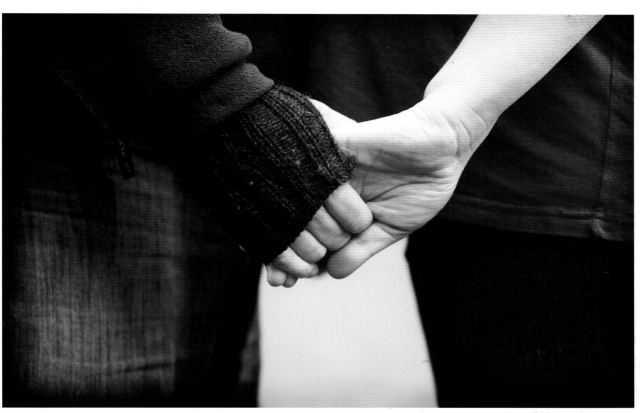

◀ **Reflection in bucket**
by Stephanie
Whenever we seek out the
details that move us and find
something that stirs our soul,
we can use a selective focus
to bring it to the forefront.
Here, Stephanie's use of
the sweet spot of focus is
especially effective in the way it
highlights the reflection on the
water and the stillness of the
moment. Instead of the bucket,
Stephanie saw the reflection.
Her perspective and how she
captured it tell a unique story.

Composition

TO SUGGEST TRANQUILITY IN A PHOTOGRAPH, DISTILL WHAT'S IN THE FRAME DOWN TO THE ESSENTIALS. DELIBERATE SIMPLICITY OF COMPOSITION IS A MUST.

How you decide to arrange different elements and subjects inside an image frame is the key to creating a visually compelling picture, especially if you want to share the sense of stillness of the moment you're capturing. Mindful compositional elements such as balance of or simplicity in the subject matter, and angles, perspectives, and focus will help you achieve your desired results.

Choosing whether you want to place the main subject off-center or capture perfect symmetry depends on various things such as the color of the sky, the space and visual elements around the subject, and what interests you about the shot. Purposefully setting your subjects off-center when composing your images will allow you to capture and reveal the emotion around them, prompting the viewer to sit up and take notice. An off-center treatment will also create a sense of continuity, reminding the viewer that the story doesn't end at the picture's edge; there's a life outside the frame. The viewer will look and want to see more.

Shoot It!
As often as possible, take a few minutes and consider different angles and perspectives before deciding how you want to compose your image. It's your chance to experiment and try something new, to expand your knowledge and skills.

▲ **Still water**
by Maile
To distill a deliberate emotion or feeling in a photograph, you must consciously frame the shot to support that end vision.

▲ Carousel
A simple shift of point of view can have a dramatic impact on your photos and open your eyes to a wide range of new possibilities.

▼ Coffee shop windows *by Sarah*
Sometimes the perfect symmetry emerging from our daily lives can create eye-catching compositions and also communicate a sense of serenity and order. Using elements like line, signage, repetition or reflection can work together or separately in creating compelling compositions.

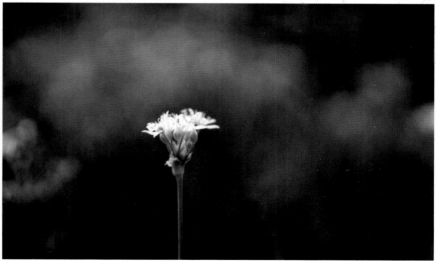

▲ Single flower *by Karen*
Keeping the composition simple and devoid of elements at the edges of your image is probably the most effective way to convey stillness, while maintaining the viewer's focus on the moment and the subject, and emphasizing the sense of peace around it. Just as one word can hold more power, meaning, and truth than an entire book, sometimes the simple image of a flower can move us in ways we had never imagined.

Lighting

SUBJECT MATTER SETS THE STAGE FOR IMAGES OF STILLNESS; LIGHTING CAN HELP SUPPORT THE EMOTION THE SUBJECT EVOKES. USE LIGHTING TO EVEN MORE CAREFULLY DESCRIBE THE STILLNESS YOU DISCOVER.

Whether it is wrapping us in a warm, gentle glow or bringing out small details of our daily life, light is inherent to the photographs we take and an essential element in crafting evocative imagery. The truth is, if you look at something and are immediately moved or inspired, most likely it is beautifully lit. And though some rules in photography are daunting and intimidating, learning some basic facts on how to use and play with light can add depth and quality to your images.

▲ **Parisian street**
Shooting directly into the sun, or having it just outside the frame, can help reveal a moment of calm and reflect warmth and a sense of quietude. This Polaroid photograph was taken on my way to work as I was stepping out of the metro station all bundled up in my favorite scarf. The day was dawning and the smell of fresh bread was wafting through the air. I closed my eyes and took a few minutes to bask in the early morning light before moving on with my day.

See It!
Here, shooting into the sun washed out the colors because the film is overexposed. Notice how the tones of the image are muted, which adds to the calm and melancholy feel.

Shoot It!
Shooting into the sun can result in sporadic and inconsistent images. The more you experiment, the more you'll find what works for you, and you'll find what you like and how to better achieve it.

▲ **Autumn in New York**
Equipping yourself with the basics on how to use and manipulate light can enhance the quality of your images.

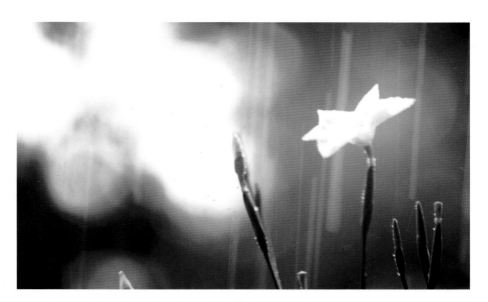

▽ Colors of the wind

Bright sunlight can enhance color and boost contrast. It can also accentuate texture and elements of composition like lines, shapes, and backgrounds. Unlike shooting into the sun, when you shoot with the sun at your back, the effect will often result in bold, vibrant color.

▶ Under the rain *by Karen*

Soft diffused light is almost always effective in creating soft-spoken imagery. Whether it's the magic hour right before sunset, when the world is painted in pinks and purples, or if the weather itself filters the light, offering gentle illumination as was the case with this delicate bloom, soft light almost always speaks of calm and peaceful beauty.

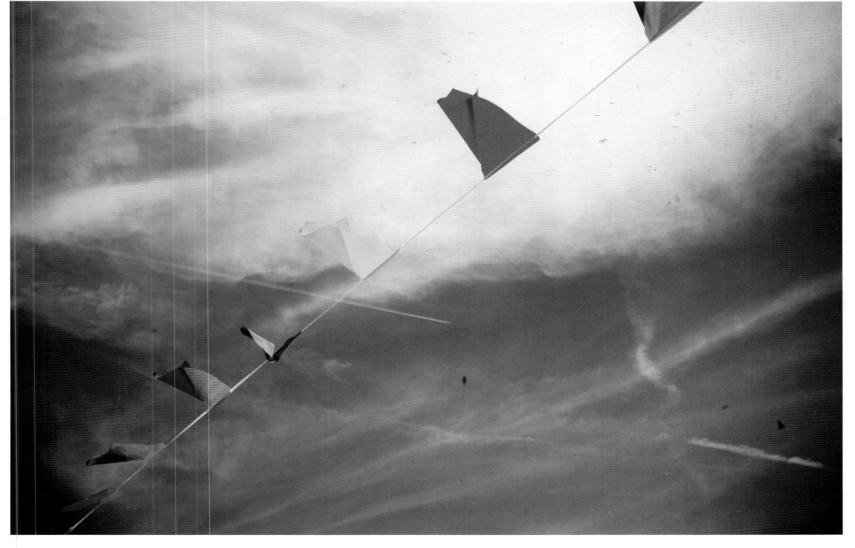

Details

NOTICING THE LITTLE THINGS CAN HELP KEEP US CENTERED. THE SIMPLEST OF DETAILS CREATE IDEAL STILL-LIFE STUDIES, VIGNETTES THAT SPEAK TO OUR HEARTS AND INFLUENCE OUR IMAGES.

In capturing moments of quiet and calm, the whispers of the details are sometimes what matter most. Calling attention to them using depth of field and focus helps express the feeling that the photographer wants to convey. When you notice something small and beautiful, an object, or even a connection, and you focus on it, you are distilling a single point of importance. You elevate it, isolating it from the background and accentuating its delicate and subtle details.

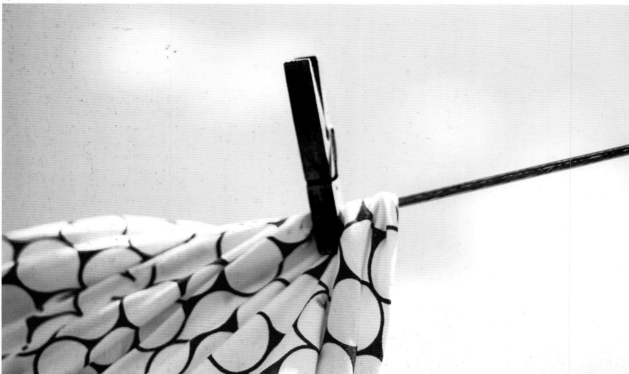

▲ ◀ **Red umbrella** *by Sarah* / **Clothespin** *by Kate*
These two still-life images are perfect reminders for us to keep our eyes open to the most mundane of details and to be mindful of how the color, shape, and mere simplicity of a subject can help achieve a most inspiring and striking image.

▶ **Unspoken**
Capturing an image of a mother and her child can speak volumes about the tenderness and trust that connect the two. The gesture of holding hands is a universal symbol of love that people can not only relate to, but feel.

See It!

The unspoken connection between two people can be powerful in its stillness. Focusing on the point of universal connection and allowing the viewer to bring their own interpretation is one way of evoking strong, yet silent emotion.

▲ **Through the fence** *by Sarah*

"The middle of February is usually a dreary time of year where I live in Chicago, a time when I prefer to curl up with a book at home rather than be outside, dissolving into the drab winter background. As I was trudging past my neighbor's house one such bleak day, I was surprised by this image of a dried-out bouquet left over from warmer months. I was struck by how beautiful it was, even in death, and how it looked so hopeful, as if it were stretching its neck and arms through that chain-link fence with its face turned upwards to the cold winter sun."

Processing

PHOTO EDITING ALLOWS YOU TO FURTHER QUIET DOWN YOUR
IMAGES. WHEN YOU KNOW THE FEELING YOU'RE TRYING TO
ACHIEVE, PROCESSING CAN HELP ENHANCE IT.

Stillness usually happens before we press the shutter button. Because it is a state of mind and not shaped by the circumstances, when we are moved and inspired by the sense of peace exuding from a scene, the image we take naturally expresses that very feeling. Yet sometimes, we come up with images that are good but could be even better "if" something else had happened—for example, if the composition was a bit different, or the colors more or less vibrant, or the details highlighted. This is when photo-editing software can help us make up for little mishaps and enhance the mood and sense of tranquility in our images.

▲ **Café Cluny** by *Stephanie*

There are many ways to heighten a sense of stillness while post-processing your images. One is to create a vignette, darkening the edges of the shot and focusing on the subject. You can also mute the colors instead of accentuating their vibrancy or add a yellow cast to create a vintage look, communicating nostalgia and charm, as Stephanie did here. Sometimes, all you need to do is turn the mode of your image to black and white, and let the enticing tonal range of whites, grays, and blacks evoke a different set of emotions, eliminating distracting color.

▲ After the party
Photo-editing software can be used to manipulate an image until you arrive at the desired result.

▶ Eiffel Tower Polaroid
There are no processing options available when you shoot with a Polaroid camera. The idea is that you get what you get, and the only way to manipulate the image and achieve the desired outcome is by better understanding your camera, and the film you use, and by planning your shot ahead. This exercise, though frustrating at times, is an effective way to explore your creativity and can work to your overall advantage, sharpening your senses and attention.

Each Polaroid camera is unique, with its own quirks and characteristics. You might need some time to get used to focusing manually and being more vigilant about the lighting (Polaroid SX-70 cameras require a lot of direct, natural light). Each year, I wait for the longer and warmer days—perfect "Polaroid SX-70 weather."

7 Documentary
Stephanie C. Roberts

"I work from awkwardness. By that I mean I don't like to arrange things. If I stand in front of something, instead of arranging it, I arrange myself."

DIANE ARBUS

THERE WAS A HUM OF ENERGY IN THE ROOM. I COULD FEEL IT when I peeked in the window and eased open the door to document a glimpse of lunchtime leisure in a classroom at Shepherds Junior School in Arusha, Tanzania. The children were seated closely beside each other on wooden benches. Clutching bright plastic bowls, they scooped rice to their mouths and chatted between a flurry of bites and glances. Entering the room, I quietly placed my audio recorder in the "on" position at the teacher's desk, then stepped before the classroom of children to survey the natural light of the interior space. Shifting my wide-angle lens to autofocus and lifting the camera to my squinted eye, a silent current snapped through the room as curious eyes turned toward me. Smiles followed and eyebrows lifted. These children, ranging in age from six to 12, were eager to be seen.

As a documentary photographer, I make my best images when my subjects are engrossed in the action of life—when they've lost interest in me and have forgotten my presence. But here, on the first day of my week-long visit to this primary school, I was unable to hide. I was the *muzungu* (white person) visitor with the big camera "from USA." My fellow Shutter Sister, Jen Lemen, and I had just arrived at the primary school to document the story of Mama Lucy Kamptoni, founder of Shepherds Junior School, and her students. As much as I wanted to blend into the background and just observe their ritual of lunch at that moment, I surrendered to the role of subject in that buzzing classroom, smiling wildly back at those beautiful children exposing their keen interest in my presence.

"Take me," a young boy insists, jumping out from under his desk, bits of rice dropping to the floor. I oblige without hesitation, then turn the camera screen towards him so he can admire his image. He responds with a proud grin and quickly repositions himself for another shot. Sparks fly as benches scratch the concrete surface, making way for eager footsteps.

"And me, take me!" says another.

"Take us," they say, throwing their arms around each other, doing all of the things I never want my subjects to do. I give myself permission to click, despite the weight of my presence in their eyes, and so our relationship begins with a wealth of grins, giggles, and goofy poses. We fall into a comfortable rhythm of clicks and poses, until I notice a flurry of activity with a collection of students toward the front of the classroom.

"What is your name?" a fiery young boy exclaims to another student, extending his index finger inches from his subject at the teacher's desk. "What is your age? Where do you stay?" he continues in rapid succession.

I ease quietly toward the lively exchange to find that this young boy had discovered that my audio recorder was on and took the initiative to begin interviewing his classmates. I can't help but smile at his bold stance and booming voice. There the students stood, completely engrossed in this young boy's line of questions, sharing their answers with excitement—eager to not just be seen, but to be heard. And as I repositioned myself to study my subjects engrossed in the action of life inspired by my forgotten device, I was grateful to go unnoticed.

Introduction

CAN YOU VISUALIZE THE EXPRESSION ON your daughter's face just before she blew out the candles on her sixth birthday? Do you remember how exciting it was to see your son's courage mount and culminate in a bold leap off a dock? Most of my childhood memories would have faded, had it not been for my mother documenting significant moments in my life with her Polaroid camera. Her camera surfaced at dance recitals and in the driveway each year on the first day of school. It captured family members seated around holiday tables and prom poses. Because instant and film-based photography had a notable cost associated with the number of exposures captured, the family camera was often held at bay and reserved to document "special" events. Each image had to be worthy and significant. But today, thanks to digital photography, we can be free to experiment with our exposures. We have the power to instantly review, delete, and re-shoot images with ease. I shoot more often because of this.

For me, the power of photography is most clearly evident in its ability to document and celebrate the significance of a single moment in time. These moments seem to most often occur when we least expect it. Naturally, my camera is on hand for those "special" events, but documenting the fascination found in everyday life with something as simple as the camera on your mobile phone can be even more compelling.

◀ **My boy's bold leap**
You don't have to visit faraway lands or witness life-changing events to practice the art of documentary photography. In fact, the closer you are to your subject and the more comfortable you are in the setting, the more intimate and expressive your images will be.

Shutter Sisters' Blog
BY SARAH-JI

Recently, I shared with another photographer my hesitation to identify myself as an "artist." I don't have any formal training in photography or fine art or even mediocre art. I'm not the type of person to spend serious time in art museums and I am more than a little bit embarrassed at my lack of knowledge of famous photographers. You see, when I take photographs, I consider my camera a documentary tool. My first thought is not about making art, but about capturing the humdrum moments that comprise our lives.

And I'm beginning to realize that I don't need better credentials to embrace my inner artist; I need courage. And by courage, I love how Brené Brown points to the original definition of courage as being able "to speak one's mind by telling all one's heart." I think that one way for me to "tell all my heart," or my own story, is through my photographs of the mundane and yet fleeting, and often beautiful moments of my life as a mom, wife, daughter, sister, and friend. These are the stories I have a compulsion to document and this is my inner artist that I have the courage to finally recognize.

Approach

DOCUMENTARY WORK IS MORE ABOUT OBSERVING YOUR SUBJECTS THAN INTERACTING WITH THEM. AS A DOCUMENTARY PHOTOGRAPHER YOU ARE MORE A "FLY ON THE WALL" THAN A PARTICIPANT.

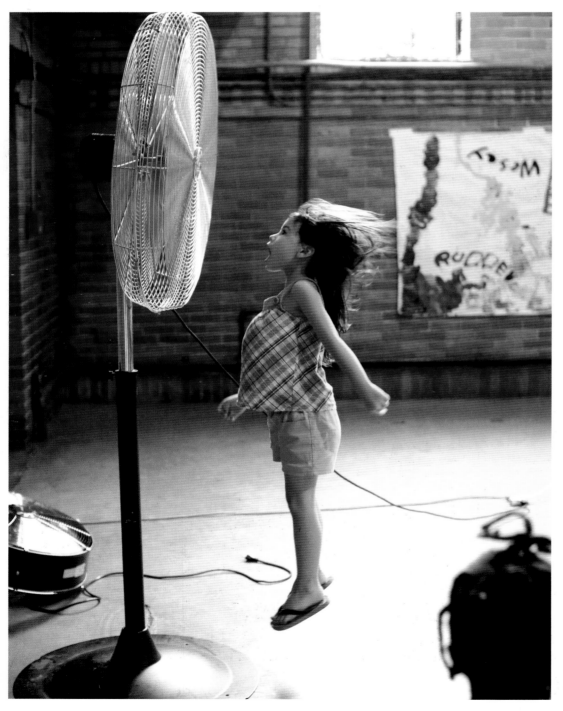

Shooting documentary images requires you to be patient and yet alert—to quickly adjust your camera to accommodate subtle shifts in light and areas of focus—and to be flexible enough to change your perspective, crafting compositions on the fly as the story unfolds just beyond your lens. Pretend you are invisible. Soak in the wide view first, then eliminate elements of the setting that are not important to the story. What you choose to include in the viewfinder shapes the intent of the story and ultimately the viewer's emotional connection with your image.

Ask yourself what's unique or revealing about the environment in the context of the story. Focus on the action and then quickly shift your eye to facial expressions or hand gestures. Watch feet. Tilt your lens. Get down on the floor, hop up on a chair, or creep in closer to see if this perspective tells the story in a more unique way. Don't be afraid to shift your body to create compositions that ebb and flow with the fluid nature of the experience.

◀ **Getting air** *by Sarah*
The secret to creating powerful documentary images is to insert yourself in settings where people can comfortably interact with each other or their environment. Sarah didn't have to ask her daughter to jump up and say "AAAAHHHH" into the fan because people, particularly kids, will simply do what comes naturally to them. Those are the true moments we seek to celebrate.

◀ Living miracle

Push yourself to places where you've never been and open your heart and mind to soak in new experiences "for the first time." Use the uniqueness of your fresh perspective to document a powerful experience—such as the delivery of this new baby.

See It!

Not only is this an emotional subject matter, the image itself is powerful in its razor-sharp focus of everything from the baby's wrinkled feet, the texture of the doctor's clothes and gloves, and also the reflective highlights on the baby's skin and umbilical cord. All of these elements work together in creating a perfectly documented, living miracle.

▲ The way it is

I made this image on the day Jen and I shared with BEST (Business and Entrepreneurship Support Tanzania), an Arusha-based non-profit organization, during our Picture Hope trip to Tanzania. We were traveling in the back of their vehicle to meet their clients, "the poorest of the poor," in remote villages. In this image, you can see the weight of the experience in Jen's expression, contrasted by the detachment of her daughter seated beside her. As you document life experiences, seek to reveal emotions that are honest and true.

Perspective

GATHERING A LOT OF INFORMATION IN A SINGLE SHOT OFTEN MEANS A WIDE SCOPE. BUT IT'S UP TO YOU HOW TO EFFECTIVELY TELL THE STORY IN ONE FRAME AND IT CAN TAKE A SPECIAL PERSPECTIVE.

As you create documentary images, perspective defines not only the vantage point of your camera—the placement of your feet and the tilt of your lens—but also the unique personal perspective you bring to the experience— the position of your heart and your mind. While there are times when an objective perspective is required to expose the reality of a subject or situation, particularly in the art of photojournalism, making images for yourself allows you to share a perspective about a subject by determining what you choose to expose in your images.

Shutter Sisters' Blog
BY JEN

We are walking on a thin muddy path that borders Agnes' rice paddy. This is the land she works with her husband in order to feed her children. Before she obtained the seed capital from BEST, a locally founded NGO, she barely had enough to survive. Her house was nothing more than pieces of sheet metal rigged together with scrap wood and rope. Now she works this land and sleeps in a simple bed in a solid house with the profits of her own labor.

I try to wrap my mind around what it takes to keep this field, this family, alive and thriving. I know I should be watching her hopeful eyes and capable hands for a sign, but all I can see is her feet. How she carefully picks her way through the muddy field, how she knows where to step, how to walk, where to stand. How the immense strength of her spirit carries her, even as the frailty of her body dares her destiny and expands her hope.

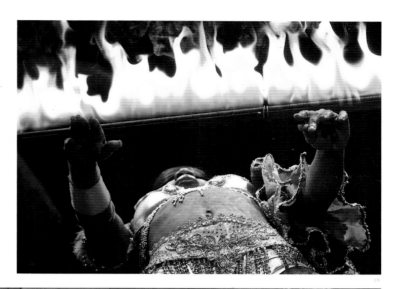

▶ Dance with fire

The position of your lens will influence the way in which the viewer consumes an experience. Creeping in close to your subject engaged in an intense moment such as this using a zoom lens lets you offer an intimate perspective without being physically intrusive or disruptive to your subject.

▼ An act of balance

The art of parenting is complex. Like a balancing act, many of us can relate to the call of an exciting career balanced by the anchor of a sweet child. Because I am a mother with a career, I could appreciate the authenticity of this moment. I could have waited for my friend to hang up the phone, to turn his focus entirely toward his son, but the reality of this moment resonated with me.

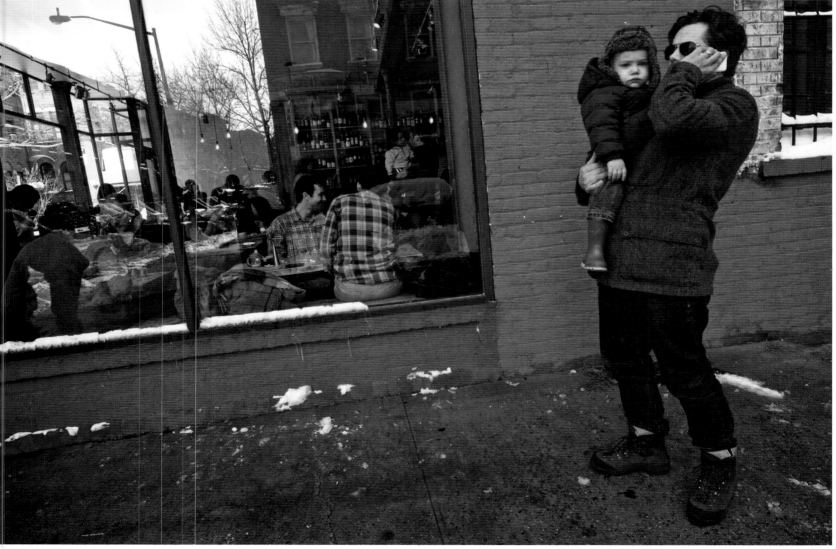

Composition

COMPOSING A SHOT THAT BALANCES THE MAIN SUBJECT WITH
SOME CONTEXT AND DETAILS OF THE MOMENT AT HAND CAN BE A
CHALLENGE AND IS OFTEN ACHIEVED THROUGH A WIDE-ANGLE LENS.

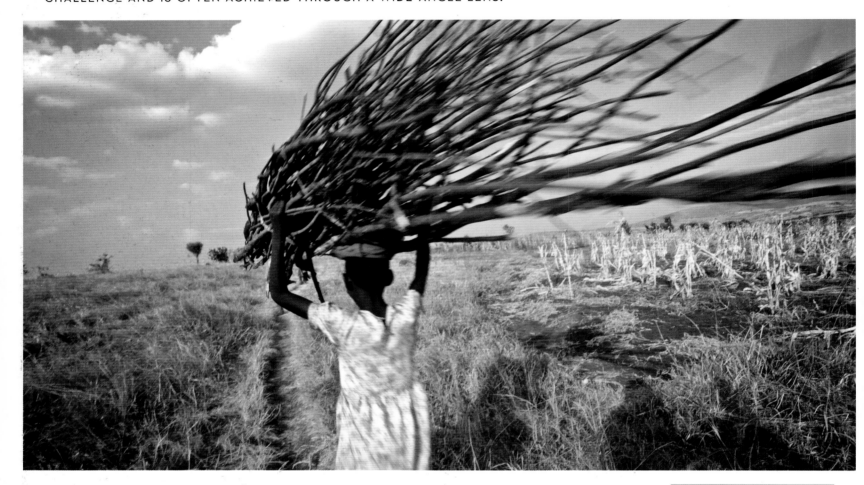

Composing documentary images most often happens on the fly, requiring you to think fast and move your body to reveal an intriguing view of an experience. (Either that or display incredible patience in anticipation of the perfect moment yet to be revealed.) Telling a good story with your image requires you to consider not only the placement of your primary subject, but also to balance that subject with details found in the setting, to place the shot in context. To do this most effectively, I shoot with a wide- or super wide-angle lens to expose as much information about the experience as I can, immersing the viewer in the space to explore the story.

▲ **Her path**

She walked toward me through the field in Rwanda. Slipping me a shy glance, she pressed past me without pause, carrying the bundle of sticks that would fuel the fire for her family's evening meal. The bundle of sticks and the narrow dirt path draw the viewer's eye to a single point of intersection just at the edge of the horizon. The weight of her shadow and mine in the lower right quadrant of the image helps to balance.

See It!
Shooting with a wide-angle lens (14mm) while approaching your subject will offer an intriguing distortion. See the sticks coming right out of this image! With the slight blur of motion and the strong diagonal of the sticks, the composition lends itself to the fluidity of this poetic daily routine.

▶ Family

Melanie's collection of pets meandered in and out of my field of vision throughout our visit. When she sat down on the covered sofa to talk about the process of making art, her dog Lucky and one of Melanie's 12 cats jumped at the chance to get close to her. I stood over Melanie and chose to include the empty dog crate and her clutter-free drafting table in the composition to give the viewer some open space to balance the intensity of this trio's connection.

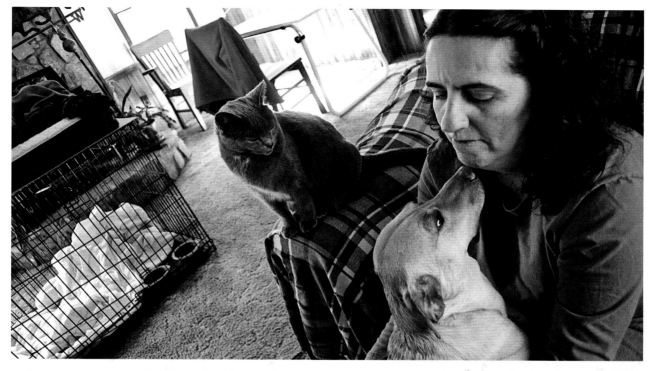

▶ Male bonding

Place the primary subject of your image off-center to give your image visual interest and consider the natural lines that appear within a setting to direct the viewer's eye where you want it to go. In this image, I placed the boys off-center and tilted my camera slightly to balance the prominence and detail of my primary subject with the weight of the stone wall. By placing the wall on a diagonal plane, your eye is naturally drawn to follow this line straight to the subject.

Lighting

BECAUSE YOU'RE RECORDING A MOMENT IN TIME WITH LITTLE OR
NO ABILITY (OR EVEN DESIRE) TO MANIPULATE YOUR SCENE, YOU
HAVE TO DO YOUR BEST WITH THE LIGHT YOU'VE GOT.

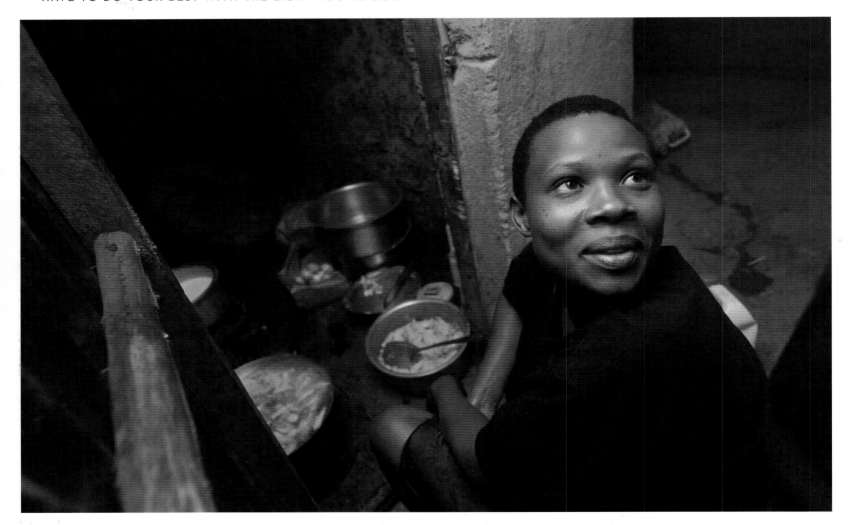

Light has the power to set the mood and shape the emotional connection between the viewer and the story as it unfolds. Images bathed in light tend to inspire uplifting feelings of hope, joy, serenity, even bliss—while images with less light convey a sense of drama, depth, sensuality, and mystery as edges fade into darkness. The more you shoot, the better you become at learning to sculpt light rapidly by adjusting your aperture, shutter speed, and ISO settings, freeing you up to follow the actions of your subject.

▲ **Betty's glow**

Because there was just one dim light bulb overhead in this simple outdoor setting and I wanted to keep my ISO on a low setting (to avoid a grainy portrait), I reached for my speedlight. Turning the speedlight, or external mount flash, to point behind me and tilting it to the left at a 45-degree angle, I bounced the light diagonally off the wall behind me to bathe Betty in a soft, warm glow of light.

Shoot It!
Using an external flash gives you the flexibility to "bounce" the flash light off of walls or ceilings. Experiment with this creative technique for softer results than using your flash pointed directly at your subject.

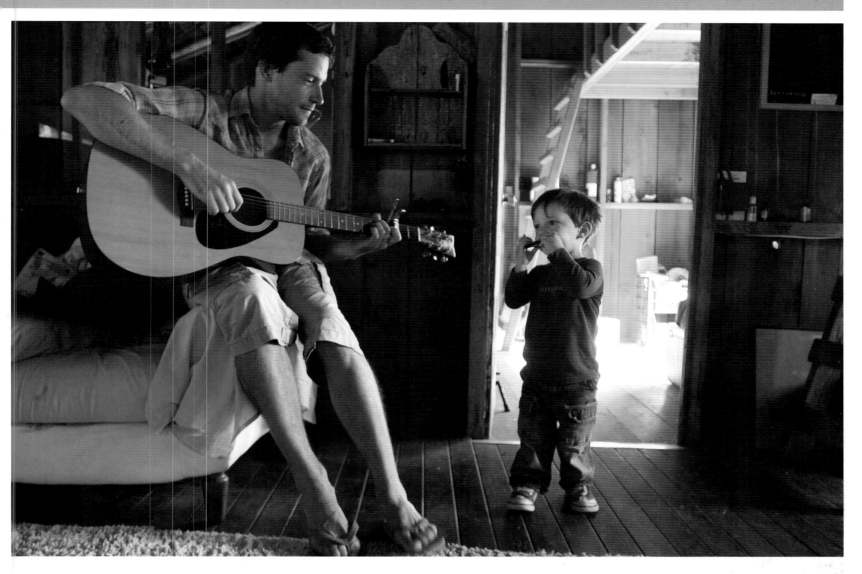

 ▲ **Jam session** *by Andrea*
Documenting life's moments inside the home often puts you in challenging lighting situations. Just remember that exposure, highlights and shadows can be adjusted with image processing, but the moment can't be recreated. Typically, when bright light is coming from behind your subject, it will place your subject in the dark, but in this case there was enough light in the foreground to offset the warm glow coming through the window in the back room. You can generate foreground light using flash.

Shutter Sisters' Blog
BY TRACEY

Despite my plans to execute our annual birthday-cake-baking ritual in the light of day (for optimum photographs of course), some years it's more difficult than others to find the time. This year, I knew that baking at night (past our bedtime even) wouldn't offer a picture-perfect scenario. Luckily, I have long abandoned my expectation for perfect so I figured I'd give it a shot (or two) and tell this year's story as it really is. We're busy. And my daughter is growing up. And although life sometimes gets sticky, it's always sweet. This shot will stand as an all-time favorite of mine. I should have remembered that when I surrender and give it my best attempt to cook up something wonderful, something yummy happens.

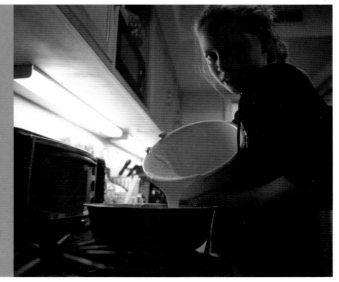

Details

WHETHER IT IS A FACIAL EXPRESSION, TEXTURE OF THE
LANDSCAPE OR CONTEXTUAL DETAILS, CLICKING THE SHUTTER AT
THE RIGHT SECOND IS ESSENTIAL IN CAPTURING "THE MOMENT."

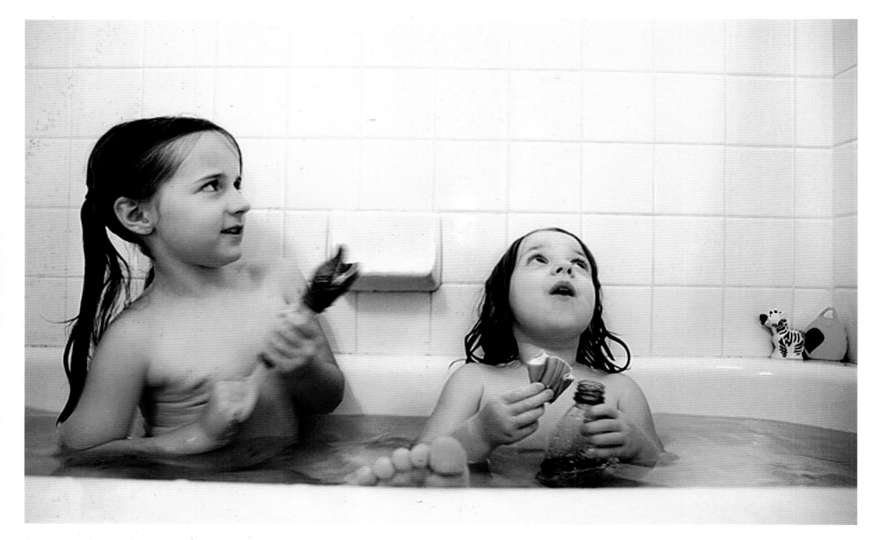

Choosing to notice and incorporate details in your documentary images helps provide context and clues for the viewer, and can often add an element of irony or humor to your images. Small details in the setting might include an odd expression on someone's face in the periphery of action, or the presence of something unique such as a turtle shell displayed over a fireplace, or a clever phrase written on the front of someone's T-shirt. Also consider details that can help reveal subtle information about your subject, such as the frayed edges of a worn sweater or skinned knees beneath too-tight shorts to offer a more authentic view.

▲ **Intrigue in the tub** *by Maile*
Successful documentary images are most often captured as spontaneous moments. But what makes this shot of Maile's so expressive are the little details she captured in the setting—tiny toes pressed up against the edge of the tub, the curious expressions of the girls' discovery of something mysterious beyond our view, and the inclusion of two small toys in the corner of the tub anchoring the composition.

▶ Beyond the window

As you consider the details of a setting, think about what they might indirectly reveal to the viewer. Shooting an image with a narrow aperture setting ensures your entire shot will be in focus, which helps give context to the story and the subject. By sharing the details of a particular space—such as a welcoming living room, toys on the floor, a pregnant woman's profile by the window—it's obvious that my friend is expecting her second or third child. It's these kinds of telling details you can reveal in documentary photography.

Set It!
ISO: **1600**
EXPOSURE: **1/15 SEC**
APERTURE: **8**
FOCAL LENGTH: **14MM**
FLASH USED: **NO**

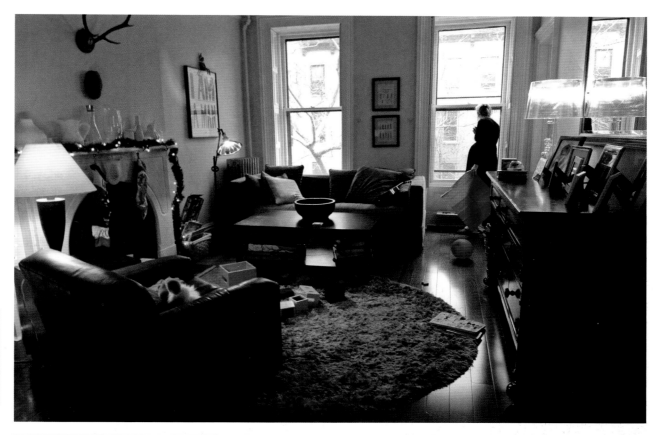

▶ Her beauty

As I moved carefully in the tight space of this beauty shop in the Remera district of Kigali, Rwanda, to study the beauty of Grace and the art of hair styling, I was surprised to see the vast variety and quantity of familiar products lining the walls of this foreign space and intrigued by the tools used to straighten and curl her hair. By using a wide-angle lens and a narrow aperture setting to focus on the details, I was able to offer a complete view of the scene here, while maintaining a focus on Grace.

Processing

WITH LITTLE OR NO TIME TO PREPARE, SHOOTING IN A DOCUMENTARY STYLE CAN SOMETIMES WARRANT A LITTLE EXTRA HELP AFTER THE FACT. ENTER POST PROCESSING.

▼ **Her light**
Processing images in black and white works well for high-contrast images and in situations where you want to emphasize an expression or a gesture.

As you study your collection of documentary images during or following a shoot, you may be tempted to delete images that appear to not work on first glance. Hold yourself back and apply a broad filter before pressing that delete key. You'll be amazed at how making some simple adjustments to the exposure and white balance can save a well-composed image made under dismal lighting conditions. Or how converting a complex scene of clashing colors can be simplified and redefined as a black-and-white image. I often go back through my archive of images—some of which I took years ago—and find something magical that I didn't see before because over time I've changed. It could be a delicate gesture, a curious facial expression, or a new appreciation for the blur of motion to convey the essence of a moment in process. Give yourself some time and space away from your documentary images so you can evaluate and process them more objectively.

▶ **Faith dancer**
One of my favorite processing techniques for documentary images is to enhance the contrast and definition to play up the gritty details and intensity of an image. I made this image of the faith dancer under really dim lighting conditions. To compensate for the lack of light and my inability to use a flash, I increased the ISO setting up to 6400 (causing the grainy texture of the image) and used a really wide f/2.8 aperture setting. By adding a substantial vignette to darken the edges of the image, I sought to pull the viewer's eye to the dancer in the center of the image.

▶ **Evening indulgence** *by Sarah*
Sarah's take on vintage processing lends emotional impact with a bit of whimsy to this honest moment in time. Its soft tones enhance the focus on her subject's full-body expression and away from the complexity of the street scene. Because the Chicago streetlights at night are generally quite orange, Sarah used a preset she created, aptly named Kinda Vintage, to desaturate all the colors by a little more than 50 percent.

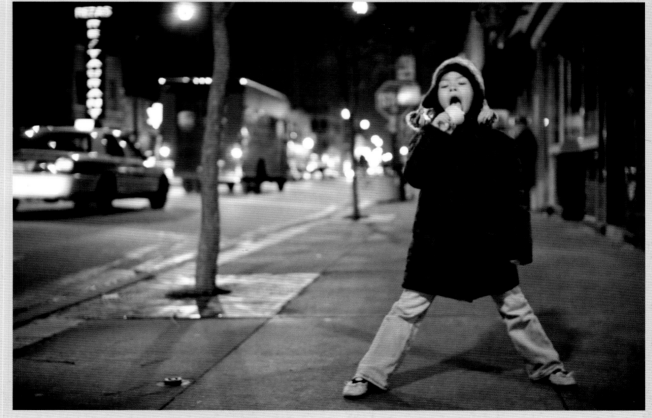

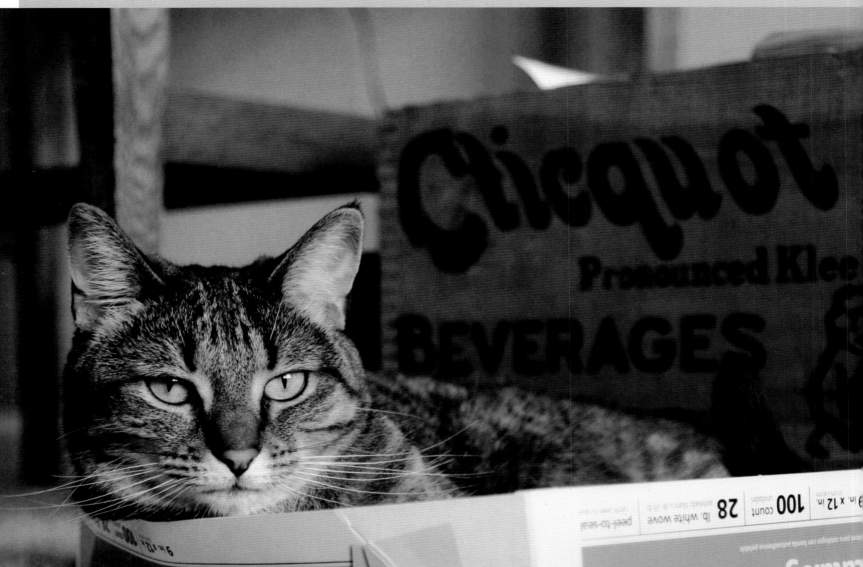

8 Creatures
Paige Balcer

"Our perfect companions never have fewer than four feet."

COLETTE

WORKING FULL TIME FROM A HOME OFFICE HAS THE POTENTIAL to be dark and lonely; days tend to stretch on endlessly with little social interaction. Needless to say, it can be difficult to stay motivated. By mid-afternoon, after many hours in front of my computer screen, I often begin to lose steam. Luckily, this happens to be about the time that my cat Roxy is ready to wake up from her eight-hour morning snooze and wander into my office to say hello. It instantly cheers me up to see her strut into the room, her tail shaped into a question mark—it's her way of saying she's happy to see me. It warms my heart when she jumps over the arms of my desk chair and into my lap, waiting for me to pet her between the ears. She continues to "help out" in my office by lying on papers I have stacked on the floor, curling up in empty boxes or containers, chewing on bubble wrap, and loudly meowing at me when it's time for dinner.

While most of the time Roxy is a bright spot in my day, I've never met a more complex animal. She gets quite playful at night and loves to chase her toys around the house. But her playful spirit can turn spooky in an instant. One night she went from chasing a ribbon to lunging at me like a flying squirrel in a matter of minutes. She is stubborn, opinionated, and moody, and often leaves me wondering what she's thinking. Almost every night as my husband and I get ready for bed, she stands in the doorway to our bedroom and loudly protests. One would think that after years of the same routine, Roxy would accept that she isn't allowed to sleep on our bed at night. This is one mysterious creature—but I wouldn't change a thing about her.

In addition to being my favorite furry companion, Roxy is also the reason I became serious about photography. Shortly after she came home as a kitten, four years ago, I became frustrated with the slow shutter on my point-and-shoot camera as I tried to photograph this new member of our family. Trying to capture a frisky, frolicking kitten was difficult! So I bought my first digital SLR camera and a whole new world opened up to me. Photography instantly became a big part of my life and gradually blossomed into a career. Since then, I have practiced my photography skills on flowers, buildings, sunsets, and people. But no subject has been more valuable to me than Roxy. She has modeled for me since day one, her personality shining through in photographs, and she has learned to deal with that strange black box that's often pointed at her face, clicking away.

Roxy is so much more than just a cat. She's my buddy, my office assistant, my model, and my moody, funny, playful friend. We have a mutual love and a strange relationship that only the two of us understand. And I am grateful to her for being the reason that photography is such an important part of my life today. She doesn't know it, but her presence has opened up the world to me, allowing me to see her—and everything around her—in new ways, through the lens of my camera.

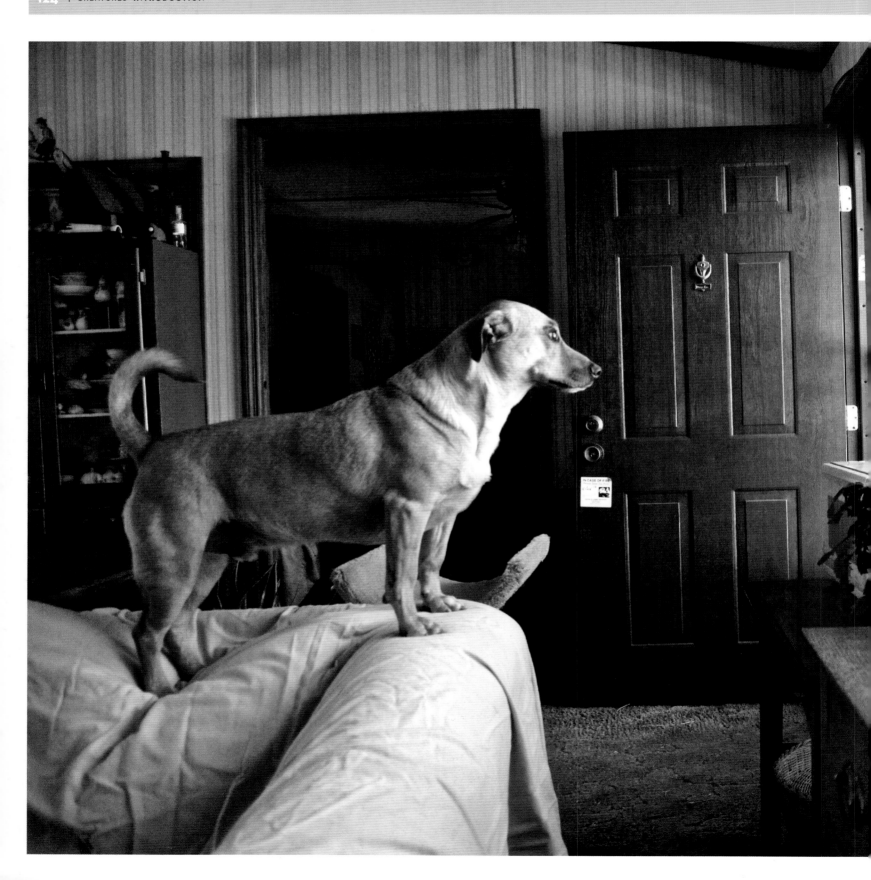

Introduction

ANIMALS MAKE WONDERFUL SUBJECTS TO photograph for several reasons; they can be cute, mysterious, funny, and full of personality. These traits can make the most interesting photographs, drawing the viewer in, piquing their curiosity or just making them laugh. More importantly, many animals play an important part in our daily lives and are often considered family.

Although animals can be unpredictable and fleeting—which is perhaps part of their charm—by seeking a better understanding of these creatures and our relationship to them, we are able to transform an ordinary animal snapshot into a stunning, meaningful image.

◀ Watchdog *by Stephanie*
This black-and-white image tells a poignant story about Lucky. By capturing the subject's stance— poised and on lookout—Stephanie is able to convey the intensity, strength, and unwavering loyalty of her friend's canine companion.

Shutter Sisters' Blog
BY STEPHANIE

Shooting the personal spaces of creative individuals is such a thrill for me—like getting a peek behind the magic curtain. Several months back I spent the day with my friend Mel in her home, capturing images and video of her, together with her paintings, and her diverse assortment of once-stray pets. Mel's dog, Lucky, commanded attention that day and worked his way into nearly every image I made—wagging his tail, jumping on furniture, and pawing at Mel as she spoke and pulled out paintings from her too-full flat file. At one point, his nose literally touched my lens.

"When I first brought him home, I thought, gosh, I don't know about this one. He's pretty intense," Mel confessed with raised eyebrows and a chuckle. She told me the story about how she had found him in an abandoned pen on a piece of property near her farm. The neighbors had moved and left him behind without food or water. Seeing him here, pictured on his throne with a clear view of his new domain, reminds me how lucky we are to have people like my friend Mel in this world.

Approach

PERHAPS THE MOST UNPREDICTABLE OF ALL SUBJECTS, THE CREATURES NEAR AND DEAR TO OUR HEARTS DEMAND PATIENCE, PERSEVERANCE, AND A QUICKNESS OF HAND TO CAPTURE THEM ON FILM.

Depending on the relationship between you and the animal you would like to photograph, it may be necessary to alter the way you approach the scene. First, think about what you want to achieve with your photograph. Are you imagining a documentary style? A pet portrait? A macro shot? Consider the style of photograph and consider the animal.

To capture shots candidly, "being invisible" is important. A zoom lens can help. Animals are very alert and aware of their surroundings—they will definitely take notice of you if you are too close. Imagine what would happen if you got within ten feet of a dog and knelt down. That's the surest way to give him the idea that you want to play. You'd blow your cover and your lens might get a slobbery kiss. And I know from experience that if you get too close to cows, they will slowly turn and walk away.

▶▼ **Face to face / Boy's first fish** *by Kate*
Because our relationship between animals and people can vary greatly, telling the story of the connection can stir emotion. In this photograph of a child staring in wonder at a captive gorilla, we immediately feel the curiosity, contentment, and connection. Or in the case of Kate's young, proud fisherman the story is totally different, and yet each image holds its own wonder and magic.

> **Shoot It!**
> *Set out to spend some time doing a portrait session with your pet. Pay attention to the light. Find a place to shoot where you can see the catchlights in your pet's eyes and fire off a number of closeups. With dogs, a high-pitched sound often gets an endearing and expressive head cock. Quintessential head shots of pets are always a treasure.*

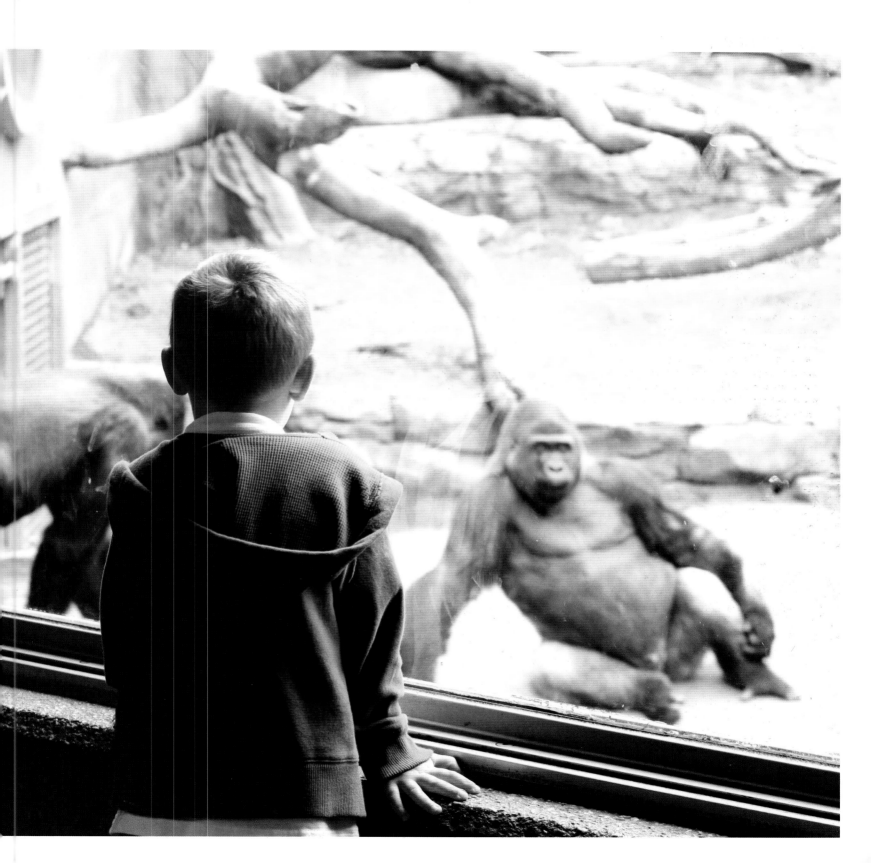

Perspective

CREATURES EXIST ON A TOTALLY DIFFERENT EYE LEVEL THAN WE
DO—SOMETHING TO CONSIDER AS YOU PLOT OUT AN EFFECTIVE
AND CREATIVE USE OF PERSPECTIVE IN YOUR PHOTOGRAPHS.

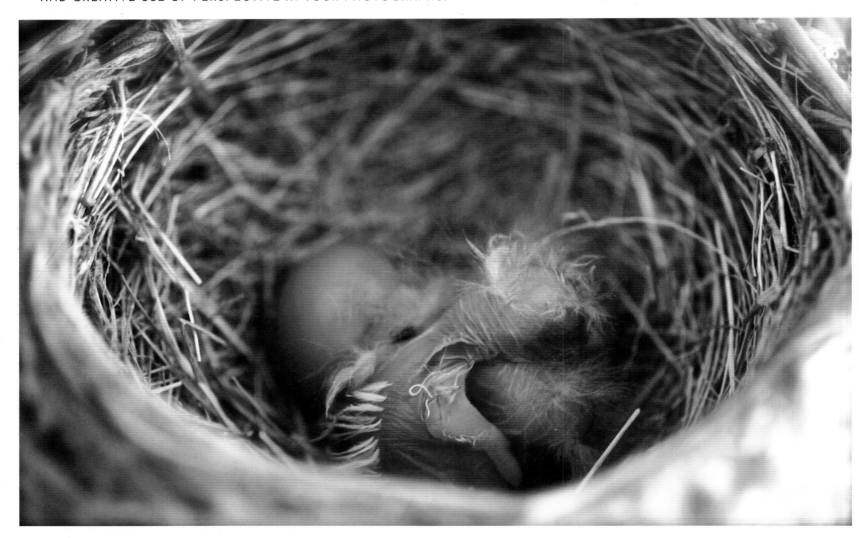

Whether it's a cat lying in a ray of sunshine, a robin sitting on a fence, or a dog frolicking around in the backyard, animals often display behavior that is typical for their species. So how can we capture the essence of an animal while still creating a unique photograph?

Attempting to tell the story of your animal subject is an integral part of capturing a compelling photograph, so why not follow the animal's cues? Considering the animal's point of view and how it might see the world can help give you a unique perspective. Combining that with what you are bringing to the shot can often lead to the kind of images that stand apart and capture the true emotion of the creature you're focusing on.

▲ **Bird's-eye view** *by Jen*
This photograph of these newly hatched baby birds is breathtaking. What a special moment we have been invited to witness as these brand new babies snuggle together and wait for their sibling to be born. Jen was able to capture this moment perfectly by filling the frame with the nest and getting a nice tight shot from above. It really gives us the feeling that we are witnessing a sacred moment in nature.

▶ **Goofy goat** *by Andrea*
One way to play with perspective is to utilize a wide-angle lens. Using a wide-angle lens up close tends to warp the image in the foreground. This subtle distortion can accentuate the humor and absurdity of our companions. The wider your lens and the closer you get in proximity to your subject, the more bowed your image will appear. The goat's expression is endearing here, but the humor is accentuated by the wide-angle perspective of the shot.

Shoot It!
Use your lens at its widest setting (24mm for example) and get in close to your subjects. Or better yet, let them approach you. As they do, focus and shoot. The closer they are when you shoot, the more distortion there is. Beyond expression, this is what adds humor and interest to shots of our furry friends.

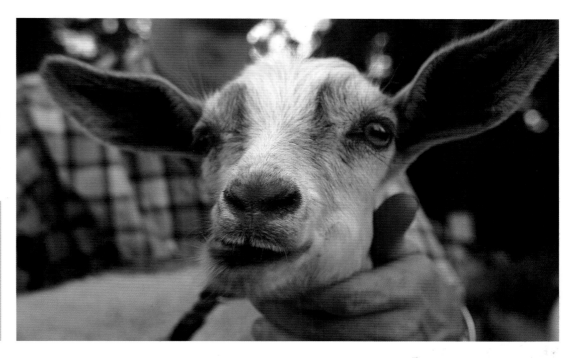

◀ **Pigeon perspective**
Sometimes an image takes on an otherworldly quality. I took this picture in a touristy part of Chicago, where pigeons are tamer than most family dogs. Typically I wouldn't be interested in taking a picture of them because they are a mundane, everyday sight to me. But something about this image made them look like alien birds walking on the moon. The low angle, shallow depth of field and near lack of color (although it is a full-color photograph) brings a strange yet interesting feeling to the image. A perspective like this is unexpected and out of the ordinary, which suggests a new, uncommon reverie to these common creatures.

See It!
So many elements of this shot work together to make it successful (and mysterious). The vast negative space in the foreground glows in contrast to the black background, while the curved lines and texture of the pavement add interest. The birds' positioning in the frame, their lack of clarity and their near-frozen stance makes for a strong composition and heightens the mystery.

Composition

PHOTOGRAPHS OF ANIMALS CAN END UP LOOKING LIKE SNAPSHOTS UNLESS YOU USE CREATIVE COMPOSITIONAL TRICKS TO HELP YOU BETTER TELL THE STORY OF THESE QUIRKY YET ENDEARING SUBJECTS.

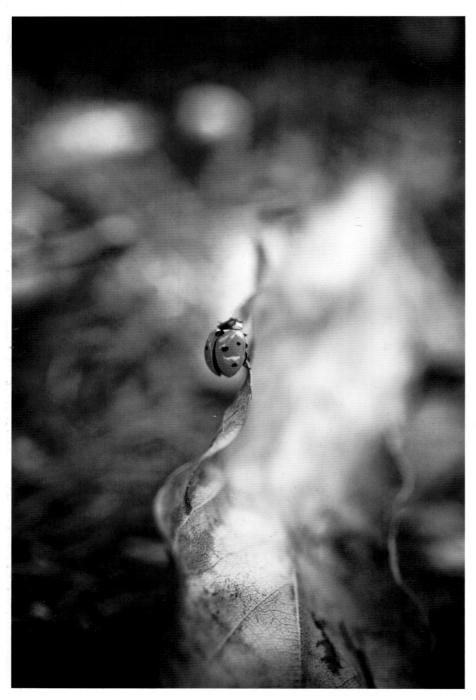

One of the first subjects I learned about as an art major in college was composition. Learning how to properly compose is one of the basic principles of fine art. All art relies on composition as the starting point of a great piece. That being said, spending the time to perfectly compose your shot isn't always possible when a dog is running toward you or a bug, like the ladybug Tracey discovered, is scurrying about. The best thing you can do is to get familiar with the "rules" of composition—and then break them if need be.

▼ **Farm dog taking a break** by Sarah

One of the ways to achieve a great composition is to follow the "rule of thirds." In other words, split your image into thirds and place your main subject on one of the imaginary lines. You'll notice in Sarah's shot of the farm dog that his nose is about a third of the way from the bottom. That leaves plenty of room around the dog to create a sense of space—with the added benefit of showing some context with the barn in the background.

Shoot It!
Choose your subject and lock in the focus by pressing and holding your shutter button halfway down. Keeping it held down, recompose your shot to follow the rule of thirds. You can begin by using this deliberate approach until eventually it will become second nature.

Set It!
ISO: **400**
EXPOSURE: **1/200 SEC**
APERTURE: **1.8**
FOCAL LENGTH: **30MM**
FLASH USED: **NO**

◄ **Little lady** by Tracey

Although this small creature was captured right in the center of the frame, it doesn't lack visual interest. Tracey tenderly framed her delicate subject using a shallow depth of field, which draws your attention directly to the ladybug. Beyond that, the texture and color lend themselves to this simple, yet strong composition.

▼ **Two shaggy sheep** *by Kate*
In this shot the placement of the two sheep creates a kind of optical illusion. The two similar shapes on each end of the frame are equally balanced and the frame has been split with an interesting line of negative space between them. The image boasts not only a curious personality (or two), but visually pleasing composition.

▶ **Cat crop**
A tightly cropped image is a fabulous way to show the most intriguing features of an animal. Something that might even turn your focus away from an expressive face and share a totally different side of the story. By cropping an image, like this one of my cat, we are forced to focus on the item in her paws, which not only creates a perfect illustration of her favorite toy, but offers a strong compositional choice through unusual cropping. The white negative space that anchors the shot offers a balance to the color, texture, and content of the top half of the frame, which together works nicely.

Lighting

SINCE YOU'LL OFTEN BE WORKING OUTDOORS FOR THESE SHOTS,
CONSIDER HOW TO USE THE LIGHT YOU HAVE TO HELP GET YOUR
ANIMAL'S UNIQUE PERSONALITY TO SHINE.

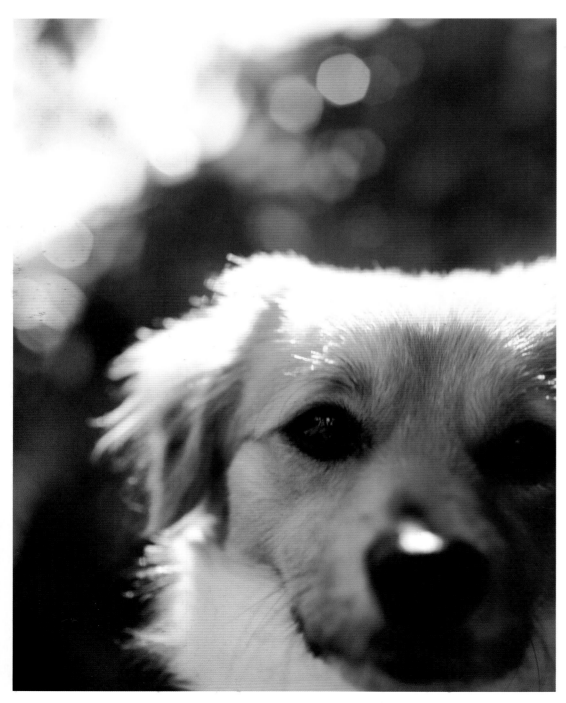

Photographers are always considering light and lighting conditions when shooting. But you may not have the luxury of choosing a specific location to pose your beloved animal friends. Arming yourself with knowledge of different lighting scenarios will certainly help when the time comes to capture an attention-grabbing creature.

To highlight an animal's fur, use backlight. As the light comes from behind my cat, it illuminates a halo of fluff. When shooting into the light try to use a Manual mode, as Auto mode can read the light wrong and suggest an exposure that doesn't create the effect you're after.

◀ ▶ **Sparkling beauty** *by Tracey*
/ Bird with bokeh *by Sarah*
What is it about that soft, blurry light known as "bokeh" that can give a photograph such a magical quality? Tracey's dog portrait is a perfect example of how to accent a pet photograph with beautiful bokeh. Leafy trees offer dappled or spotty light, so placing them in the background can help in finding this kind of circular bokeh. The sparkly background acts as a playful backdrop and balances out an unconventional composition. Sarah captures it in her shot of a young fowl in a similar way.

Shoot It!
The trick to capturing bokeh like this is to set your f-stop as low as you can, then focus on your animal, making sure you've allowed some space in the frame for the dappled light in the background. If you want your circles of light to get smaller, change your f-stop setting. Experiment to find what you like best.

Set It!
ISO: **100**
EXPOSURE: **1/200 SEC**
APERTURE: **3.2**
FOCAL LENGTH: **50MM**

▶ Sunlight halo
Here I needed to find the perfect exposure
between my subject and the background; to
highlight the edges of my cat's body and get
some detail into the background I set it manually.

Set It!
ISO: **400**
EXPOSURE: **1/250 SEC**
APERTURE: **2.5**
FOCAL LENGTH: **50MM**

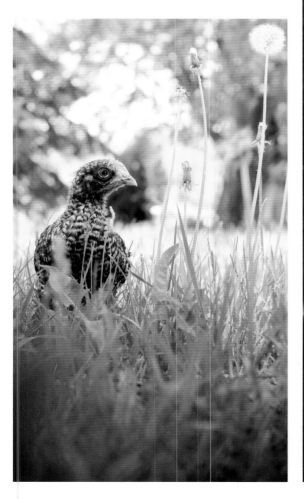

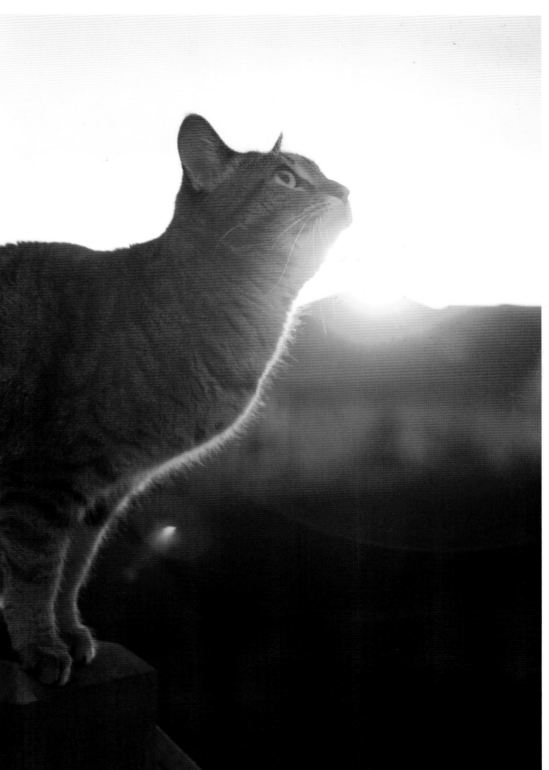

Details

DETAILS ARE THE SMALLER PIECES OF THE BIGGER PUZZLE. WHETHER YOU'RE SHOOTING AN INTRICATE INSECT OR A LITTLE SNIPPET OF A MUCH LARGER ANIMAL, DON'T OVERLOOK THE DETAILS.

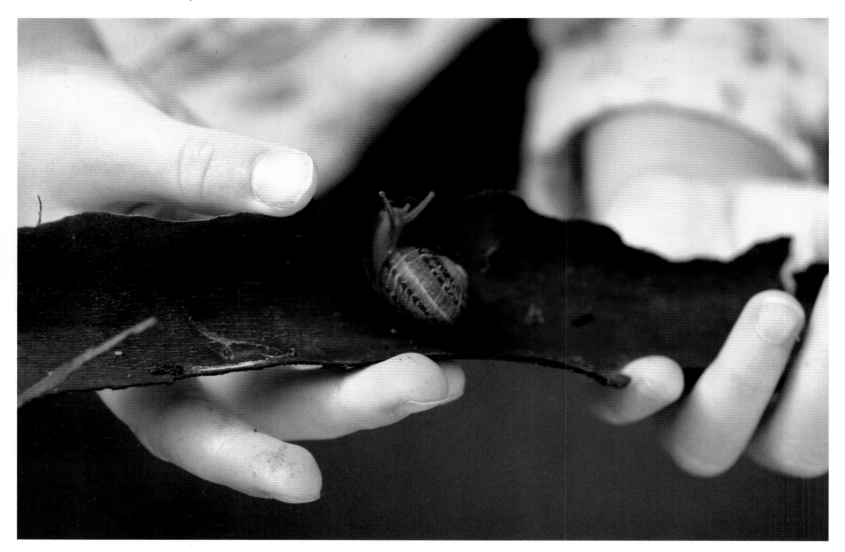

There are so many interesting creatures in this world, large and small, that deserve to be noticed. We could probably all slow down a bit and take a closer look at the living things that surround us. A tiny snail, a lone bird high in the sky, or the fuzz around a horse's mouth. These are the details that remind us of what makes up our earth, the beings that bring life to our life.

▲ **Tiny wonder** by *Tracey*
Children are often more aware of these details than we are, as Tracey's daughter proves here. They curiously seek out these creatures, helping us bring our attention to small yet significant things.

See It!
What we see in this shot is a celebration of texture and color. There's a lot going on here with all of that yet the muted gray background balances the other elements, maintaining a feel of simplicity, and at the same time offering the perfect canvas for showcasing a reverie of tiny wonders.

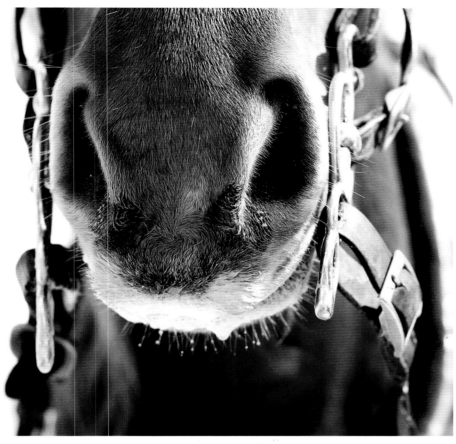

◀ **Fuzzy horse muzzle** *by Kate*

Horses are large, strong animals with such gentle dispositions. Kate has perfectly captured that juxtaposition in this image by closely focusing on the soft fuzz around this horse's muzzle, while still using perspective to show the height and power of the animal. It's details like this that really show the essence of the animal.

▼ **A little love** *by Tracey*

"It didn't take long for the newest member of our family to work her way into our hearts. And she has quickly become one of my favorite photographic subjects. Like I did with my young children, I chose to capture elements of her that to many might go unnoticed in the hope to visually narrate the story of not only who she is as a dog, but who she is as a part of our family and what she means to us. When she lays down with her paws extended in front of her, her legs create a perfect heart shape. That detail says it all in terms of her importance within the family."

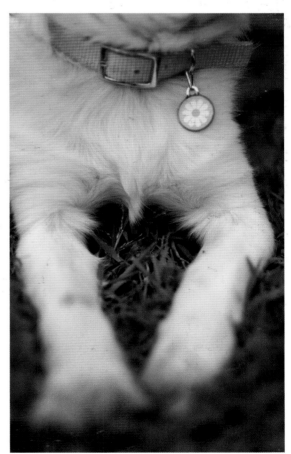

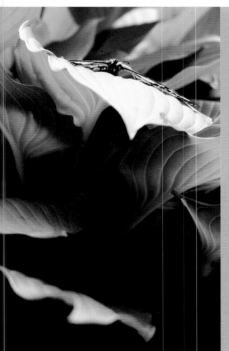

Shutter Sisters' Blog
BY KATE

"They only live for ten hours, you know, or three days, or barely a week, or something like that," said Justin to me gently, puzzled as to why I stood there with the ailing butterfly in my hand. And I thought, "Well then that's a lifetime and a whole new way to think about ten hours or three days or barely a week."

"You are good and beautiful, and perfect," I whispered to the butterfly as he wriggled faintly, beaten by a broken wing. He seemed to be listening. "You go on to be an elephant or a brook trout or a tiny baby boy, and have fantastic adventures of a whole new kind. You take your glorious yellow with you, thread it into your next soul so we all can admire it forever."

This morning I went back to the hosta and he'd been blown by the wind into its stem forest. I righted him, delicate as he was, already having lost the moisture and suppleness of life, and spoke to him again, but this time he was elsewhere, and all that seemed left was just his shell.

Processing

ANIMALS' BODIES DISPLAY RICH COLOR AND EXTREME TEXTURE—THE STUFF POST PROCESSING WAS MADE FOR. PLAY UP THE PARTICULARS WITH EDITING TOOLS.

The options are endless in the digital darkroom. The mood of a photograph can greatly be played up with a little extra post processing. Photographs of animals are often rich in texture, whether it's because of fur, feathers, scales or wrinkles, and will pop even more with a little added contrast or color.

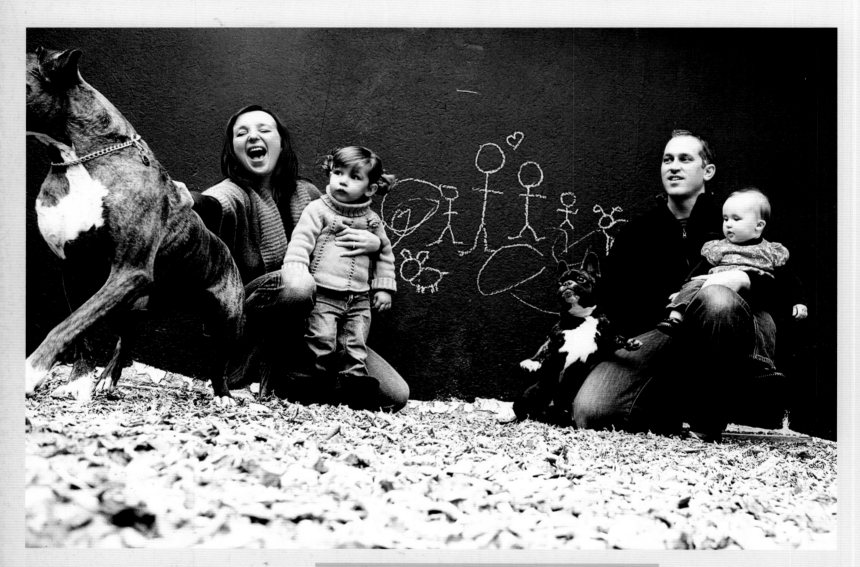

▲ **Funky family portrait** *by Maile*
This candid photograph clearly shows a fun and energetic family. The movement and composition are fabulous, but what really gives this shot an extra pop is the way it was processed by Maile. Increased contrast and saturation, coupled with vintage-feeling colors, work wonderfully in this instance.

Shoot It!
Maile shared her technique: "I used a Photoshop action to process this image. First, I increased the contrast. Then I applied a favorite 'action' I use called 'Pool Party' and lessened the opacity to 30 percent. This softened the contrast, and then slightly muted the overall look of the image. I then sharpened the image using Photoshop, which is how I finish off most all of my images."

▶ **Rustic roost** *by Sarah*
One of the magical things about post processing is the way that it can enhance the mood of a photograph. Sarah has given us a peek into the world of a roosting chicken and enhanced it with warm, deep colors and a rich vignette.

▶ **Black-and-white beauty** *by Karen*
One of the quickest ways to transform a photograph is to convert it to black and white. This works well with highly textured subjects, making it a perfect method to use on animals. Notice the deep wrinkles in this elephant's face and how they are enhanced by the wonderful contrast of the black-and-white conversion. It's hard to imagine this processed any other way.

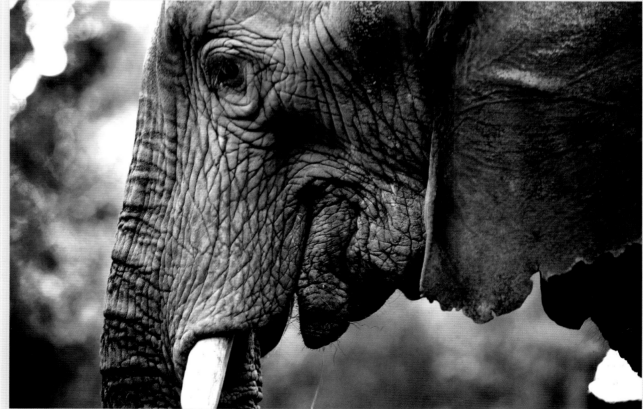

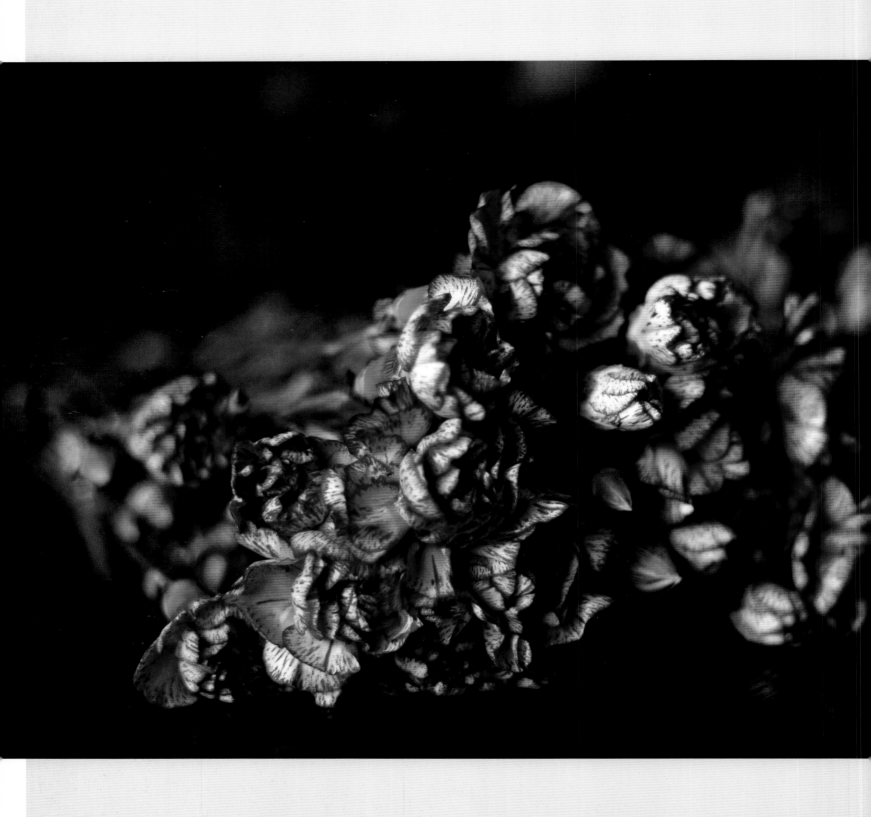

9
Table

Karen Walrond

"I'd rather have roses on my table than diamonds on my neck."

EMMA GOLDMAN

I LIVE IN THE UNITED STATES, BUT MY HUSBAND MARCUS IS FROM England. Every 18 months or so, our family travels to Cornwall, his home county, to visit his family and therefore, every 18 months or so, I visit my very favorite kitchen table in all of the United Kingdom.

There is a kitchen table I love which sits in the tiny kitchen of a 500-year-old farmhouse that belongs to Marcus' auntie Pam and uncle Pete, two of the warmest people in the land. I believe, however, that even prior to their ownership, only people with really lovely souls owned this home, for every time we visit, the house itself seems to welcome us.

As soon as we arrive, we all troop into the kitchen for the ever-ubiquitous cup of tea. It's a tiny kitchen: it can't really hold more than five people comfortably (and most of them had better be sitting at the table, so as not to get in the way). Pete pulls out enough mismatched mugs from the handmade cabinets for everyone and immediately puts the kettle on; the rest of us squeeze in around the table. As Pam searches for cookies for us to have with our tea, my daughter Alex and I watch as Marcus endures teasing from his family about the few additional gray hairs he's earned from his last visit. He takes it in his stride, knowing it's a sign that his uncle and aunt are indeed very happy to see him.

Finally, mugs steaming, Pam and Pete join us at the table and we really get down to the business of catching up on each other's lives. Pete built this table himself and its rough-hewn surface holds our tea, cookie crumbs, a vase of flowers from Pam's garden, and all our stories from the past year and a half. Here, we celebrate each other's triumphs and empathize with each other's disappointments. It is at this table that the bonds of our family are strengthened, far-flung though we may all be.

Later, it occurs to me that even though I hold a special fondness for that kitchen table in England, the truth is that it is around tables like these all over the world where some of our most meaningful moments occur. In addition to nourishing our families, we do our hard work at tables, as well as our hard play. We use tables to make simple altars, signifying people or places or ideologies that are important to us. We write journals, letters, notes, take messages; we laugh, commiserate, rejoice, and show our love around tables. It is no wonder at all that artists and photographers since the beginning of time have always loved capturing the moments that occur on and around tables. It's no wonder I do. Because even taking a simple photograph, capturing the flowers from Pam's garden, can bring me back to a beautiful time at her kitchen table.

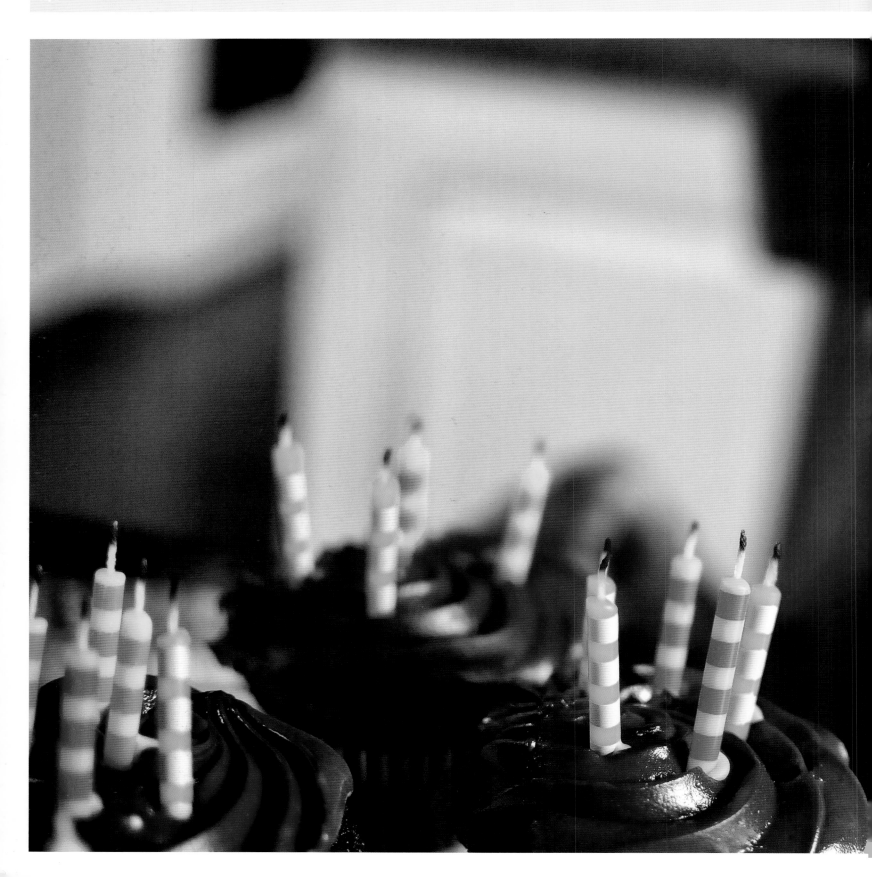

Introduction

READING, WRITING, EATING, CELEBRATING, organizing, remembering—chances are we've done all of these things at or around a table. We work, we play, we groom, we cook, and we eat at tables. All of these things—these tiny, simple, ordinary, and yet extraordinary moments—weave together to create the fabric of our everyday lives. Photographing these moments not only helps us preserve our own memories of the events, but it also creates a record for our families and friends who come after us, enabling them to catch glimpses of our present-day worlds.

As you use your own unique perspective in shooting these types of images through maximizing photographic style and approach, you tell your own story. Our tables are more than just a collection of items sitting on a horizontal surface. What we collect, arrange or even stack up on our table has meaning. As you begin to see these shots as they really are—a narrative of how you choose to live, what you love, and how you gather together—you'll never look at your kitchen table in the same way again.

◀ **Chocolate celebration**
It was my husband's 40th birthday, and my daughter Alex and I bought cupcakes with brightly-colored candles to celebrate his big day. I wanted to capture the colors of the cupcakes, but as I was framing the shot, I realized that Alex had already tucked into one of them. So I readjusted my perspective to capture her gusto. The result, instead of just a pretty picture, tells a story.

Approach

HOW YOU SEE "THE TABLE" WILL ALWAYS BE INTERTWINED WITH FEELINGS AND A DEEPER MEANING, WHICH WILL IN TURN INFLUENCE HOW YOU SHOOT IT.

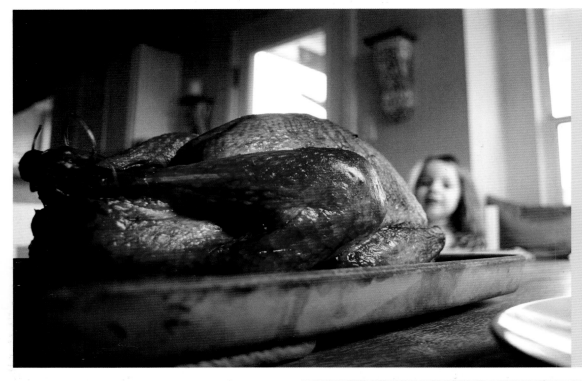

Shutter Sisters' Blog
BY MAILE

There are so many ways that one can fall into the perfection trap around the holidays. In the past, I've built Thanksgiving up to be an unattainable figment of perfection. I rarely hosted for fear that I wouldn't have the right ladle, or butter knife, or other perfect plate or dish. The performance anxiety was just not worth it. But as I get older, those things matter less. I'd like to say that if you're the kind of person who judges me by my utensils, then I'm sure we're not compatible. (Especially since it's only recently that I stopped feeding my children out of boxes.) It also goes deeper than that. The world lately has been filled with so much uncertainty; these are concerning times. But they're also a blessing because they nudge us to find and focus on the things (which are usually not things) that we are certain about.

The concept of "the table" is much more emotional than it may seem. Our lives often revolve around our tables. It makes sense that each photographer will approach the imagery around a table in his or her own unique way. Even the simplest of table photographs captures a story or an emotion—and from this point of view, photographing your tables and gathering places can lead to enchanting results.

For me, one of the best moments in life is when family and friends approach the dinner table in anticipation of a delicious meal. In general, people are all smiles, eagerly awaiting the feast; they laugh and graciously hold chairs out for each other, they ooh and aah over the cook's work. It's a lovely moment and one of my favorites to capture with my camera. But to do it properly, this usually means taking a few seconds to step back, really look at the scene, take a deep breath, and be really mindful of my emotions and feelings before I actually squeeze the shutter on my camera.

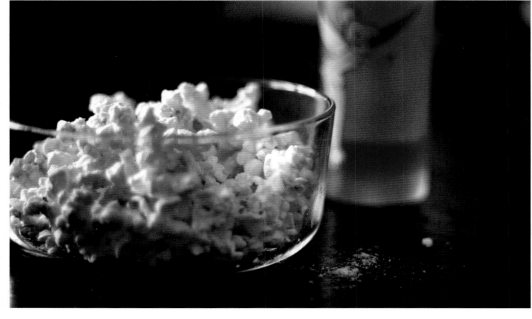

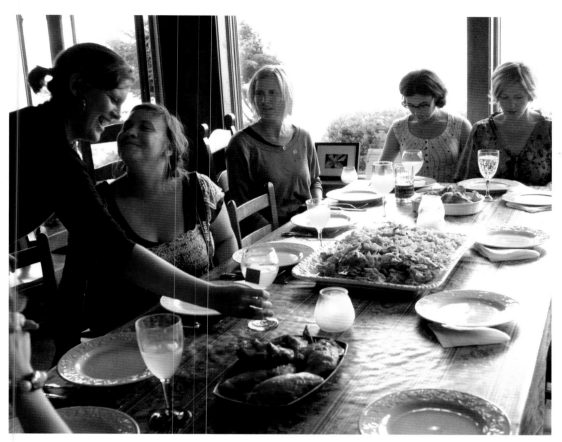

◀ New friends gather around the dinner table

A few friends gather together here for their first meal of the weekend, in what would be their home away from home for the days that follow. It's obvious that the ice had been broken (somewhat aided by rum punch) and the prospect of the days ahead had everyone feeling particularly energized. And while the photograph shows the order of the clean dishes waiting to be filled and all the glassware, dinnerware, and cutlery in the shot is placed just so, what you really notice is the energy among this group of women, the shared respect and admiration, and gestures that reveal that they are really happy to be together.

▼ Quiet breakfast *by Andrea*

At first blush, this seems like such a simple tableau—a boiled egg, a crumpled napkin. But looking closer, we see that what makes this image interesting is the *texture*: the crackled surface of the yellow table, the raised pattern around the edge of the plate, even the smear of lipstick on the crumpled napkin, telling us that the person enjoying this quiet meal—presumably the photographer—is a woman. A beautiful example of how color, composition, and texture—even in a simple image—can tell a story.

Shoot It!

Notice the little rituals in your own daily life. You can either compose a still life of the subjects you'd like to include or shoot just as it presents itself with little interference. Either way you're documenting a slice of your life that you want to remember.

◀ Popcorn and Tinkerbell

This image tells the story of a daily ritual at our house. And each day it goes exactly the same way: popcorn in the favorite clear glass bowl, and cold milk in the Tinkerbell glass and Parmesan cheese (my daughter's topping of choice) invariably all over everything. I photographed the scene as a way to remember it, because, let's face it, my days of sharing messy popcorn with my kid are numbered. As childhood is fleeting, so are the endearing memories that go with it.

Perspective

A TABLE IS NEVER JUST A TABLE. THEREFORE, BEING
DELIBERATE IN THE WAY YOU CAPTURE "TABLESCAPES"
WILL MAKE ALL THE DIFFERENCE.

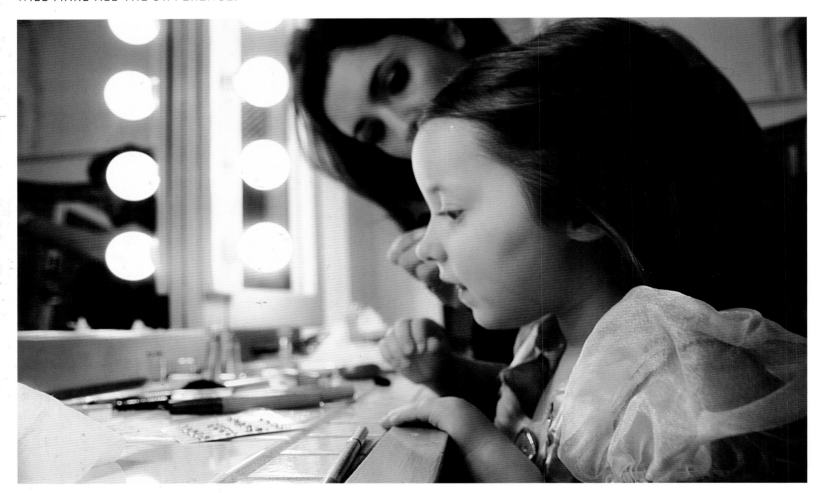

One of the easiest and most powerful ways to convey emotion or expression in a photograph is to do so with a surprising or different point of view. There is no right way to shoot an image. Certainly you can glean inspiration from photographers you admire, however, photography is ultimately about conveying your own unique perspective on a subject. Through experimentation with perspective you can discover and hone your own signature style.

▲ **Feminine wonder** *by Maile*
Maile's image of her daughter at the vanity table is from a low and close perspective, making us feel as if it were captured in secret. The camera focuses on the expression of wonder on the girl's face as it is illuminated by the Hollywood-style lights. The woman's face behind her is obscured and in many ways, unnecessary for the shot—it's all about what's happening for this little girl, probably feeling for the first time like she's all grown up. And because of the way this was shot, we feel it too.

See It!
Because of the low perspective, the line from the edge of the table is included in the foreground of the shot, which points right to the centered subject here. Shooting the girl up close adds to the intimacy of the moment, but by using a wide-angle lens (17mm), Maile offers the context of the moment—the makeup, the stylist, and the vanity lights. The lighting is soft and warm, which beautifully adds an ethereal quality to the image.

▶ Anticipation

My daughter Alex sits, trying to be patient as the cookies cool. I couldn't resist shooting this familiar scene from her perspective. Focusing on the cookies, with a shallow depth of field, Alex is slightly out of focus in the background (but with her smile and excitement still quite clear). I was able to crop the shot very tightly using my macro lens, lending intimacy to the image. The result is that viewers of this image also tend to feel a slight impatience to taste the cookies!

Shoot It!

Use a shallow depth of field (set your aperture to 4.5 or under) and compose your shot focusing on the main subject (a cup of tea, a bowl of fruit, vase of flowers). Be sure there is another point of interest in the frame too. In this case, it was Karen's daughter. Playing with your sweet spot (the focused element in your photograph) can lead to all kinds of compelling imagery.

▶ Morning light

I was asked to photograph objects at a friend's home and was struck by the candelabra sitting in the middle of her breakfast table. The candles inside the holders had already melted to about half their contents, suggesting the possibility of a cozy and intimate evening the night before. For this reason, I adjusted my perspective to capture the detail of the melted candles, as well as the morning light streaming through the window beyond.

Composition

YOU CHOOSE TO SHOOT TABLE SCENES FOR A REASON.
FOCUSING ON WHAT YOU VALUE MOST AMIDST EACH SCENE
WILL HELP YOU CONVEY THE FEELING BEHIND THE CAPTURE.

There's a reason why artists since the beginning of time have captured still life with fruit on canvases and film: items placed just so can attract the viewer's eye. In this section, we will demonstrate how considering the placement and composition of subjects in our frame can draw in the viewer and tell an appealing story.

▶ **Rolling stone** by Kate
Composing a shot with an unexpected crop can be effective in capturing the energy of the moment. The high-octane activity captured in Kate's shot of her son is only accentuated by her choice to crop the image to highlight his flailing hands and flying food; even the fact that he's wearing a Rolling Stones' T-shirt combines to help create intensity (and a little humor).

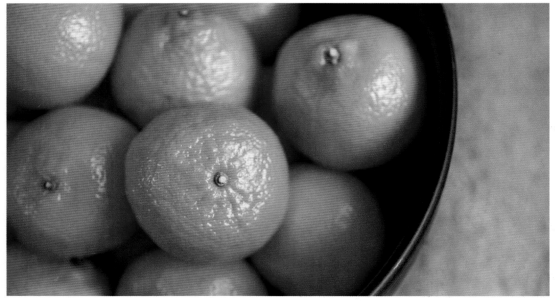

◀ **Bowl of sunshine** by Paige
One great way to compose an image is to have strong elements like repetitive shapes or startling colors. In Paige's shot of a bowl of oranges, the circular shape of the oranges is repeated by the bowl; in addition, the strong orange color of the fruit dominates the image, but doesn't overpower it—the color is kept at bay by the rim of the dark bowl and the gray of the table beyond.

▶ **Greens** *by Kate*

In this shot of a dish of greens, notice how the background, table color, and bowl are neutral colors, which helps to really emphasize the shocking green of the fiddlehead ferns waiting to be consumed. Kate made sure that the maximum lighting falls on the vegetables; in addition, she ensured that the greens are in sharp focus, unlike the rest of her image, and employed the rule of thirds—the focus is framed within the left third of her image, making for a more visually appealing shot and a strong, effective composition.

See It!

The perfectly chosen point of focus for this shot is the intricate texture and exotic shape. The placement of the focus is off to the left, as is the entire bowl. This division of the frame with the form of the bowl takes your eye from the greens in the bowl, over to the right of the image (following the white glow of the bowl), and then loops your gaze back again to the details of the food. Gently guiding the viewer's eye within a frame like this is an example of thoughtful and successful composition.

◀ **His spot for tea** *by Stephanie*

Repeating patterns in a frame is a powerful way to compose a shot to hypnotic effect. Stephanie's image of the countertop at a coffee shop is powerful precisely because of its organization and repetition of pattern. Notice how the menu in the foreground is repeated in the reflection in the coffee pot; similarly, the stacked tea mugs are mirrored by the perfect placement of the subject's hands and interlocking fingers.

Set It!
ISO: **400**
EXPOSURE: **1/60 SEC**
APERTURE: **3.8**
FOCAL LENGTH: **22MM**
FLASH USED: **NO**

Lighting

LIGHTING AND MOOD GO HAND IN HAND AND BOTH CAN BE EFFECTIVE NARRATIVE TOOLS AS YOU TRANSFORM YOUR TABLE SHOTS INTO MEANINGFUL, EVOCATIVE STORIES.

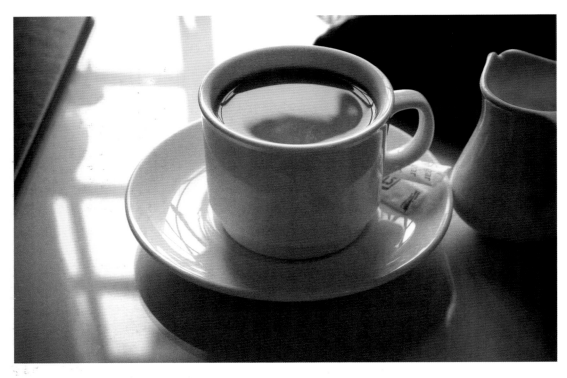

One of the most important elements of any photograph, regardless of subject, is lighting. It's really only a matter of getting into the habit of "looking for the light." The concept is actually quite simple and can mean the difference between a good photograph and a great one. Creative use of light can help convey expression and meaning in an image, particularly in a shot that doesn't include a human subject. For moments where we are communing at a table, restricting our light source to what's naturally available can help convey the intimacy of the surroundings in a way that feels far more inviting and intimate than using a flash.

◀ **Room service** *by Tracey*

Tracey's simple black-and-white image of her coffee is another example of capturing light as it reflects from an object. What we notice is not necessarily the cup with the coffee in it, but the light from the nearby window, and how it reflects both in the liquid and on the table surface below. By choosing to desaturate the color from her image in post processing, Tracey forces us to pay attention to the light and we start to think about her quiet morning with her cup of room-service coffee—which, as we all know, is sometimes the very best kind.

See It!

Low-fi, vintage-camera photography is effective for even the most mundane subject matter. That Karen found the light here and not only saw it through the utensils, but shot directly into the sun gave her not only illuminating flare, but circular sun spots that she was able to place one within another, within another. The light of this shot paints the perfect photograph and composing it within a square frame is a great fit.

▶ Pancake and honey

As you start looking for the light, it starts to become clear what kinds of amazing effects light can have on subjects. Light not only illuminates, but it also reflects, refracts, and creates magic. Consider the light that is the focal point of this image of honey falling on my Saturday-morning pancakes: the focus of the shot is at the point where the honey meets the pancake, rather than on the pancake itself—it is where the light is making most of its magic, adding to the feeling of expectation and anticipation.

▶ Celebrating a friendship *by Maile*

Notice how the light is refracted through the glass of wine in Maile's image of dining with a friend. The light causes the wine to almost glow, adding to the air of celebration, which is enhanced by her smiling friend just out of focus in the background, holding her own wine glass, possibly in a toast. The entire scene evokes a feeling of calm festivity.

See It!

Reflective surfaces can bring a new and different dimension to your images. Begin to not only observe all the reflections you find in your living space, but recognize them as photographic opportunities. Shoot your subject with the reflection in the same frame or shoot just the reflection. Compose a shot solely for the sake of mystery. There are elements that appear in your reflections that may have eluded the naked eye and might surprise you.

▶ Teatime

I took this shot one chilly November day in a small town in England, when my family and I had ducked into a small teahouse and café for lunch (and to escape the cold). I became captivated by an older couple sitting in the huge bay window of the café, speaking intently to each other in hushed tones, while enjoying their wine, their meal, and each other's company. By shooting the image so that the scenery outside was exposed properly, the two figures appear in full silhouette, adding to the mood of intimacy between them. Although you may often hear the rule that your light source should be behind you, it's really more of a guideline; in this photograph, the unlit couple provides the perfect context to convey a scene of quiet conversation.

Details

OUR TABLES HOLD OUR FAMILY RITUALS, OUR PRIORITIES, OUR PASSIONS; NEARLY EVERYTHING ABOUT US. IT'S WHAT MAKES THESE DETAILED IMAGES SO RELEVANT.

Set It!
ISO: **200**
EXPOSURE: **1/200 SEC**
APERTURE: **1.8**
FOCAL LENGTH: **50MM**
FLASH USED: **NO**

Often, when we're shooting items or events on or around a table, those elements are common to our cultures—we're celebrating a birthday, or creating art, or having a meal. These things, while different, might actually be happening all around the world in some form or fashion every day. In order to make your photographs special and distinctly yours, it's important to focus on the little details, the tiny things that help tell the story of your unique experience.

Shutter Sisters' Blog
BY JEN

It's not a minute past 10 a.m., yet there he is, sending the girls out for a treat. In this Rwandan home, there's no greater privilege than to get to drink Fanta. (And it may really be Coca-Cola, or Sprite, or orange soda—but the word for all these treats is Fanta and for momentous occasions, nothing else will do.)

So go ahead, take the cap off that warm, soft drink and sling it back like it's champagne on New Year's Eve, even if it's bright and early on a Wednesday morning. Fanta says someone is happy to see you. Fanta says you're an honored guest. Fanta says your presence is something to remember. How is it that the simplest things can tell you that you matter? How is it that the magical appearance of a lukewarm soda can let you know you're loved?

▶ **Home**

Details can be clues to the story behind a photograph. As a writer and a photographer, I work out of my house and there's nothing I love more than being engrossed in my work when a thunderstorm moves in. I feel like my home studio is a little cocoon, leaving me safe and protected from the outside world. On this particular day, I had attended a meeting and returned home just before a storm had moved in, and I was feeling extra comforted by my warm desk lamp, thankful I wasn't still outside in the elements. I took a photograph to commemorate the feeling, using depth of field to draw the viewer's focus to the word "home" on the keyboard. The lipstick on my teacup? A telltale sign that I'd been somewhere rather important earlier.

See It!

Look for even the tiniest detail that can act as a narrative of your shot. Words are literal, but highly effective in helping to tell a visual story. Seek out a word that might help narrate your shot. Capturing it like Karen did (with the word in sharp focus) brings the viewer's attention to it, even when it's small in the context of the big picture.

▶ **Color and light**

Late one gray afternoon, as I was watching my daughter set up her art supplies on our plastic-covered kitchen table, I couldn't help but notice the startlingly bright colors of the paintbrushes she was using. After asking her if I could capture her brushes with my camera, I positioned the brushes on our table near the open window—shooting directly from above—and adjusting the aperture to a wide-open setting, so that even though the colors were pronounced, only the details of the brush tips were in focus. The gray light added to the feeling of peace that was descending on our art-filled afternoon.

Processing

BECAUSE THERE'S USUALLY A REASON FOR CAPTURING A TABLESCAPE, POST-PROCESSING TOOLS CAN ACCENTUATE THAT CREATIVE INTENTION. EVERY SHOT OFFERS A NEW POSSIBILITY.

Shooting the image of your table vignette is only half the story: depending on the tools you use and how you process the image, the final expression of a photograph can vary wildly from photographer to photographer, from mood to mood. When I first started shooting, I was very skeptical of Photoshop and other post-camera processing tools, until one day I spoke with someone at my local camera store.

"There's nothing wrong with Photoshop, Karen," he said. "It's just processing—similar to what we used to do with chemicals back in the olden days." That's when it dawned on me: digital processing doesn't have to be about deception; in fact it can be all about artistry. It can be a tool to help communicate what you saw or felt at the time you took the image. After all, if you were amazed by the colors, or the sparkle in someone's eyes, or the moodiness of the sky, then why not make sure that those who see your images are struck by the same things?

Over time, I've come up with a few unofficial rules for myself when using Photoshop (or any other photo-editing software), which helps ensure I'm using the tool in a way that feels as authentic for me as possible. I say this without suggesting that others using the tool in a different way are being dishonest—again, art is in the eye of the beholder.

◀ **Tinted stems** by *Tracey*
Sometimes when uploading images from camera to computer, an image reveals itself on the larger screen differently than it did in the much smaller viewfinder of the camera. Although I am mindful when shooting to deliberately capture a scene or still life that catches my eye, sometimes it isn't until I process it that its true beauty presents itself. These stems submerged and entangled behind the glass were too interesting a sight to pass up. But this little vignette didn't look exactly like it does in this processed shot. In fact, it was less compelling. Photo-worthy, yes, but the blues and greens that I later enhanced, particularly in the tone of the reflective glass table, beckon the viewer to investigate the image and also evoke a sense of calm that I only experienced after processing it.

Shoot It!
You can use post processing to challenge your original monochrome shot. Experiment with options like saturation, hue, and luminance in processing to see how many different color interpretations you can create from the same image.

In editing, I don't choose to remove objectionable objects from my images. Instead, I have learned to try to shoot my best shot, avoiding distracting objects in the frame as I shoot and making these "edits" before I squeeze the shutter. Beyond keeping my shot true to what I originally snapped, it saves me additional time and effort in post processing.

But because frankly sometimes my camera just can't capture how amazingly blue-green the ocean is, or how shockingly yellow the fall foliage happens to be without a little help, I sometimes bump up the hue of a color, or accentuate the contrast in an image. Editing like this can help better recreate the scene as I originally saw it, as it really was, and as I want to remember it.

With almost every image I shoot, I use a sharpen tool and increase the contrast. These two simple steps have proven to enhance every image I shoot to my liking. Through experimenting and testing editing tools you'll find what works for you—maybe as a rule of thumb, or maybe on an image-by-image basis. It's up to you.

Using a "vignette" tool can effectively highlight the object of your photographic affection. A vignette darkens the edges of your image, which in turn illuminates the subject in the center of the frame.

▶ **Keys and coffee at Café Brasil, before and after**
The before and after of this still life demonstrate the difference in what the shot looked like straight out of the camera. What made me decide how to process this shot? Simply, when I was creating this photograph, I was struck by the light reflected by the coins and the keys, and the bluish quality of the light on the table. Once the image was uploaded into my computer, I chose to accentuate those features. I bumped up the contrast to enhance the light as it bounced off the coins and I increased the color saturation just enough to show the blue quality. The result is a shot superior to the original.

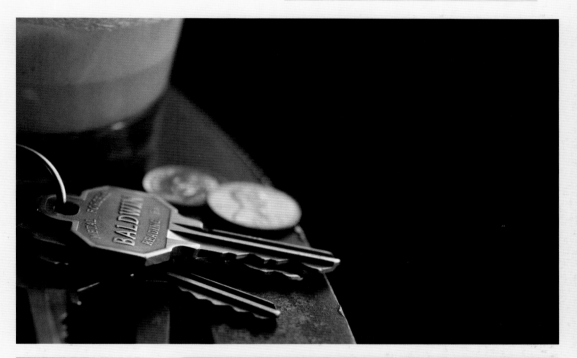

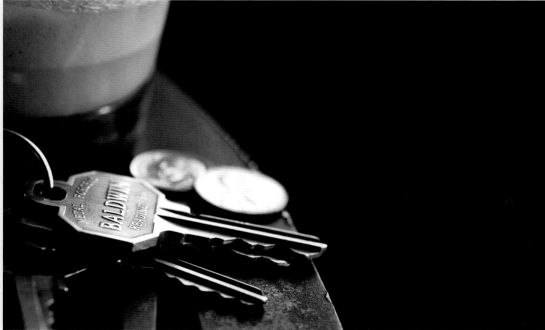

10
Togetherness

Jen Lemen

"But let there be spaces in your togetherness and let the winds of the heavens dance between you. Love one another but make not a bond of love: let it rather be a moving sea between the shores of your souls."

KAHLIL GIBRAN

HER NAME IS ESTERIA. SHE LIVES IN A WIDE, OPEN FIELD IN Rwanda in the house her son, Innocent, built for her. Five- and ten-dollar bills came from all over the world after I told the story of going to stay with her, out of a gesture of love to her daughter—my very best friend—who lives in the United States, so far away from her. The first time we met, Esteria welcomed me like a long-lost daughter, the child she never knew. I went to her arms as if I had always belonged there and then sat back to hear the stories—how she had been dreaming of a girl like me for 30 years, how she had been waiting, how relieved she was I brought the lights.

On this visit she confessed that the recurring dream was not an easy one—that she had seen a white woman coming into her house with torches, how she feared that the house would go up in flames, how it disturbed her so much she told her two closest sons and her daughter, years before we met. She tells me, only now, that all her dreams had come true, only none of it happened the way she imagined.

The house in her new dream would be a new one to replace the mud shack that was falling apart in the spring rains. The light would be her eyes shining at the thought that she had ever been afraid. The fire would be the love that ignited when we gathered—her children, her grandchildren, and me—all in the same place, all of us equally enchanted by the other. The torches would be a bagful of headlamps that made her laugh and laugh to see the light shining from her head as she made her way across the room that had always been dark, electricity a luxury not yet possible for an old woman in the village.

I ask her what she's dreaming now as she holds my hand, the one with the gold ring she gave me, the ring that is turning my finger green and making me happy. "Everything will happen in its own time," she tells me, not willing to give away any more secrets. "Besides, what could we dream that could be any better than this—to be together, body, mind and spirit? What could we imagine that could give us any more comfort? What could possibly give us any more hope?"

This is the photograph I took at the end of the conversation—the one where I leaned over for my camera with one hand, lifted it up to capture the moment in one snap. She knows this now about me, how I can't resist the urge to record the moments where we are most truly together. Like she always does, she asks if I will bring her a copy when I return to Rwanda—so she can remember it, too, when the only way we can be in the same place is in a small glossy picture she holds in her hand, the same way I hold the memory of her in my heart.

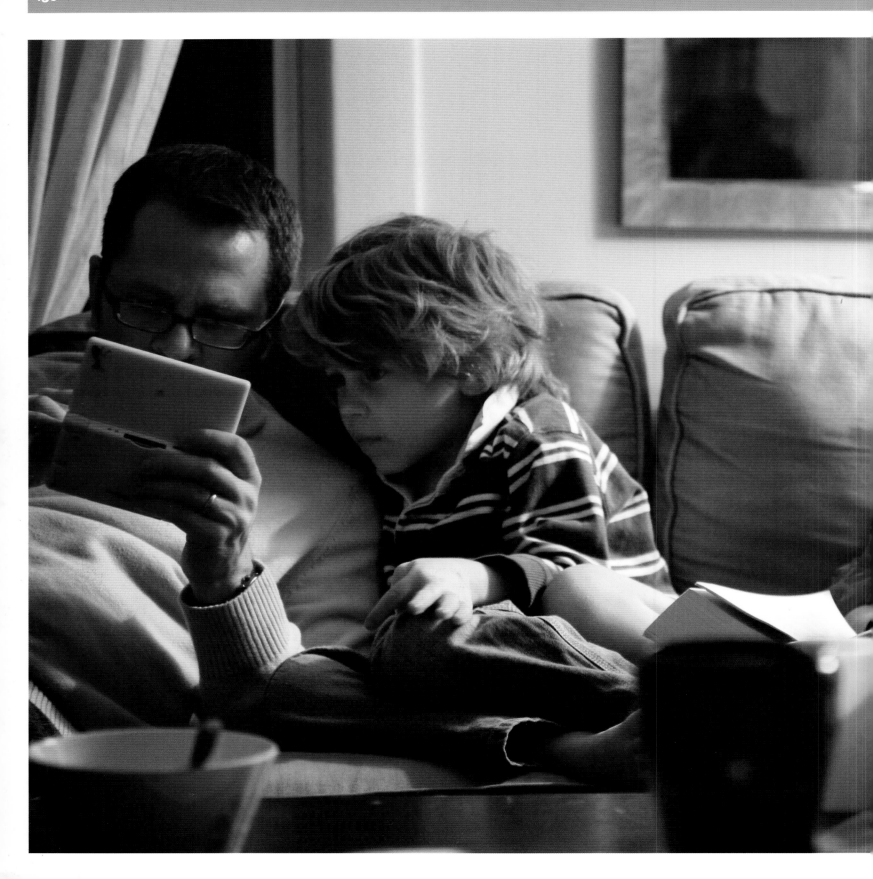

Introduction

THE DESIRE TO CAPTURE AND CHRONICLE OUR moments of being together can transform even the most casual photographer into the keeper of memories family and friends cherish for years to come. We begin with holidays, vacations, and other occasions that draw us all to the same place at the same time. We insist that everyone crowd in, put their faces together and smile for the camera, so we will have some record that we were all there in the same moment at the same time. Our togetherness extends to everyday interactions with the people we value most—the piggyback ride in the backyard, the shared bliss of the summer sun, the stolen kiss, the sweetness of having a companion when we feel most alive or even most alone. These portraits of togetherness nourish our souls long after the moment fades. They are our record of how we loved, keeping us together in spirit—even as life sometimes demands that we be apart.

The key to photographing togetherness is an eye turned on all the ways our hearts and minds connect. These connections exist all around us and can be revealed, and explored at any given moment. Like a detective looking for clues to solve a mystery, the curious photographer collects evidence that proves we are closer than we think. Sometimes the proof is obvious—a spontaneous kiss or a passionate embrace. But more often the signs are subtle—an extended hand, a backward glance, or a body leaning in with interest.

◄ The comfort of home

You can discover togetherness wherever people come together by using your camera like a periscope, observing from deep below the surface, looking for signs of connection or grace. From this thoughtful orientation, even the most simple shot can capture a depth of togetherness that you and your subjects will cherish forever.

Shutter Sisters' Blog
BY MAILE

"Photo shoots" are a strange concept when you think about it. People invite strangers with cameras into their homes, hoping they'll be able to capture and solidify a bit of what they feel for each other. We all know inherently that our dearest moments are fleeting. And so we expose ourselves. Because it's worth it. Because if it works, we're left with pieces of actual paper, pictures that feel permanent, and that depict and prove our most sacred connections. Our minutes, which were once evaporating, now feel solidly tangible. As photographers, we know this is the expectation. We know people want us to fish out all the real bits of their lives. We love what we do and we want to do a good job. And if we're not careful we can become on a mission about it. And that's when the magic bleeds right out of your work. Because finding moments is like chasing a rainbow. The second you feel like you know how to get there is the second it disappears. That's what keeps it adventurous: the idea that some things cannot ever be planned or plotted. They can only be waited for and revered.

Approach

IMAGES THAT DEMONSTRATE A SENSE OF TOGETHERNESS CAN BE OBVIOUS OR SUBTLE, SIMPLE OR COMPLICATED. ALL THAT MATTERS IS THE CONNECTION.

Catching people in a moment of honest connection requires a certain kind of seeing. And making sure that interaction makes it into your viewfinder is another challenge in and of itself. More often than not photographers will tell you that the most poignant moments of togetherness usually come in those off-script moments, long after you have carefully placed your subjects together where everyone was lined up just so. By allowing yourself the freedom to move in and out of a scene, you can turn your attention to mood, light, composition, storytelling and gesture—key elements in creating images that reflect the relationships already present in the room.

▼ **Woman and kids on brown couch** by *Stephanie* Having the right lens for the occasion and deciding where to stand ensures you'll be ready when the scene unfolds before you. Stephanie's super wide-angle lens was the perfect choice for this small dark room in Kigali, Rwanda. By standing quietly against the wall, Stephanie was able to capture the shot without disturbing the tenderness of the moment. In addition, her lens was wide enough to reveal a stark bare room, highlighting the intimacy of the conversation on the couch and the subjects' physical proximity.

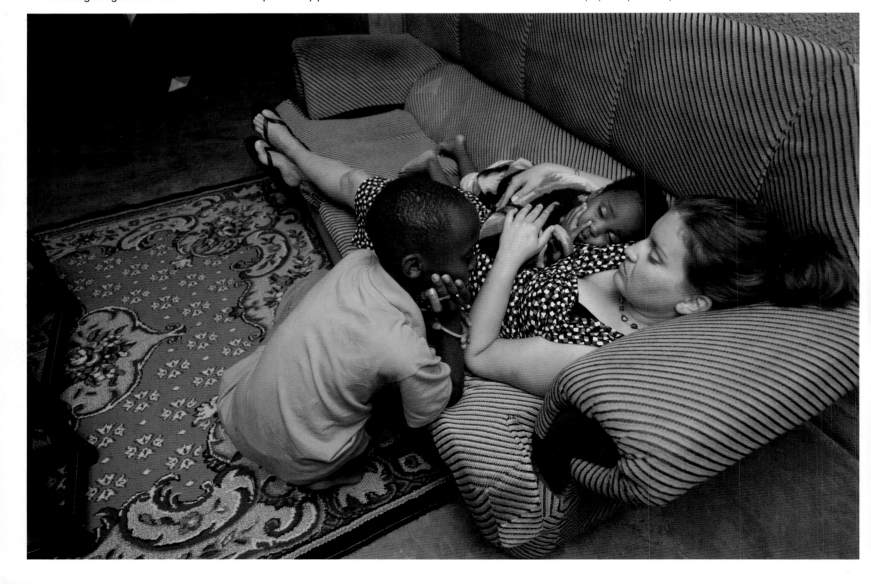

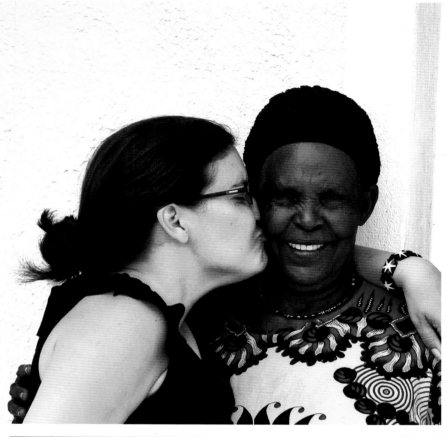

◄ **Impromptu smooch by Lilian Bizuru**

You can mastermind your best togetherness shots by relinquishing your right as a photographer to place everyone in the frame, and ask for permission instead to shoot without explanation as events unfold.

▶ **The weight of truth**

Not every image of togetherness needs to be cheerful to capture the relationship between your subjects. This photograph reveals both the heavy-heartedness of the mother and the companionship of the child. By turning your lens on the truth of a situation, even if circumstances are challenging, you provide a record of the way we hold onto one another when hope feels elusive and life demands too much. You can honor the full spectrum of the human experience when you approach all the facets of being together—even in those moments when we feel disconnected and alone.

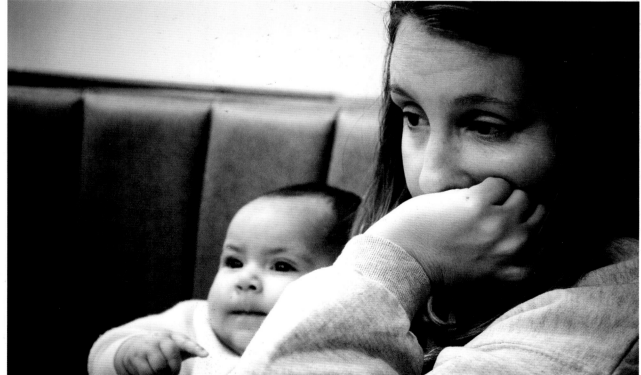

Perspective

AS YOU REVERE THE RELATIONSHIP OF YOUR SUBJECTS, CHOOSE
A PERSPECTIVE THAT HIGHLIGHTS BOTH THE VISIBLE CONNECTION
AND THE EMOTION THAT LIES BEHIND IT, JUST OUT OF SIGHT.

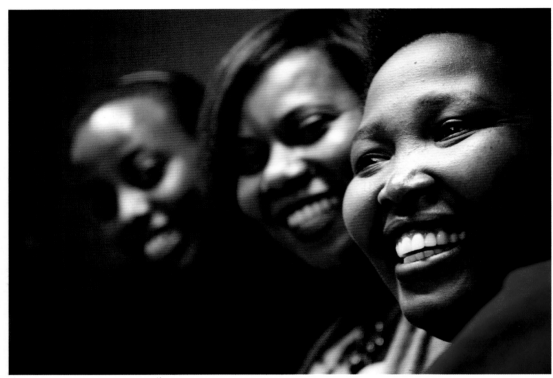

Have you ever looked at a photograph and realized something about a person or a relationship by what you saw there? Some instances of togetherness are uniquely revealed by the photographer's point of view. Your ability to look through the lens and find what is unsaid will speak volumes about the emotions your subjects share. Where you stand and what you choose to see can create as well as reveal a sense of connection that isn't easy to get at first glance.

◀ **Expression of friendship**
Shooting in a line directly to your side is a simple way to capture the intimacy of your subjects from a new perspective. The beauty of this point of view is you can catch a variety of expressions amongst the group without insisting that everyone look your way. This method might also allow you to capture your subjects off the cuff in a more natural situation, free to express their true emotion. Plus it brings an unique and unexpected perspective that transcends the traditional approach to point-and-shoot snapshots.

▶ **Boyish charm**
Sometimes you can communicate the most by standing right in the middle of the action. It's hard to avoid the joy and fearless nature of these boys in a field in Rwanda. Their relaxed and happy expressions, and willingness to look straight into the camera offers an intimate perspective on the ease they shared. I simply stood in the middle of their circle and shot whoever popped into the frame first. Processing these images in muted tones accentuated their expressions and minimized the dinginess of their clothes—a factor that may have drawn attention away from the more important subject, which is the bond the boys share.

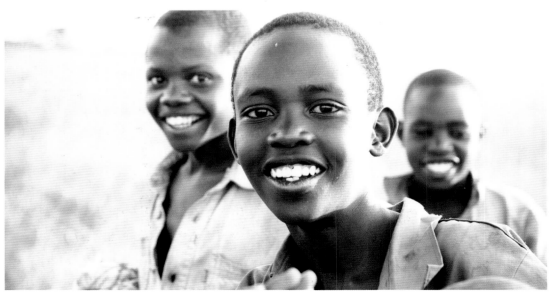

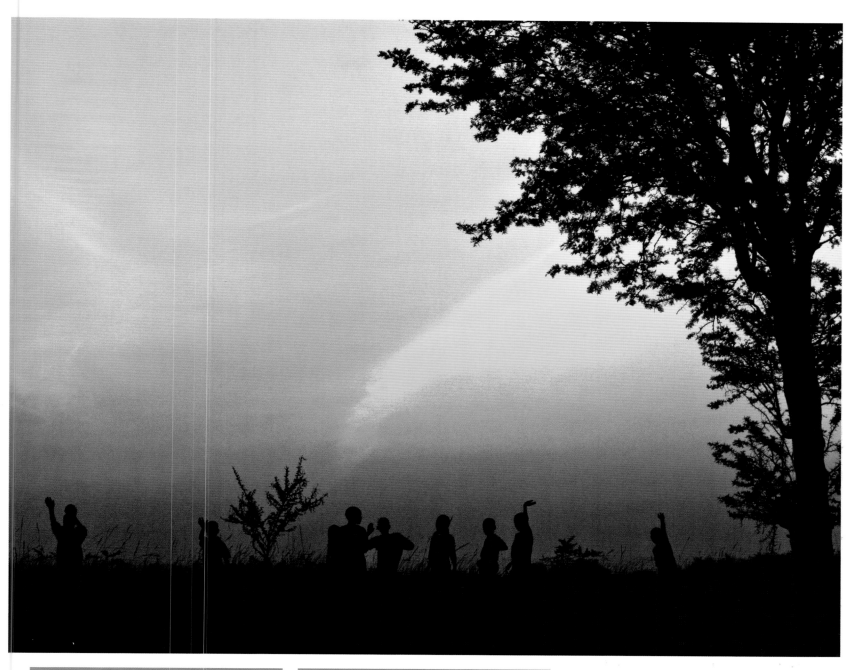

See It!

The evening sky creates a perfect backdrop for the silhouettes of the young subjects. The light allows the viewer to take in the full range of their motion, while the dark tree and tall grasses offer perspective on how small the boys are in the expansive field. This perspective also reveals how many boys are playing and the ease with which they interact.

Shoot It!

Try your hand at using silhouettes or shadows of your subjects to tell a story. The challenge is to find the gesture that symbolizes the emotion at hand. It's one more way to capture an emotional connection without using facial expressions.

▲ Joy in silhouette

This image captures the same boys, but this time at a distance of about 100 yards. Notice how distance creates a new perspective on the emotion they share. From this vantage point you can see their innocence and the universal, exuberant nature of their play. This could be any field in any country—but the viewer immediately recalls the joyful, carefree nature of childhood.

Composition

THE COMPOSITION OF SUBJECTS INTERACTING MIGHT SEEM TRICKY,
BUT ALLOWING YOUR SUBJECTS TO NATURALLY RELATE TO ONE ANOTHER
OFTEN LEADS TO AN INTUITIVE AND POETIC COHESION.

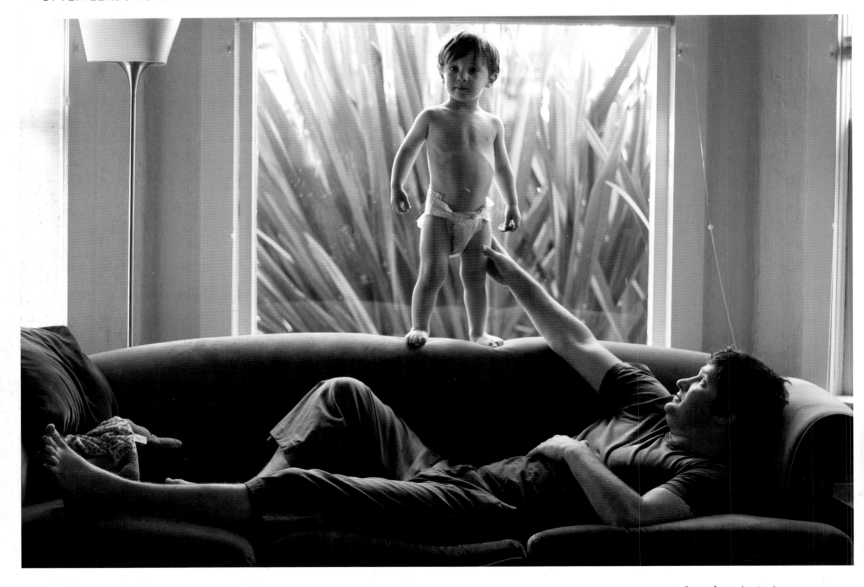

Composition creates the perfect conditions for the deepest
transfer of emotional expression in a photograph. A simple gesture,
a well-framed scene—these are the hallmarks of composition
and the way the photographer examines the power of human
connection. Whether you find the scene waiting for you or create it
yourself, your take on composition can honor the togetherness your
subjects share.

▲ **Superhero** *by Andrea*
Ordinary shots from uneventful
days can communicate
everything you ever needed
to know about the relationship
between subjects.

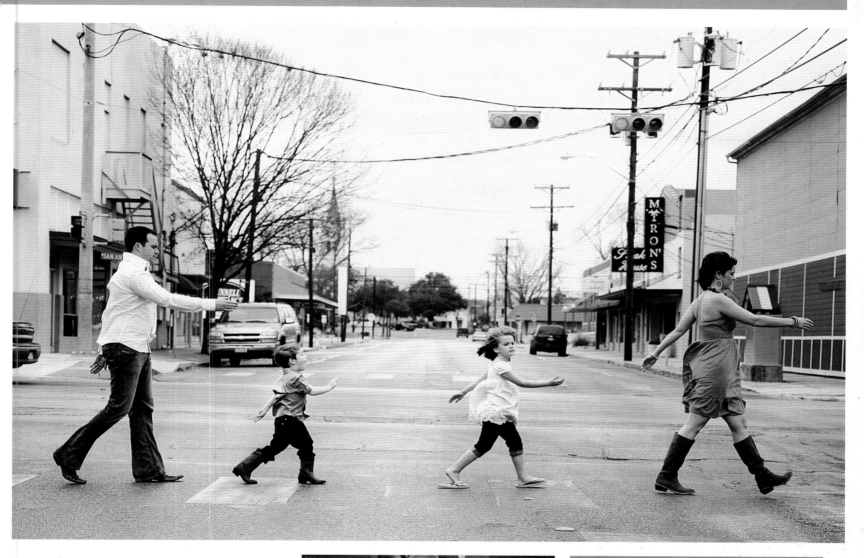

▲ **A stroll down Abbey Road** *by Maile*

On the contrary, one might choose to formally arrange the subjects in order to reveal the playful nature of their bond. In this scene, Maile recreates the famous The Beatles' *Abbey Road* album cover with this family of four. The result is a joyful commentary on their togetherness and enduring bond. By deliberately recreating an iconic scene, Maile invokes humor and brings lighthearted fun to one moment in this family's cherished history.

Shoot It!
Imitation is the ultimate form of flattery. Find an image or pose you'd like to recreate in your own photography. Remember that togetherness doesn't have to come through physical contact. The reinterpretation of the Abbey Road album cover shot shows connection and solidarity in a playful way.

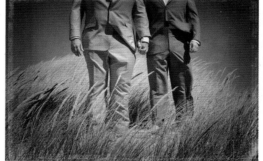

Shoot It!
Experiment with allowing your subjects to compose their own shots. How would they like to stand? Where would they like to be seen together? This small gesture acknowledges that the group being photographed plays a role in revealing the togetherness they share.

◄ **Wedding day** *by Andrea*

Sometimes the most straightforward arrangement of people creates the most powerful commentary. In this shot, two young men about to be married stood together in this traditional lineup and then asked for their portrait to be taken. The result is a capture that accentuates the strength of the family ties and the timeless nature of their commitment to one another.

Lighting

THE LIGHT USED TO ILLUMINATE TWO OR MORE PEOPLE CAN ADD TO THE EMOTION OF THE RELATIONSHIP(S)—BE IT DRAMA, EASE, DISCORD OR TENDERNESS. USE THE LIGHT TO INTENSIFY THESE FEELINGS.

Lighting plays an important role in establishing the emotional mood of the togetherness through the frame. Whether you choose natural light or take the artful assistance of the flash, your take on lighting will convey warmth, depth, intensity, or repose. Let the light reveal something important about the images you create. The golden hour—the first and last hour of sunlight during the day—is an ideal time to capture togetherness through your viewfinder.

▼ **The warmth of sisterhood**
The sun was just about to set behind me as I photographed these two young girls in a wide open field in Rwanda. The presence of warm natural light minimized the contrast between the skin tones of the girls and the pale grasses amongst which they were standing, creating a warm inviting tone to the image. This same field, nestled in a wide open savannah, is punishing in its harsh sunlight during the day, but by late afternoon there's no better place to shoot. I've learned to keep an eye on my ISO and shoot with as much natural light as possible at the optimal time of day.

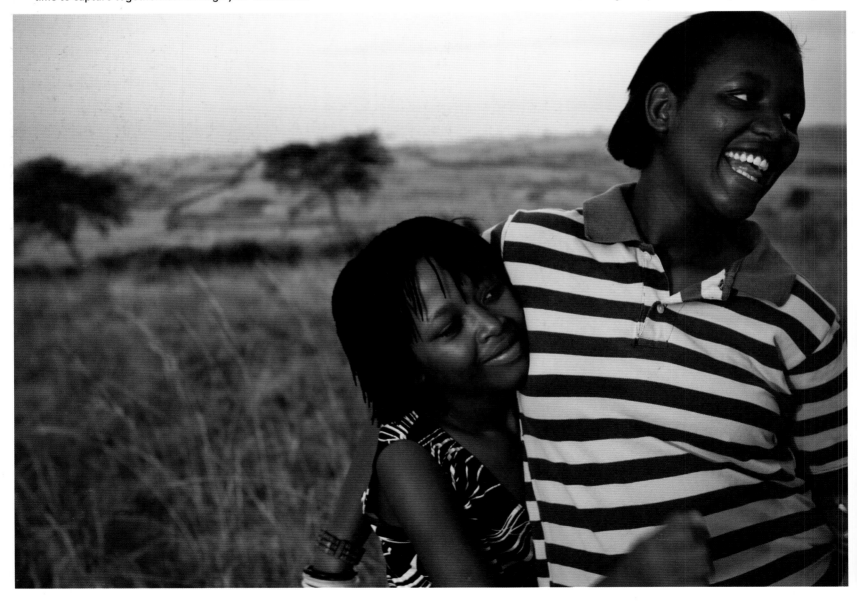

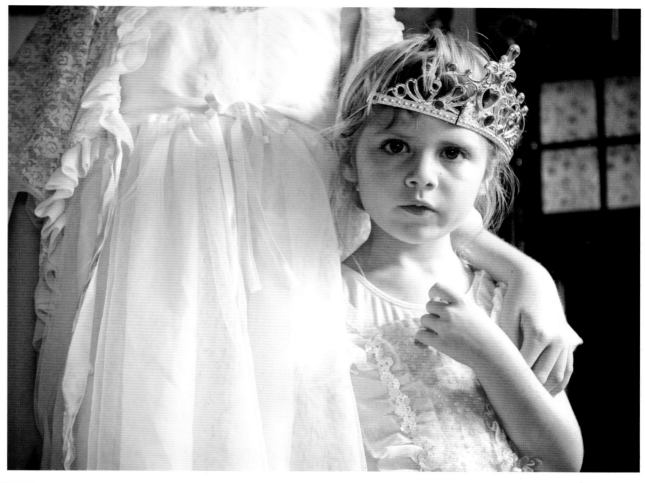

▶ **Little sister** *by Tracey*
Because shooting in the context of home will often evoke the truest tenderness between your subjects, finding the right light at the right moment can be challenging. In the case of Tracey's shot of her daughters, a nearby window casts a sidelight that is both soft and dramatic, adding to the overall emotion of this affectionate gesture between sisters. You might have to pull back the curtains and dial up your ISO to get the proper exposure, but when you're looking to capture relaxed and meaningful connections between your subjects, it's worth every effort.

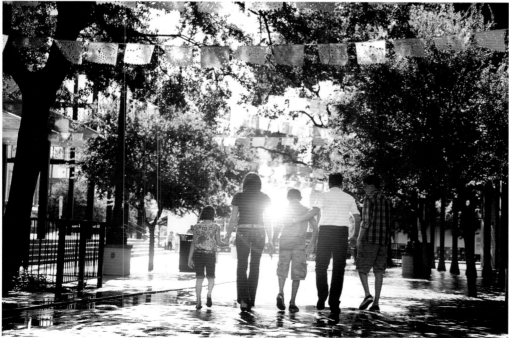

◀ **Toward sun** *by Maile*
Who says shooting into the sun is a bad idea when it comes to gathering up love in your lens? You can't help but feel hopeful when watching this family walk straight towards the light. Maile uses the sun as a focal point to create an image where anything feels possible and the connection between people becomes something to honor and celebrate. The flags take on a brighter hue as well, as the direct sunlight illuminates everything of color in this image.

Details

FOCUSING YOUR ATTENTION ON THE LITTLE NUANCES BETWEEN
PEOPLE CAN HELP DICTATE WHAT NEEDS TO BE SAID IN YOUR
IMAGE. LET YOUR SUBJECTS BE YOUR GUIDE.

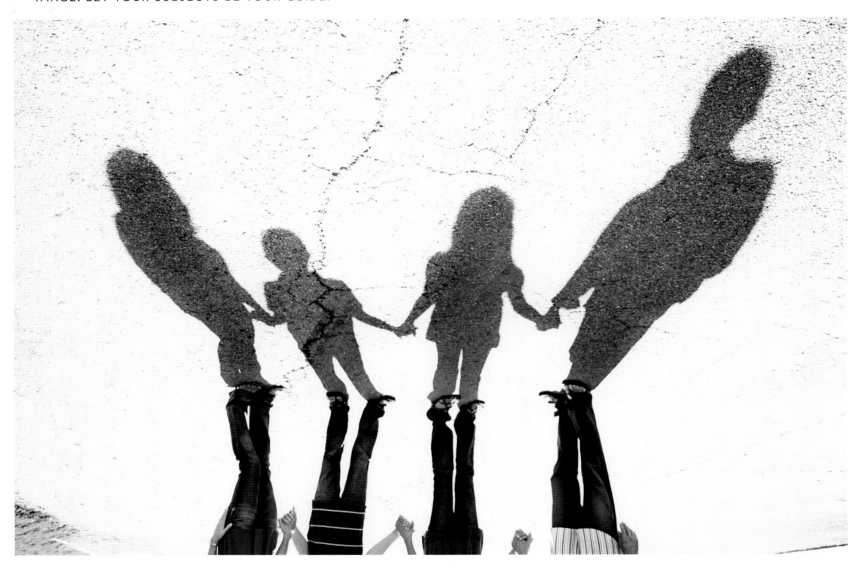

It is the job of the photographer to see the things that others often miss: the subtleties of expression, gesture, body language, the seen points of togetherness and those that are only inferred. It takes more than just a keen eye. It takes a lot of heart and the willingness to dig deeper and feel your subjects. Being willing to read between the lines will elevate your imagery and capture compelling pictures of your subjects.

▲ **One family connected** *by Maile*
There are infinite ways to capture connection through your lens. Focusing on the details, however, helps to tell specific stories of your subjects. Even the unexpected details can be effective, as Maile's shadow family proves.

Set It!
ISO: **250**
EXPOSURE: **1/1000 SEC**
APERTURE: **2.8**
FOCAL LENGTH: **17MM**
FLASH USED: **NO**

▶ **Turikumwe (we are together)** *by Stephanie*
The details of a relationship may seem intangible,
but if you're seeking the magic between two
people, these connections will make themselves
clear to you. In shooting a photograph of the same
couple, Stephanie takes an important step back
to give us another point of view—a look into their
relationship. From this vantage point, we notice the
man's arm draped comfortably against the young
woman's shoulder as they move into the house
together. You can see the togetherness between
the subjects in both images, but from two different
perspectives.

Shutter Sisters' Blog
BY ANDREA

*I've always been a hands person. Thinking
about any friend I have, I can very clearly
conjure up an image of their hands. Some
are strong and look like they could do
many hours of work in the hot sun, while
others are more delicate and gentle, with
long fingers and painted nails. One friend
of mine has so many lines crisscrossing all
over her hands that I know she surely is an
old soul. And then there are Ben's toddler
hands, like little starfish exploring the
world. I am moved by how much hands can
say in a photograph, how much love can be
transmitted by a gentle squeeze, and how
much they can hold. There is a Rumi quote
I love: "Look at your eyes. They are small,
but they see enormous things." I think the
same goes for hands. They are small, but
they hold enormous things.*

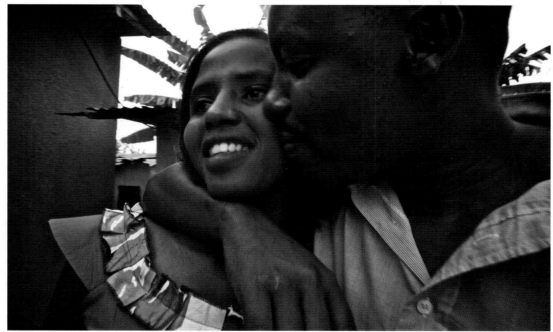

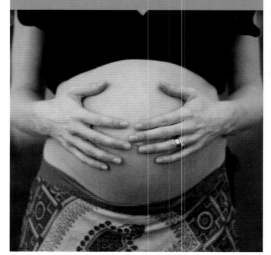

▲ **A love that's true** *by Stephanie*
In this shot, Stephanie captures an intimate
moment by standing in so close to her subjects
that we can feel the tightness of his embrace and
the affection of his kiss. This intimate perspective
allows us to get a front-row seat for this love story.
The kiss is the most obvious of affections, after all,
but it never gets old.

Processing

THE ABILITY TO EITHER LIGHTEN THE MOOD OR INTENSIFY IT
IS AVAILABLE IN THE DIGITAL DARKROOM. EMOTION CAN BE
BOLSTERED AND MEANING ENHANCED WITH EVEN SLIGHT EDITS.

Digital processing is a powerful tool for redirecting the viewer's focus and highlighting an aspect of togetherness that might otherwise be overlooked. Modern moments can appear timeless when brought into black and white. Vignetting can intensify the heart of the shot. Emphasizing grain or soft focus can create a haze of nostalgia. Don't be afraid to put your own editorial spin on the connections you observe through the lens by playing with processing.

▲ **When joy overflows** *by Sarah*
This indoor nighttime shot brilliantly captures the pure pleasure of the subjects enjoying an evening to remember. Through desaturation of the often overly yellow color of ambient lamplight, Sarah chose a warm-tone monochromatic palette instead to help better tell this story of intimacy among friends. The city lights in the background offer lovely depth and texture, and a magical backdrop of bokeh.

▶ Timelessness of together

This recent photograph took on a very different feel when processed in sepia tones. The sepia took this family outside of time and echoed long generations of the kind of togetherness we recognize in post-modern times as a tribe. Tweaking the contrast also gave the girl at the door a more prominent presence in the photograph and minimized the background, leaving the impression that this photograph could have been taken at any time, in any era across the African continent.

▶ Feet to feet

My favorite subjects in Rwanda know how much I like to photograph feet. This photograph, shot off the cuff after everyone in the room had their feet photographed, turned out to be the real treasure in the digital darkroom. By lightening the corners in a reverse vignette, the concrete floor takes on the curvature of the earth and bumping up the contrast reveals that the man's feet are solid on the ground, while mine appear to be floating. The child's foot in the corner, now more pronounced with the added contrast, adds to the intimacy of the trio and the togetherness we continue to share.

Shoot It!
Vignettes are a commonly used technique that can help draw attention to the subject usually in the center of the frame. Using the reverse vignette—lighter instead of darker around the edges—can create a totally unique and pleasing effect.

REFERENCE

Glossary

Aperture The opening of the camera through which light passes. Its setting is measured in f-stops and determines the size of the opening. The size of the opening, depending on the focal length of the lens, impacts the area of focus and the amount of light passing through the camera. The higher the f-stop setting (for example, f/16, f/22), the narrower the opening, resulting in less light and more of the image appearing in focus. The lower the f-stop setting (for example, f/1.4, f/2.8), the wider the opening, resulting in more light and a narrower area of focus, blurring more of the image.

Backlight Illumination of a subject from behind. Backlighting helps separate the subject from its background, often producing a halo-like glow around a subject when enough foreground light is present. When the backlight is significantly more intense than the foreground light, the subject will appear as a silhouette.

Bokeh The blur in the out-of-focus area (the area outside the depth of field) of an image. A shallow focus (i.e. using a wider aperture setting) will create an image with more prominent out-of-focus areas. A deep focus (i.e. using a narrower aperture setting) will create an image with minimal out-of-focus areas. Use bokeh behind your subject in focus to set it apart from the background. This can be particularly effective for portraits. Use bokeh to suggest background elements without showing too much detail in documentary images, or to lend a more abstract, soft or dreamy feel to your image.

Composition The placement or arrangement of visual elements in the viewfinder or in an image.

Contrast The difference between an image's lightest and darkest tones. In a low-contrast image, colors or tones blend more gradually showing minimal difference between highlights and shadows. In a high-contrast image, colors and tones are differentiated more abruptly, showing a more prominent difference between highlights and shadows.

Depth of field The portion of an image that appears sharp. A large depth of field or deep focus places the entire scene in focus by using a narrow aperture setting (for example, f/16, f/22). A shallow depth of field emphasizes the subject and de-emphasizes the background, with a wide aperture setting (for example, f/1.4, f/2.8).

Diptych Two images intended to be displayed together.

DSLR (digital single-lens reflex camera) A digital camera that uses a mechanical mirror system and a pentaprism (a five-sided prism used to channel a beam of light by 90 degrees) to direct light from the lens to a viewfinder on the back of the camera. You can use a wide variety of interchangeable lenses varying in focal length with a DSLR, giving you the broadest range of creative control for image making.

Exposure The amount of light used to create an image. An overexposed image is created with excessive light, resulting in loss of detail, a washed-out appearance, and blown-out highlights (solid white areas). An underexposed image is created with minimal light, resulting in a dark image with excessive shadows. Also refers to the cycle of a single shutter—for example, a

long exposure refers to a single extended or slow-shutter cycle used to capture a low-light scene. Exposure can be adjusted as you shoot, or in post processing using common image processing applications.

External flash An external mount strobe flash attachment for a DSLR. The quality of light emitted from an external flash unit is usually more effective and typically warmer and softer than the camera's built-in flash. An external flash can be used in low-light conditions to avoid the necessity of using higher ISO settings that could impact the quality of the image or in bright, high-contrast light to fill in any harsh, unavoidable shadows that the sun might cast on your subject(s) with added light (a technique called "fill flash").

f-stop A measurement that expresses the diameter of an aperture. Measured in one-stop increments (i.e., f/1.4, f/2, f/2.8, f/4, f/5.6, f/8, etc.), each aperture setting has half the light-gathering area of the previous one as the f-stop number increases. The physical size of the aperture will depend on the focal length of the lens.

ISO A setting that determines how sensitive the image sensor is to light. It is the digital equivalent of film speed. A lower ISO setting (i.e. 200) or slow speed is used for bright light conditions and ideal image quality. A higher ISO setting (i.e. 1600) or high speed is used for low-light conditions. The higher the ISO setting, the more "noise," or grain, will appear in the image.

Lens flare A visual effect (polygonal shapes, bright streaks, or an overall washed-out look) created when very bright light (often emitted from the sun) enters the lens and hits the camera's digital sensor.

Macro Close up. A macro photograph shows sharp details at a close focal distance.

Monochrome Shades of black and white, or shades of a single color. Color images can be converted to monochrome (or black and white) with most image-processing applications.

Negative space The space around and between the subject(s) of an image. The use of negative space, as a balance to the subject(s), gives the viewer's eye a place to rest and is an important element of the overall composition of an image.

Perspective The way in which objects appear to the eye based on their spatial attributes. Refers to the photographer's position and chosen depth of field relative to the composition.

Processing A method of editing and printing digital images in a variety of creative ways that might include one or more of the following: cropping, making adjustments to exposure, contrast, saturation, definition, sharpness, or white balance, or applying vignettes, filters, or textures to images. Often referred to as "post processing" because it is a manipulation of the image done after the photographer shoots and uploads the digital file to the computer.

Saturation The intensity of color. A saturated color is vivid, while a less saturated color is more muted or closer to gray. Saturation can be adjusted with most image-processing applications.

Shutter speed The amount of time the shutter is open (measured in seconds), exposing the image sensor to light through the aperture. Slow shutter speeds are used in low-light conditions, extending the time until the shutter closes, and increasing the amount of light gathered. Fast shutter speeds are used in bright-light conditions, decreasing the time until the shutter closes, and decreasing the amount of light gathered. Shutter speed is adjusted in association with the aperture setting to determine image exposure.

Viewfinder The component of the camera that the photographer looks through to compose, and in most cases to focus, the image.

Vignette A visual effect showing loss of clarity (i.e. blurring or darkening) toward the outer edges of an image. This processing technique lures the viewer's eye toward the center of the image. A vignette can be applied using most image-processing applications.

White balance Refers to the temperature of white light (warmth vs. coolness). White balance can be adjusted before you shoot using the white balance settings that most DSLR cameras offer or it can be corrected after the fact in most image-processing applications.

Without the love and support of our families, friends, and the stellar community of creative women at the Shutter Sisters' blog, this book could have never come to fruition. We cannot thank all of you enough.

Thank you to Adam Juniper for recognizing the perfect pairing of Shutter Sisters and a book on expressive photography, and for acting on it. Thank you to Natalia Price-Cabrera for her commitment and hard work. And a very special thanks to editor extraordinaire Carey Jones for every single edit, suggestion, and encouraging word. Her involvement throughout this entire process has been invaluable.

This book is dedicated to Shutter Sisters everywhere.